£19.95

779.

S/L

UELI ALDER

YANN AMSTUTZ

GEORGE AWDE

KRISTOFFER AXÉN

ANNA BEEKE

BENJAMIN BEKER

JOSHUA BILTON

ANDREI BORDEIANU

SAVAŞ BOYRAZ

THIBAULT BRUNET

MAXIME BRYGO

CHRISTINE CALLAHAN

TEHILA COHEN

JEN DAVIS

DAVID DE BEYTER

NICOLAS DELAROCHE

SYLVIA DOEBELT

DRU DONOVAN

ELIZA JANE DYBALL

LINA EL YAFI

SALVATORE MICHELE ELEFANTE

DAVID FAVROD

DANIELA FRIEBEL

ROBIN FRIEND

MATTHIEU GAFSOU

ANNE GOLAZ

LENA GOMON

NICK GRAHAM

AUDREY GUIRAUD

CLAUDIA HANIMANN

FLORIAN JOYE

KALLE KATAILA

DANIEL KAUFMANN

CHANG KYUN KIM

ANI KINGTON

MARKUS KLINGENHÄGER

RICHARD KOLKER

SYLWIA KOWALCZYK

ANIA KRUPIAKOV

IVAR KVAAL

ELISA LARVEGO

JACINTHE LESSARD-L.

DI LIU

SOPHIE T. LVOFF

AGATA MADEJSKA

DAVID MOLANDER

ÁGNES ÉVA MOLNÁR

RICHARD MOSSE

MILO NEWMAN

YUSUKE NISHIMURA

YA'ARA OREN

ANNA ORLOWSKA

JENNIFER OSBORNE

MARGO OVCHARENKO

NELLI PALOMÄKI

REGINE PETERSEN

AUGUSTIN REBETEZ

ANDREA STAR REESE

NICOLE ROBSON

CAMILA RODRIGO GRAÑA

SIMONE ROSENBAUER

SASHA RUDENSKY

CATHERINE RÜTTIMANN

SU SHENG

ADY SHIMONY

GEOFFREY H. SHORT

SHIMIN SONG

MEGUMU TAKASAKI

JAMIE TILLER

JANNEKE VAN LEEUWEN

FREDERICK VIDAL

TEREZA VLČKOVÁ

SAANA WANG

ROBERT WATERMEYER

ADRIAN WOOD

LIU XIAOFANG

TAMARA ZIBNERS

BARBORA AND RADIM ŽŮREK

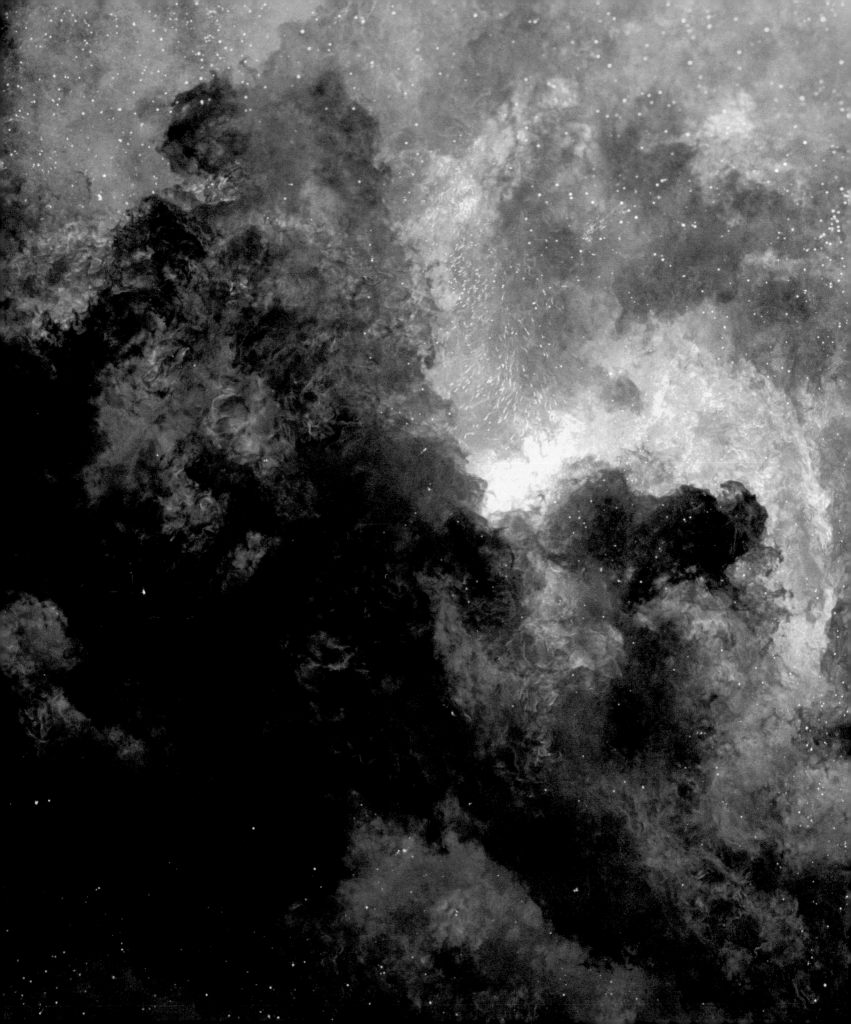

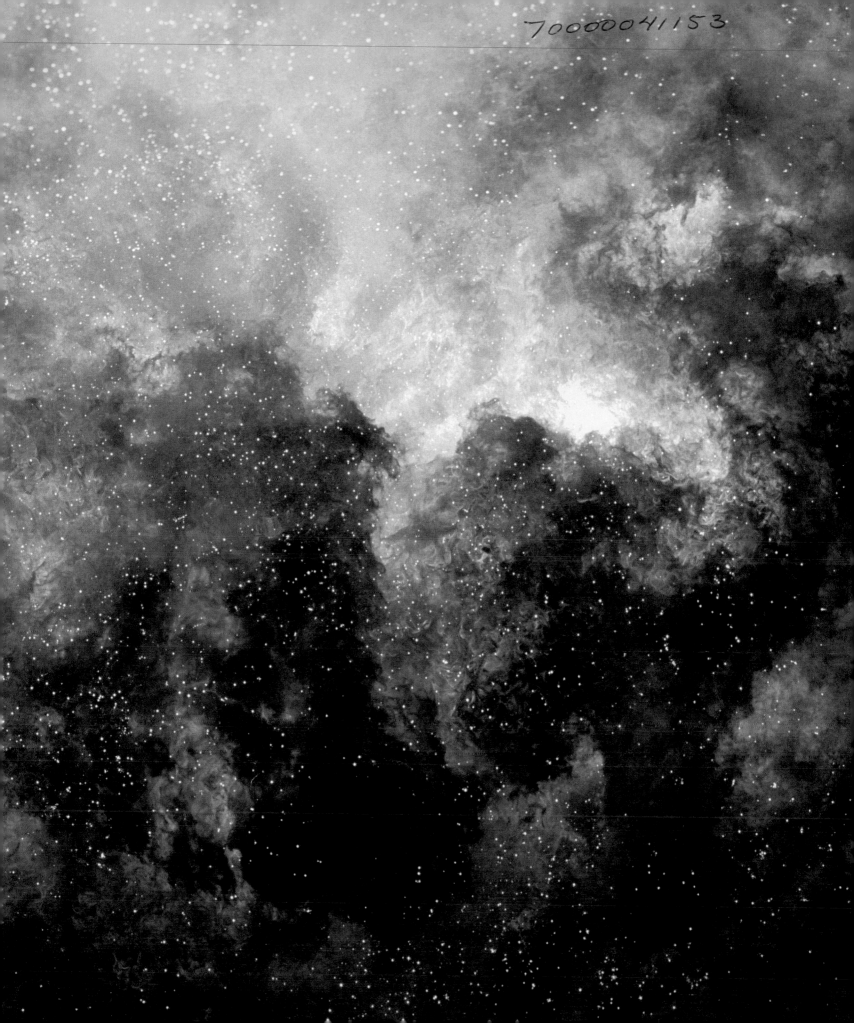

7000041153

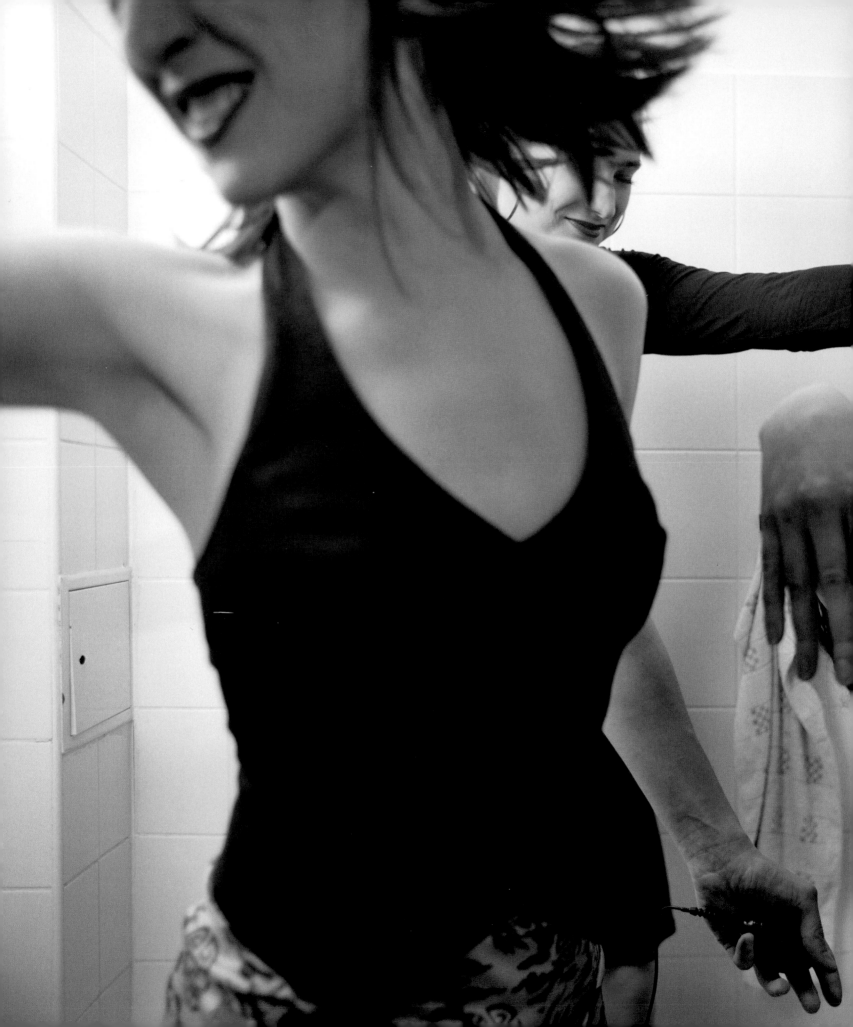

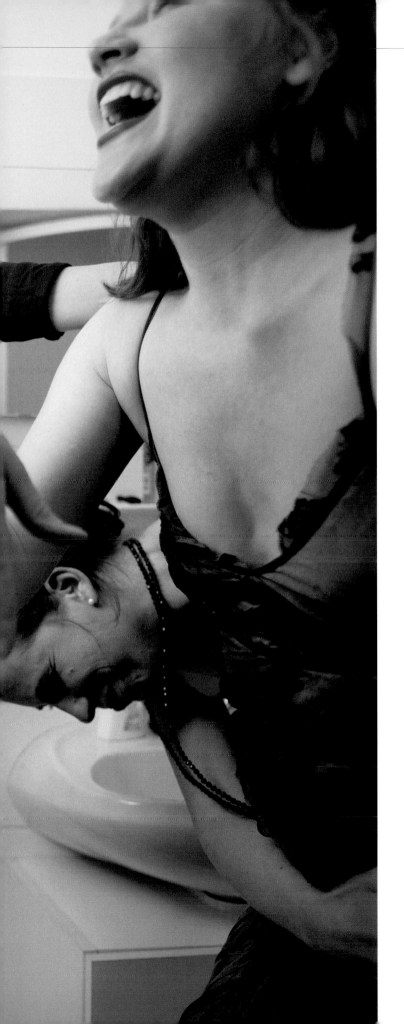

*re*Generation²
tomorrow's photographers today

William A. Ewing

Nathalie Herschdorfer

with 208 illustrations, 194 in colour

Thames & Hudson

pp. 2–3 **Geoffrey H. Short** Untitled Explosion #CFX18. From the series
Towards Another Big Bang Theory, 2007–2009

pp. 4–5 **Ágnes Éva Molnár** SELFTIMER 01, 2008

A project made possible by the generous support of

 and

Published on the occasion of an exhibition of the same name:
Musée de l'Elysée, Lausanne, 18 June–26 September 2010
Rencontres d'Arles, 3 July–19 September 2010
Michaelis School of Fine Art, University of Cape Town, 27 July–3 September 2010
Galleria Carla Sozzani, Milan, 6 November 2010–10 January 2011
Centre Gallery, Miami Dade College, 11 November–18 December 2010
Aperture Foundation, New York, 20 January–17 March 2011

First published in the United Kingdom in 2010 by
Thames & Hudson Ltd, 181A High Holborn, London WC1V 7QX

Designed by Maggi Smith

British Library Cataloguing-in-Publication Data
A catalogue record for this book is available from the British Library

ISBN 978-0-500-28889-4

Printed and bound in Germany by Steidl, Göttingen

To find out about all our publications, please visit
www.thamesandhudson.com. There you can subscribe
to our e-newsletter, browse or download our current catalogue,
and buy any titles that are in print.

CONTENTS

FOREWORD 9

PREFACE
LOOKING BACK TO THE FUTURE 10
William A. Ewing

INTRODUCTION
**DISCOVERING THE SHIFTING
TERRAINS OF PHOTOGRAPHY** 15
Nathalie Herschdorfer

THE PHOTOGRAPHERS 32
Nathalie Herschdorfer

LIST OF CANDIDATES 214

LIST OF SCHOOLS 218

ACKNOWLEDGMENTS 222

SOURCES OF ILLUSTRATIONS 224

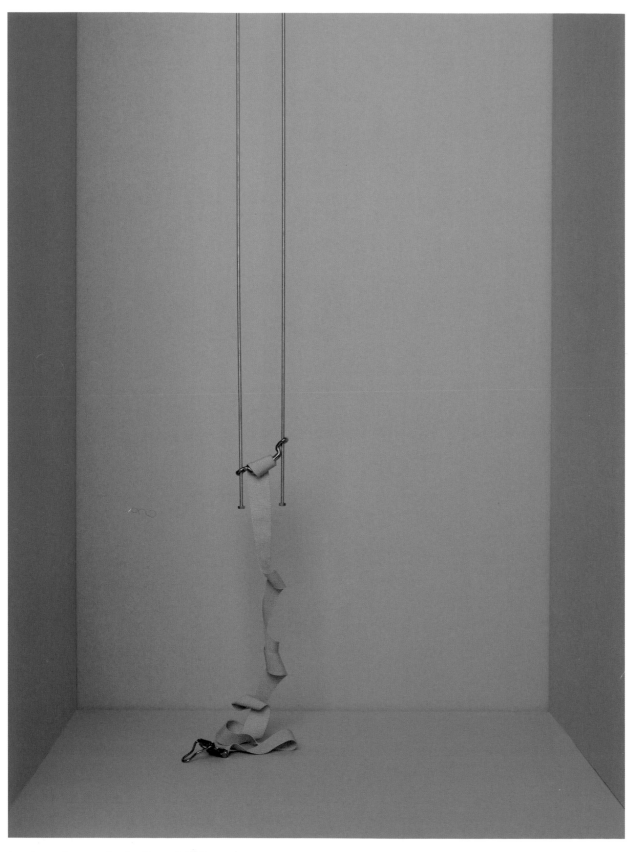

Janneke van Leeuwen Bonding Room #3, 2009

FOREWORD

Five years ago, the Musée de l'Elysée launched an ambitious international exhibition to celebrate its twentieth anniversary. As the name made clear, *reGeneration: 50 Photographers of Tomorrow* featured the work of many young photographers at the outset of their careers. The exhibition, which has travelled over the past four years to cities in Europe, North America and Asia, has been a great success on many levels. The high degree of interest in the project, on the part of both the photographic community and the larger public, encouraged us to take up the challenge once again, this time to mark our twenty-fifth anniversary.

We wish to thank our many partners in the enterprise – first and foremost the photographers, but also the many art and photography schools who put forward their most promising students; our publishers Thames & Hudson, Ltd, London, Editions Thames & Hudson, Paris, and Aperture Foundation, New York; Manufacture Jaeger-LeCoultre; Friends' Circle of the Musée de l'Elysée; Boner Stiftung für Kunst und Kultur; Ernst Göhner Stiftung; Fondation Leenaards; Loterie Romande; Office fédéral de la culture OFC; Pro Helvetia; and the Ecole hôtelière de Lausanne.

ReGeneration²: Tomorrow's Photographers Today takes the form of a book and an exhibition, launched at the Musée de l'Elysée in Lausanne and the Rencontres d'Arles in France, before touring Europe, America, Africa and Asia.

What began life in 2005 as a one-off project has grown into a long-term programme, an instrument that will enable the Musée de l'Elysée to follow developments in the field on a continuous basis. At any one time, the future of photography can only be guessed at, but the promising, energetic and committed photographers associated with *reGeneration* will make that future!

William A. Ewing
Co-curator of the exhibition and
former Director, Musée de l'Elysée

Sam Stourdzé
Director, Musée de l'Elysée

Lausanne, Switzerland, June 2010

LOOKING BACK TO THE FUTURE

William A. Ewing

In 2005, the Musée de l'Elysée undertook what was – for a museum – an unusual project. In order to celebrate our twentieth anniversary in an adventurous spirit, we decided not to wax nostalgic about the past, as is often the case with such moments, but rather to look into the future. Just how we were to do this was another question. As the digital revolution continued its relentless advance, demolishing longstanding practices in every domain of our field, we realized that only a fool would dare predict what form or forms photography would assume in 2025 – if, indeed, the term would even be recognized as meaningful (already, in 2005, Swiss educators had suggested substituting the term 'polygrapher' for 'commercial photographer', to take into account the new computer-based skills needed for image-making).

There was, however, one way to look forward. As the study of any artist's career makes clear, early works contain the seed of the mature artist, which is why a retrospective exhibition of a Pollock, a Le Corbusier or a Steichen can be so rewarding. By taking a young photographer at the outset of his or her career, we would have an idea, however imperfect, of what he or she could be doing twenty years hence. And by taking a significant number of photographers (we initially settled on fifty), it just might add up to a tantalizing glimpse of what form or forms photography might take when the museum's fiftieth anniversary came around. In other words, we would engage these young photographers as our willing and able guides.

ReGeneration was the result, consisting of an international travelling exhibition, a book, and – a not inconsequential element of the project – several opportunities for the photographers to meet one another and seek advice from specialists in the field – photo editors, gallery owners, curators and the like (such encounters were organized in Lausanne, Milan and New York). At the time, it never occurred to us that the project would be anything more than a one-off. But now, with another anniversary of our young museum to consider (this one a little more momentous, being a quarter-century), we realized that *reGeneration* had taken on a life of its own: it was still travelling, the work looked as fresh and relevant as ever, and the book was still very much in demand. We therefore decided that *reGeneration* had been an experience sufficiently interesting, and certainly sufficiently successful, to repeat.

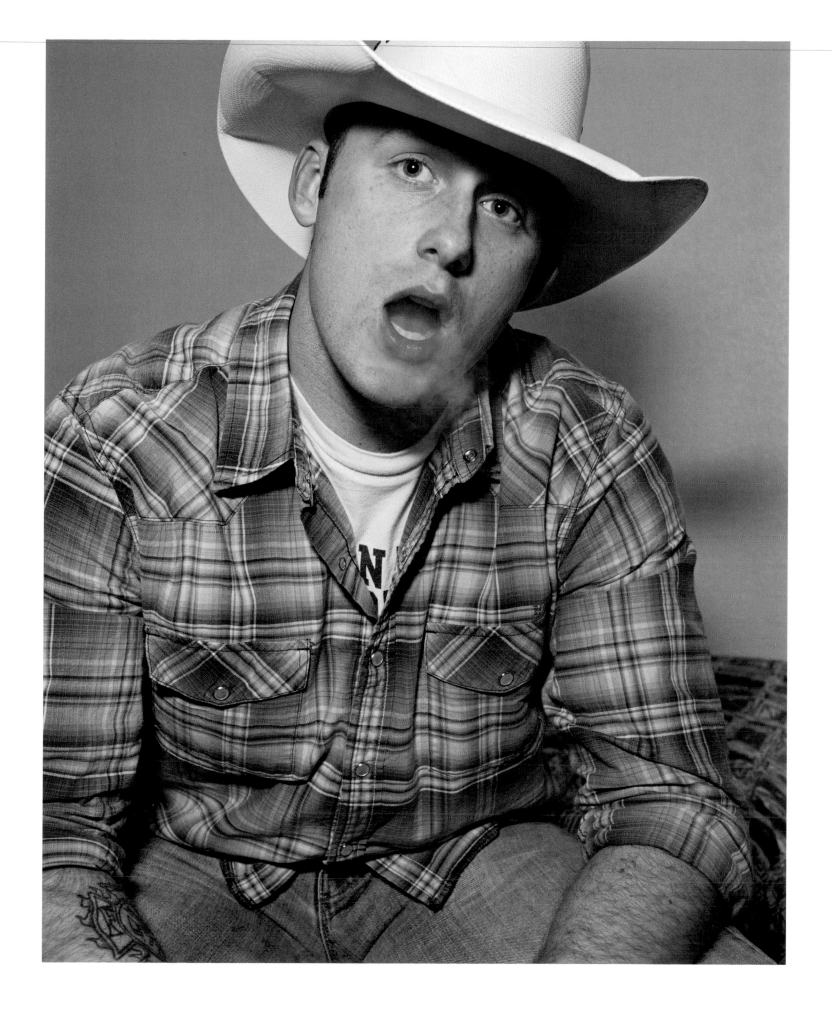

ReGeneration²: Tomorrow's Photographers Today is the equally exciting result. Once again, it is an exhibition, a book, a forum for the exchange of ideas and the forging of professional and personal friendships, and a collection which, added to the earlier works of *reGeneration*, will be preserved for the future.

I have said that the *reGeneration* project was an 'unusual project for a museum'. This is because museums generally exhibit photographers with anywhere between twenty and fifty years of work behind them (our recent Edward Steichen exhibition even covered a seventy-year career!). What museums generally mean when they speak of a young artist – in any medium – is one with at least ten years of work. This meant that our criteria for selecting students, or very recent graduates, could not be as demanding as would normally be the case. The attributes we look for in the work of a mature photographer – a consistently strong vision over time, a string of successful projects and an overall coherence to the work – were obviously far too much to ask of a debutant! Instead, we had to look for signs of talent, promise, originality, discipline – all of which call for highly subjective opinions on the part of the curators. (I am often asked what criteria I use in making choices, and I can only reply that they are personal and intuitive, but that they are based on almost forty years of looking, comparing, thinking and arguing about photographs, and that I am drawing on a vast inventory of images seen and studied over these years. It is similar for my colleagues on the selection committee: we are continually looking at, thinking about and writing about pictures of the past and the present. We see new work every day, take a close look at hundreds of portfolios every month – paper and electronic – and receive a steady stream of publications. Subjective it is, certainly, but it is still informed.)

Implicit in the question 'How do you choose?' is a challenge: 'What gives you the right to say "yes" to this photographer and "no" to that one? And "yes" to this photograph and "no" to that one?' My response to this critique is one of realpolitik: selecting, choosing, winnowing down, discarding, these actions are of fundamental essence in photography, and every young photographer has to get used to the fact that other specialists – curators, art directors, publishers and photo editors – will be doing this work, however painful it is to accept. The photojournalist who sees his five hundred images of the earthquake in Haiti reduced to one or two on the pages of a magazine (often badly captioned); the photographer whose new book has room for less than a quarter of what she considers her best work; the group exhibition which only has room for one, two or three of the photographer's pictures to represent a full body of work made over several years; the fashion photographer who sees his work savagely cropped and overlaid with spectacular graphics – these experiences are all par for the photographic course. On the other hand, those same experts can actually help a photographer by judicious selection, careful

sequencing and the like. In the case of *reGeneration*, it is this latter role that we hope to fill.

The first *reGeneration* experience was enriching on many levels – for the photographers, for the staff of the museum and the associated publishing houses, and of course for the public who saw the exhibition or bought the catalogue. For the photographers, the project was not only a window for their talents, but a chance to compare experiences and develop friendships. For the museum it was a way to survey the field of emerging photographers (between the two editions we have familiarized ourselves with the work of well over one thousand young photographers) and to obtain a sense of how young artists are thinking and feeling about the world. For the schools themselves it was a chance to showcase their strengths (the fact that the schools responded rapidly and enthusiastically the second time around was proof to us of *reGeneration*'s success from their point of view). As for the public, the positive response suggested to us that, despite the ubiquity of photography shows today and the proliferation of photographic publications, people are eager to see more, perhaps sensing that photography's potential is still far from being exhausted. If we accept Marshall McLuhan's idea that artists are the antennae of the human race, then it is fair to conclude that there is a widespread and healthy curiosity as to what signals those antennae are picking up.

As for the Musée de l'Elysée itself, the success of the first project suggested that *reGeneration* would be a useful tool beyond the obvious forms of a second exhibition and publication. To follow our rapidly mutating medium, we decided to redefine *reGeneration* as an ongoing programme. It will function for the museum as a radar system, allowing us to keep abreast of fast-moving currents in our field. It is true that a museum's fundamental mission is the preservation of the past, but this 'past' is no longer something that happened a decade ago, or a year ago; it is something that happened a moment ago – or even a fraction of a second ago (especially true of an instantaneous art form). The future arrives quickly, pauses briefly, then flees to the past. Indeed, part of the current angst of our lives is the shrunken substance of the present. *ReGeneration* might help us make sense of vertiginous change.

Parallel to the work of committed artists is the 'play' indulged in by the rest of us: it is rare now to find someone who does not have a digital camera on their person at all times, at the ready for what has been called 'casual capture'. This active participation in the visual culture may have made everyone more appreciative of the gap between our own meagre efforts and the accomplished work of serious photographers. Thus we are willing to accept that there are eyes sharper and keener than our own. Judging from the level of the imagery in this book, the artists of *reGeneration*[2] are equipped with them.

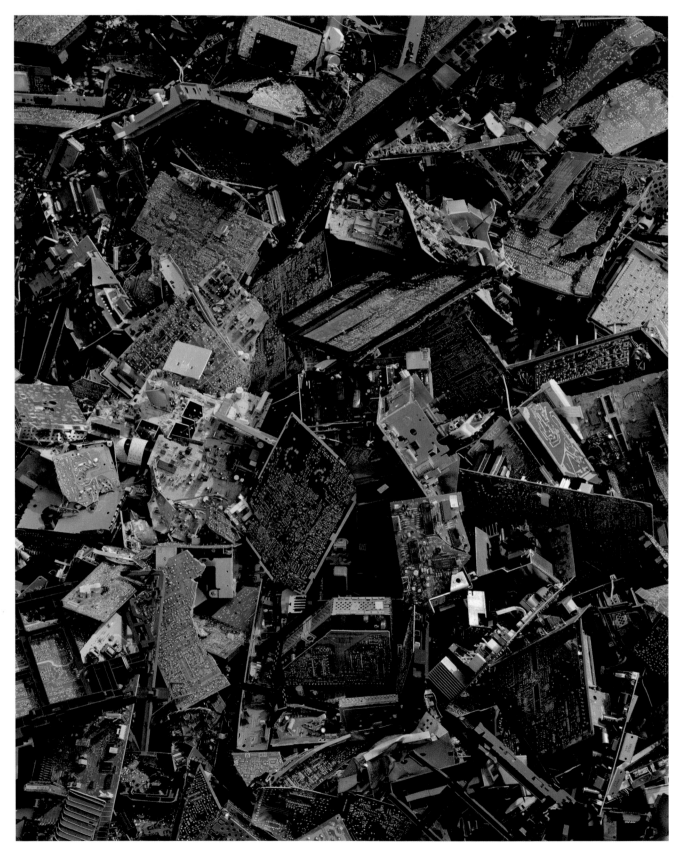

Frederick Vidal Untitled. From the series *Entropia*, 2008

DISCOVERING THE SHIFTING TERRAINS OF PHOTOGRAPHY

Nathalie Herschdorfer

'There are no facts, only interpretations.'

Friedrich Nietzsche[1]

Nowadays there are a number of exhibitions that are devoted to today's new generation of artists, but when we started work on *reGeneration: 50 Photographers of Tomorrow* a little over five years ago, we feared that the public would lack enthusiasm for the unknown artists that the project had brought together. This did not happen. Both the exhibition and the book were a success. Ten cities across Europe, the United States and Asia welcomed *reGeneration* between 2005 and 2009. More than 120,000 people saw the show, not including the many readers of the book, which was distributed throughout Europe, the United States, Korea and Japan. This success was due, no doubt, to the diversity of the work and the range of genres presented. But it may also have been the appeal of novelty and youth. The other projects that have emerged in recent years featuring very young artists prove that the public is curious to discover the work of creators early in their careers.[2] Over two-thirds of the photographers brought together in the *reGeneration* project are under thirty years old. We are undoubtedly interested in their view of the world.

In organizing the first edition of *reGeneration*, we had no intention of proclaiming that the selected photographers offered anything radically different from their predecessors. Artists often start out by studying, copying, interpreting artworks from the past. The title of the project came from the verb 'to regenerate', which implies an evolution from a given point. Reforming, rebuilding, reshaping or revivifying something means it existed beforehand. None of the artists we presented intended to start with a clean slate, ignoring the work of previous generations.

In 2005, in the first edition of *reGeneration*, we explained that the project was to identify a number of emerging photographers who, by 2025, might have achieved recognition. We gave them this period of twenty years to succeed; twenty years to establish a reputation on a solid footing. But can we really say, in 2010, that this time-frame is necessary, when fame can come one day and go the next, without even allowing sufficient opportunity for the importance of a work truly to be judged? Trends don't disappear anymore; they accumulate. Our relationship with the past has changed. All avenues have become possible. In the Internet age we live with high-speed information, and

the maturity of artists seems more and more secondary. The Musée de l'Elysée normally resists this tendency, but, while we generally present works spanning fifty years or more, we have also organized the 'retrospective' of an artist who only had a five-year career behind him. Five years after *reGeneration*, we observe that among the fifty photographers represented in the project, some are more productive than others: some, including Raphaël Dallaporta, Pieter Hugo and Angela Strassheim, exhibit and publish continuously, others have chosen to pursue their careers in other fields, and yet others – very few – have dropped photography altogether. We do not wish to draw premature conclusions, because exhibiting or publishing personal works are by no means the only options available to photographers today. Photography often goes hand in hand with commercial work, especially for those who choose to specialize in fashion or advertising. Personal work, which requires a significant investment in time, is often easier to do while one is a student, but then it has to be put aside when a living needs to be made.

Five years after the inception of *reGeneration*, we thought it would be interesting to launch a second edition, keeping to the same format. In our ever-changing world, the production rate of artists is prolific – artworks circulate over all the continents – and the evolution of photography now follows a fascinating course, with the constant flow of imagery on the Internet. Images, which can be linked with text or with sound, float in an increasingly complex visual environment. Not only are we bombarded with images in our daily lives (on the street, in magazines, on screen), but we also produce more images ourselves. This explains the growing interest in contemporary photography – a new lingua franca. Gallery owners, museum curators and publishers are offering photography an increasingly important part in their programmes.

So we decided to employ our butterfly net again. As in 2005, our efforts were limited to discovering the work of promising photographers in the leading photography schools around the world; our butterfly net can only catch a few specimens, not all of them. But it was important to gather a sufficient number to understand the direction of contemporary photography. The goal of the project was never to draw up an exhaustive list of the world's most talented young photographers, like an encyclopaedia documenting the names of the greatest artists of the past. Our purpose was, rather, to offer a panorama of current motivations and forms of expression. We did not want to focus on one region, one type of school or one particular genre. We selected the photographers on the basis of the work we received. It should be noted that many students chose to send their most artistic output, possibly thinking it was the best way to be selected by museum curators. We thought, perhaps naively, that we would also receive industrial, commercial or medical photography, but this was not the case.

The *reGeneration* project was made possible with the cooperation of the directors and teachers at the photography schools. For the first edition, we received more than four hundred portfolios, from sixty schools. For this second edition, we decided to double the number of schools. The idea, however, remained the same: the portfolios could only come from students. The schools have certainly operated as a filter – each could only submit up to ten portfolios – but the process helped us discover individuals that we would never have come across by ourselves, since most are not represented by a gallery or agency, nor are they yet published in the specialized press. We realize that selecting photographers through schools excludes those who are trying to work on their own. We accept the consequences of such a procedure, regrettably aware that some countries are under-represented or completely absent, due to their lack of specialized schooling. However, collaborating with schools of photography has enabled us to access quickly a large number of portfolios from many different regions of the world. Thanks to this collaboration – one hundred and twenty schools agreed to participate in our project – we collected nearly seven hundred student portfolios for *reGeneration*[2]. Despite our many efforts in South America, Africa and parts of Asia, we had to make the selection from portfolios mainly from Europe and North America (it is still noticeable that in the early twenty-first century there are no capitals of art, like Paris or New York were in their time). Developing countries have made good progress in education, but the teaching of photography is predominantly an established tradition in Western art schools. We agreed to follow the rules that we had originally set ourselves: only the work of students or recent graduates (2008 being the limit) from schools we contacted were reviewed.

The Musée de l'Elysée made its own selection, choosing the most relevant works on a visual and theoretical basis. All genres and subjects were accepted, whether produced by analogue or digital processes. We tried to keep an open mind throughout the selection process, whether the photographers had chosen a documentary or an artistic approach, whether they worked with film or specialized in pixel editing, and whether they supported their work with a detailed concept or preferred shooting spontaneously and freely. The names of the schools were hidden during the process. Similarly, the nationalities and background of the candidates were not criteria for selection. Our task was to judge the quality of photographs submitted by keeping an open mind as to the genres, styles and topics presented. Because the portfolios contained an average of twenty images, we were able to judge the consistency of the work. We also asked the photographers to describe their goals in a short text. These statements were useful during the final selection of the work, but in no case formed the unique criteria of selection.

In choosing work, we sought to identify the broader ideas that underpin contemporary photography. It was important for us to observe the motivations and strategies of photographers, as well as their working methods. In the introduction to the first edition of *reGeneration*, we conceded that emotion and intuition can interfere with reason and sometimes have an impact on the selection process. It is true that the work of the first edition influenced our view of the portfolios that we looked through five years later. We live in a country – Switzerland – that has a strong art-school tradition, and our selection criteria have without doubt been influenced by the major currents in Western photography. Nevertheless, we wanted to leave the door open to work submitted by non-Western countries that had accepted our invitation. We tried to identify real talent, knowing that the quality of photography schools varies greatly from one country to another. It must be remembered that the training offered in the hundred and twenty schools participating in the project is uneven: some offer higher education in photography, others are limited to technical training only. The 'academization' growing in photography in the Western world explains the theoretical references put forward by many students. Most of the photographers represented in *reGeneration* have been educated in both analogue and digital techniques, and have an overview of the history of photography. Their courses have also provided them with references to art history, sociology and anthropology. Many were able to experiment with several genres and processes. Others, as in generations before them, had only studied the technical possibilities of their medium and supplemented their knowledge by their own analysis of the work of other photographers.

In general, the quality of the portfolios received was solid and the accompanying data well documented. Browsing through all the work, we found that many students envisage their future to be in the art world. A higher education based on image analysis and practice under the direction of renowned photographers certainly encourages young practitioners to consider personal creation as an end in itself. With their studies over, some rush to show their portfolios to galleries, museum curators, writers and magazine editors. Some even produce their own publications, through the printing methods offered by digital technology: no need to wait to catch the eye of a publisher, as was the case with previous generations of photographers. Similarly, many students now have a website that presents an overview of their work. Any curator can be aware of a work without ever having seen it published or exhibited. Noah Kalina, while still a student at the School of Visual Arts in New York, showed his 'Everyday' series on YouTube. By January 2010, nearly fifteen million people had seen his 'moving' portrait, featuring 2,356 images of his face, photographed every day for six years. When we discovered it by chance on the Internet in 2007, a year after it had first gone online, five million people

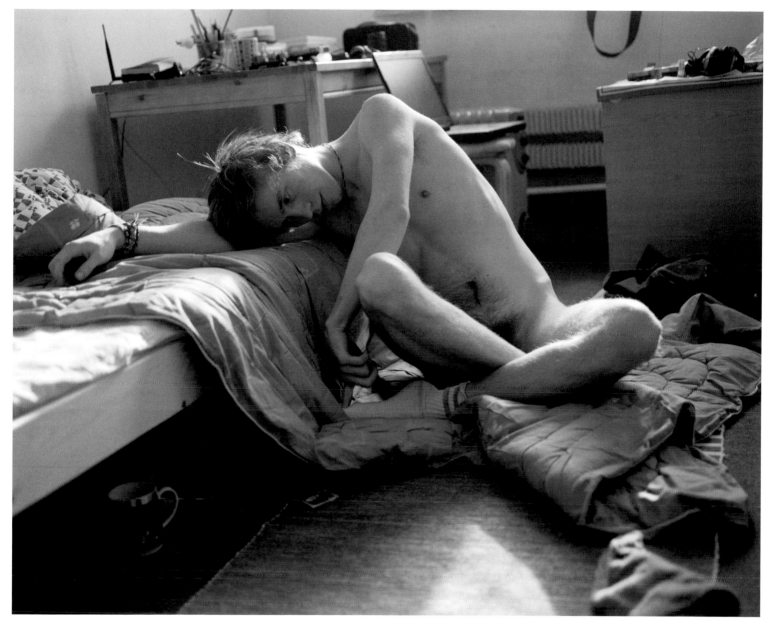

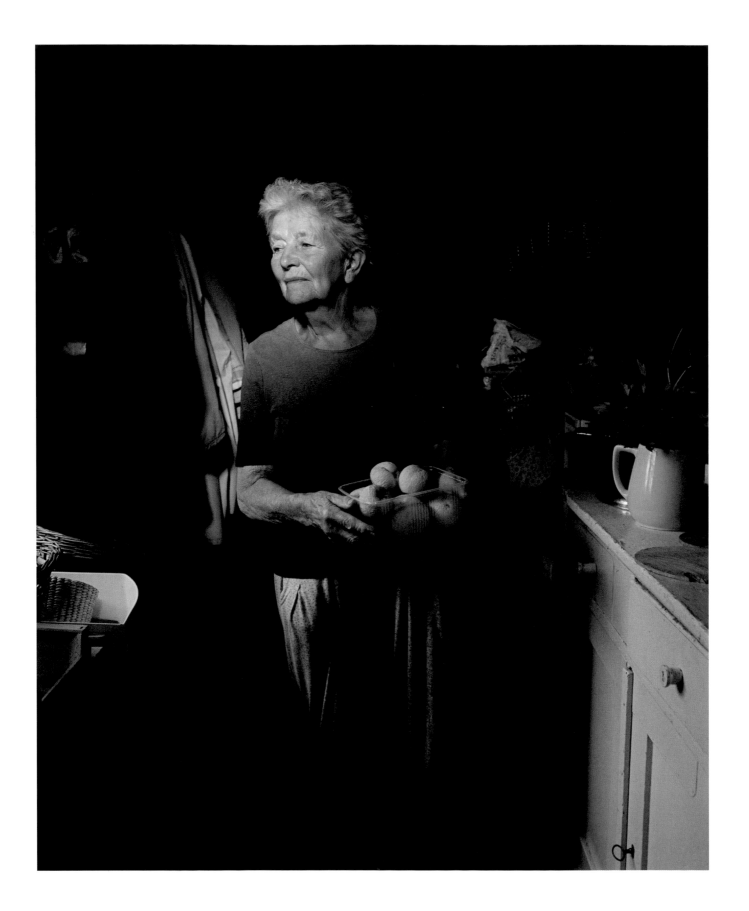

Rather than witnessing the end of photography, we are seeing a new florescence. Contemporary photography does not come in a unique style; it is as diverse in its techniques – from the use of large-format to small digital cameras – as it is in its influences. Many photographers have a sophisticated knowledge of painting and composition in art, and have read the major theorists of photography, from Roland Barthes to Rosalind Krauss. The ground is fertile for young practitioners. They remind us that the image remains ambiguous and has complex meanings. The debates surrounding the future of the medium have been numerous over the past fifteen years. The proliferation of digital technology has encouraged this movement, which has enriched our thinking regarding photography and its applications. Our understanding of images has also become more sophisticated. We know it is possible to modify, distort, recreate and compose images without even using a camera. The Internet also offers a myriad of images of all kinds. Digital technology, retouching and total construction techniques have become so widespread that nothing really surprises us when we discover new types of photography.

Looking at the works gathered together in this book, we can ask ourselves what photographers are looking for today. Some are interested in showing reality – or rather, *their* reality; others follow the path that leads to the realm of the imagination. Many works oscillate between the two. Doubt appears when we are confronted with the landscapes of Robin Friend or Jamie Tiller. Are they the result of retouching? Are they models? Ueli Alder, Nicole Robson, Saana Wang and Adrian Wood also play on this sense of ambiguity. Are their characters directed? Do these people really exist? The calculated blur between reality and fiction, found in many works, reflects a critical concern regarding the so-called objectivity of documentary photography. Jeff Wall and his cleverly constructed images opened this route thirty years ago – his first works date from 1977 – and there is no doubt that his work still greatly influences the younger generation of artists today. Fiction is an important element of contemporary photography that allows the relationship of photography to reality to be explored. Staging and the use of bright lighting that creates shadows are tricks that take us into the realm of artifice. The works of Kristoffer Axén and Anna Orlowska plunge us into a cinematographic world. In the work of Sophie T. Lvoff, the theatricality of the lighting also triggers the mechanism of fiction. Without doubt, the photographs of Markus Klingenhäger, Richard Mosse and Geoffrey H. Short are influenced by cinema, in particular action movies. This generation of artists is well aware of the equivocation of photography and the relationship between documentation and aesthetic construction. Their images fluctuate between several readings.

The traditional genres – documentary, portraiture, landscape, still life, and so on – are still with us, but they are being reinterpreted. It is often difficult

Richard Mosse Pool at Uday's Palace with River Tigris in the background, Jebel Makhoul Mountains, Salah ad-Din, Iraq, 2009

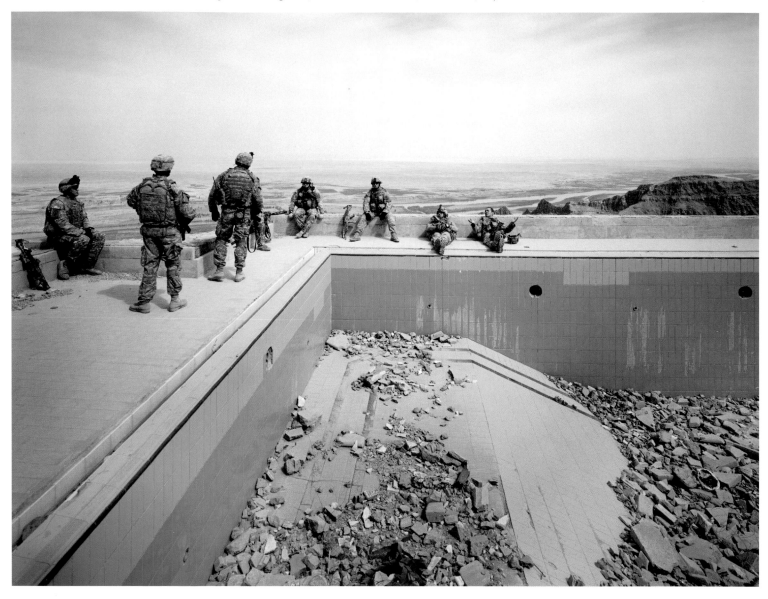

to classify a work in a single category. Photographers no longer specialize in just one technique. Working with landscape, still life and portraiture, David Favrod, SungHee Lee and Regine Petersen blur the boundaries of genres. Today, photography is inseparable from the mixture of disciplines, the use of materials and non-photographic processes. The allegories of Liu Xiaofang relate to traditional Chinese painting. Photography can be taken out of its own domain. There is the use of text, of course, as shown in the work of Lina el Yafi and Tamara Zibners. Sculpture is present in the work of Jacinthe Lessard-L. And no fewer than twenty artists represented in reGeneration[2] develop video work alongside their photographs. Ivar Kvaal accompanies his photographs with sound.

Some similar themes are found in the work of photographers from different backgrounds. Photography is no longer intended to let us discover the planet, but rather to 'explain' the world. Themes such as memory, time and identity are ubiquitous among the works in reGeneration[2]. Yusuke Nishimura seeks to represent the passage of light throughout the course of a day. Fragility and permanence are the concepts addressed by Milo Newman. Anna Beeke focuses on time and its effect on space. Christine Callahan, David De Beyter, Shimin Song and Liu Xiaofang evoke memories of their childhoods. Many artists use the medium as a laboratory of identity, because it is difficult in the new century to base our selfhood on such unsteady ground. Many artists alternate between uprooting and putting down roots. George Awde, Jen Davis, Ania Krupiakov, Ágnes Éva Molnár and Sasha Rudensky use photography better to understand their own identity. Such artists 'roam and wander' – as Nicolas Bourriaud writes[4] – and surf on cultures but without penetrating them. Joshua Bilton, Tehila Cohen, Tereza Vlčková, and Barbora and Radim Žůrek observe the concept of identity through appearance. Nick Graham, Margo Ovcharenko, Augustin Rebetez and Camila Rodrigo Graña explore their own generation. Dru Donovan, Eliza Jane Dyball, Sylwia Kowalczyk and Nelli Palomäki seek new strategies in portraiture. Photography can also be a diary. This is the case with Lina el Yafi and Regine Petersen. As for Tamara Zibners, she revisits her family history by creating photomontages and taking us along a route of her own devising to the heart of a multicultural history. These artists, by means of their wanderings, show how our lives are haunted by memories of people and events. We are forced to realize that this 'nomadic tribe' struggles to find any anchorage, any fixed identity, in our fragmented world.

Few photographers represented in the project seem to have a vocation for traditional photojournalism. Usually a reporter operates at the heart of the action and focuses on speed, spectacle and efficiency. All the tension of a situation has to be concentrated into a single image. But the photographers presented here challenge this approach and choose new documentary strategies, far from the shocking images intended to expose human suffering

to the light of day. The documentary form allows them to connect their own scenarios to real references. Current events play a major role. In the works of Richard Mosse or Catherine Rüttimann, there is a concern for addressing the news but their works really intend to produce reflection in the viewer. Savaş Boyraz, Lena Gomon, Jennifer Osborne, Andrea Star Reese and Robert Watermeyer question the environment in which we live: from their standpoint, the urban world is associated with delinquents, refugees and immigrants. SungHee Lee and Su Sheng critique a society that is focused on perfection. Similarly, Salvatore Michele Elefante, Anne Golaz, Markus Klingenhäger, Shane Lavalette and Simone Rosenbauer distance themselves from the rhythm of a photojournalist's work by taking time to build their subjects. Their works constitute a walk through a world that is simultaneously past and present. These photographers have chosen the documentary genre because they believe that photography has the ability to penetrate deep into reality. But their method is sophisticated and nobody any longer naively gives an image the status of objective truth.

Following Bernd and Hilla Becher, the leaders of the German documentary school, many photographers focus on 'anonymous sculptures'. The Bechers showed that the identity of an object can be transformed by the act of photography. The ordinary object becomes extraordinary. Nicolas Delaroche, Claudia Hanimann, Elisa Larvego, Agata Madejska and Frederick Vidal photograph ordinary objects and turn them into works of art. The works of Benjamin Beker, Audrey Guiraud and Ady Shimony are not far from abstraction either. Even when working on the theme of the consumer society, visual tricks become interesting. Matthieu Gafsou, Daniel Kaufmann, Chang Kyun Kim and Ya'ara Oren examine standards in this age of globalization. Overproduction of objects and information, rampant uniformity of cultures and languages, these are the favoured themes of photography at the start of the twenty-first century.

In the book *Art Photography Now*, Susan Bright noted that the urban landscape has become synonymous with contemporary photography.[5] The city is really the major subject of this generation of photographers, accustomed to travelling the world. They often prefer to work with a large-format camera – a format used in architectural photography – and in places devoid of any human presence. Twenty years after the Düsseldorf School, photographers are still attached to a technique that gives precise images – through the use of large- or medium-format cameras – and large-sized prints. The tradition of 'street photography' seems to hold little attraction for today's photographers, but this does not mean that they feel more optimistic about the city. Their images show burgeoning metropolises, fascinating certainly, but also highly menacing. The impact of building on the landscape and globalization on the world are central

to the work of Yann Amstutz, Bogdan Andrei Bordeianu, Maxime Brygo and Florian Joye. Loneliness is also associated with these locations that extend into infinity, as shown by Kalle Kataila or Ani Kington. The figure of 'the immigrant, the refugee, the tourist and the urban vagrant'[6] dominate contemporary creativity.

Some photographs in this book invite us to view them as brand-new visual experiences. Young photographers play with the uncertainties made possible by the medium: Sylvia Doebelt, Daniela Friebel, Geoffrey H. Short, Megumu Takasaki and Janneke van Leeuwen show us that photography is a representational system, whose main strength is to play on illusion and allusion. Their work is not easy to read and sometimes provokes questions. Beyond the topics it addresses and the perspective it offers on the world, their work is also a pleasure; an aesthetic delight.

Photography is a recent invention. Since its origins a hundred and seventy years ago, the medium has lent itself to artistic purposes and has also been present in areas as diverse as medicine, science, commerce, architecture, industry and advertising. Many of the photographers presented in *reGeneration*[2] aim to be career artists. In submitting their work to a photography museum, they have given preference to this route. But the applications of imagery are varied and a number of these practitioners will continue to develop their photographic work in fields other than art.

ReGeneration[2]: *Tomorrow's Photographers Today* is not a thematic exhibition. The photographers gathered in this volume have a number of traits in common, but their themes, sources and identities are various. *ReGeneration*[2] presents eighty photographers about to embark upon a career. All are navigating the shifting environment of the early twenty-first century. They represent thirty nationalities and have studied at forty-eight photography schools in twenty-five countries. The geographical mobility of this generation makes distances shrink. Some photographers will move to other countries, some will continue their studies in other schools, some will experience encounters that will lead them down other avenues. They will continue to develop their work. They know that trends are ephemeral. They therefore observe their peers and the photographers of the preceding generation; they study their work and analyze their approach. Their student status offers them the opportunity to experiment, to research and to explore in depth different directions. They are preparing to reveal their talents. The time is theirs to make their contribution to the world of tomorrow.

1 Friedrich Nietzsche, *Fragments posthumes*, XII, 7 [60], 1886–1887.
2 These projects include 'J'en rêve', Fondation Cartier pour l'art contemporain, Paris (2005), and 'The Generational: Younger Than Jesus', New Museum, New York (2009).
3 Charlotte Cotton, *The Photograph as Contemporary Art*, London: Thames & Hudson, 2009, p. 7.
4 Nicolas Bourriaud, email interview with Rita Vitorelli: 'Altermodernity', Spike 11, 2007, http://spikeart.at.
5 Susan Bright, *Art Photography Now*, London: Thames & Hudson, 2005, p. 16.
6 Nicolas Bourriaud, op. cit.

overleaf:

Kristoffer Axén A Day With Some Sun. From the series *At Sea At Night*, 2008

THE PHOTOGRAPHERS

Texts by Nathalie Herschdorfer

UELI ALDER	ELISA LARVEGO
YANN AMSTUTZ	SHANE LAVALETTE
GEORGE AWDE	SUNGHEE LEE
KRISTOFFER AXÉN	JACINTHE LESSARD-L.
ANNA BEEKE	DI LIU
BENJAMIN BEKER	SOPHIE T. LVOFF
JOSHUA BILTON	AGATA MADEJSKA
BOGDAN ANDREI BORDEIANU	DAVID MOLANDER
SAVAȘ BOYRAZ	ÁGNES ÉVA MOLNÁR
THIBAULT BRUNET	RICHARD MOSSE
MAXIME BRYGO	MILO NEWMAN
CHRISTINE CALLAHAN	YUSUKE NISHIMURA
TEHILA COHEN	YA'ARA OREN
JEN DAVIS	ANNA ORLOWSKA
DAVID DE BEYTER	JENNIFER OSBORNE
NICOLAS DELAROCHE	MARGO OVCHARENKO
SYLVIA DOEBELT	NELLI PALOMÄKI
DRU DONOVAN	REGINE PETERSEN
ELIZA JANE DYBALL	AUGUSTIN REBETEZ
LINA EL YAFI	ANDREA STAR REESE
SALVATORE MICHELE ELEFANTE	NICOLE ROBSON
DAVID FAVROD	CAMILA RODRIGO GRAÑA
DANIELA FRIEBEL	SIMONE ROSENBAUER
ROBIN FRIEND	SASHA RUDENSKY
MATTHIEU GAFSOU	CATHERINE RÜTTIMANN
ANNE GOLAZ	SU SHENG
LENA GOMON	ADY SHIMONY
NICK GRAHAM	GEOFFREY H. SHORT
AUDREY GUIRAUD	SHIMIN SONG
CLAUDIA HANIMANN	MEGUMU TAKASAKI
FLORIAN JOYE	JAMIE TILLER
KALLE KATAILA	JANNEKE VAN LEEUWEN
DANIEL KAUFMANN	FREDERICK VIDAL
CHANG KYUN KIM	TEREZA VLČKOVÁ
ANI KINGTON	SAANA WANG
MARKUS KLINGENHÄGER	ROBERT WATERMEYER
RICHARD KOLKER	ADRIAN WOOD
SYLWIA KOWALCZYK	LIU XIAOFANG
ANIA KRUPIAKOV	TAMARA ZIBNERS
IVAR KVAAL	BARBORA AND RADIM ŽŮREK

UELI ALDER

Switzerland, b. 1979
ZHdK – Zürcher Hochschule der Künste,
Zurich, Switzerland, 2004–2008

Basing his work on the saying 'If you get far enough away, you will be on your way back home', Ueli Alder focuses on the identity of a remote region of Switzerland, his place of origin. The canton of Appenzell – with its traditional rural landscape and culture – seeks to attract tourists keen on 'authenticity' by promoting its ancestral heritage. The imagery created by Alder recalls both local peasant painting and the American West, two genres that at first seem complete opposites. But, by blurring the lines between fiction and documentary, Alder produces his scenes of rural life with subtlety, creating a feeling of suspended time by paying close attention to composition and light, and making use of nostalgia without falling into the trap of cliché. Alder confronts us with our own contradictions: knowing that photography is not an accurate reflection of reality, still we let ourselves be charmed by the peaceful and harmonious world represented here.

Going to Fetch Wood. From the series *If you get far enough away, you will be on your way back home*, 2008

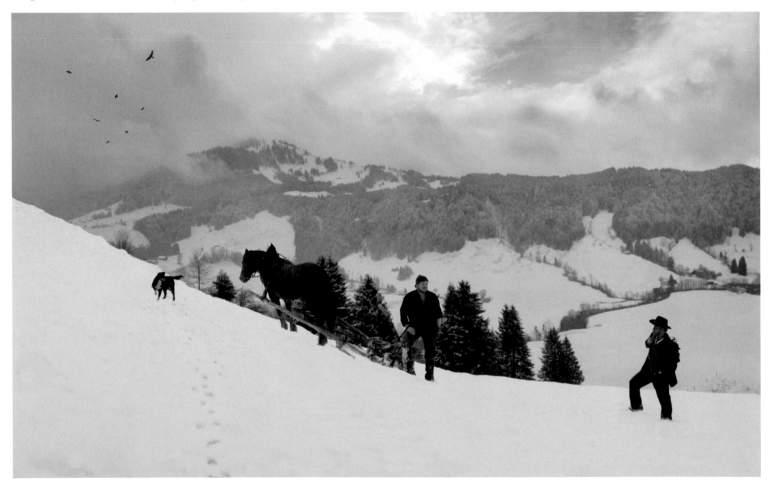

The Woodcutter. From the series *If you get far enough away, you will be on your way back home*, 2008

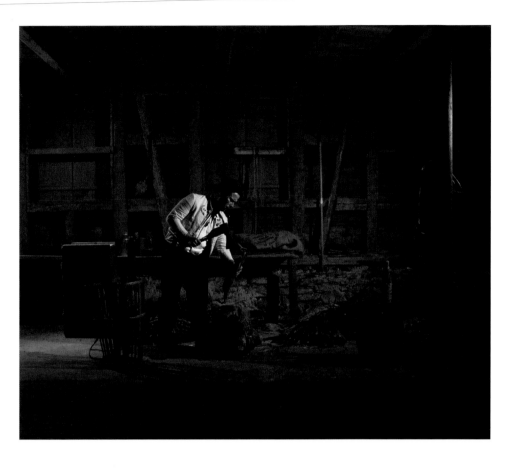

The Poacher. From the series *If you get far enough away, you will be on your way back home*, 2008

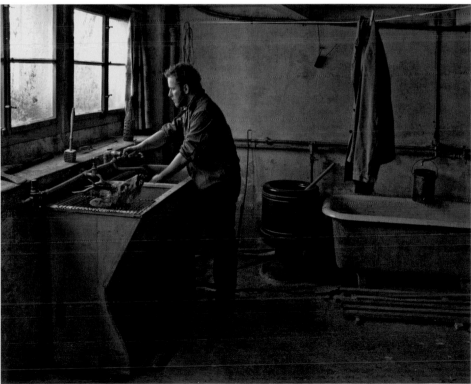

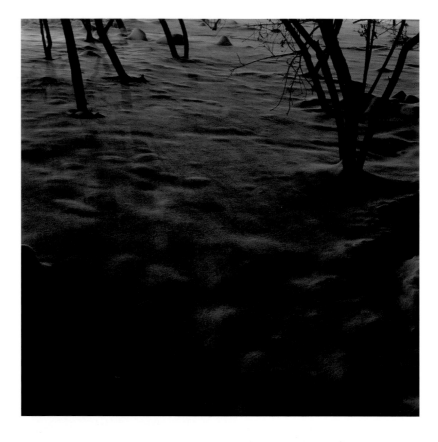

YANN AMSTUTZ

Switzerland, b. 1973
ECAV – Ecole cantonale d'art du Valais, Sierre,
Switzerland, since 2008
CEPV – Ecole de photographie de Vevey,
Switzerland, 1997–2000

Many artists are interested in the narrative dimension
of photography, but there is no such staging in the
work of Yann Amstutz. If there is any protagonist in
his night scenes, it is light. With this, Amstutz
manages to create a cinematic universe that takes us
into the realm of fiction. No human presence animates
the images, and yet something seems to have
happened or is about to happen. Mystery prevails.
Working in the urban landscape, the photographer
does not seek to distinguish between the cities he
has visited (in China, Europe and the United States).
His locations are all bathed in artificial light,
resembling one another in the feeling of loneliness
that characterizes them. The scenario is still to be
written, and the characters are yet to enter the scene.

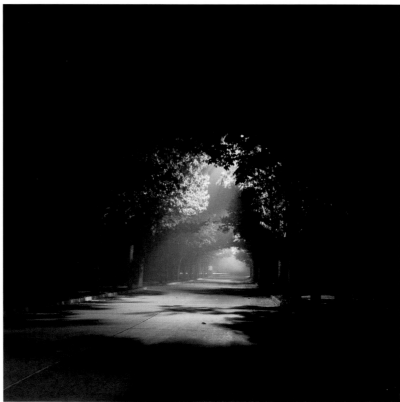

above right:
Snow Pink, Harbin.
From the series *Nighttime Exteriors*, 2000

right:
Beida Road, Beijing.
From the series *Nighttime Exteriors*, 2000

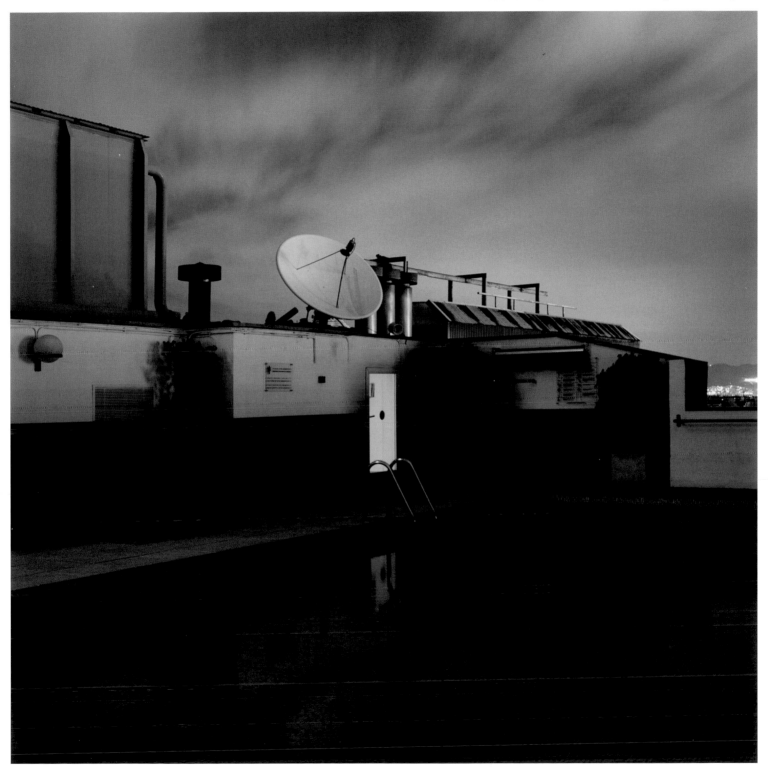

GEORGE AWDE

Lebanon/USA, b. 1980

Yale University School of Art, New Haven, CT, USA, 2007–2009

Massachusetts College of Art and Design, Boston, MA, USA, 1999–2004

George Awde uses photography to question his identity and to observe his membership of two minority communities. As part of a Lebanese family, though born and raised in the United States, he examines his Arabic roots, while as a gay man he explores the relationships he has built within the new 'family' he has encountered through his sexuality. His observations of intimacy and identity are expressed through a practice focused on the genre of documentary photography. Seeking his place within two cultures that could at first seem completely opposed – the Lebanese community on the one hand, and the gay community on the other – the photographer directs his lens on the places he frequents and the people with whom he mixes. Produced in Beirut and the United States, his work questions the definition of family and the concept of masculinity in a culture based on the patriarchal model.

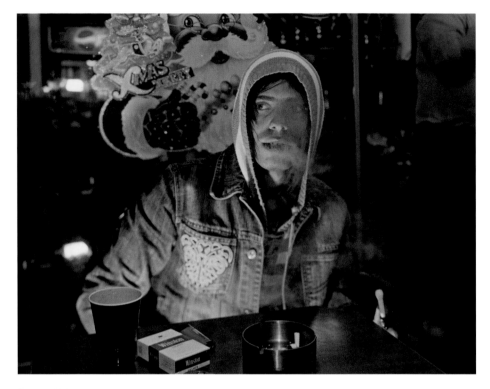

Beirut, 2008

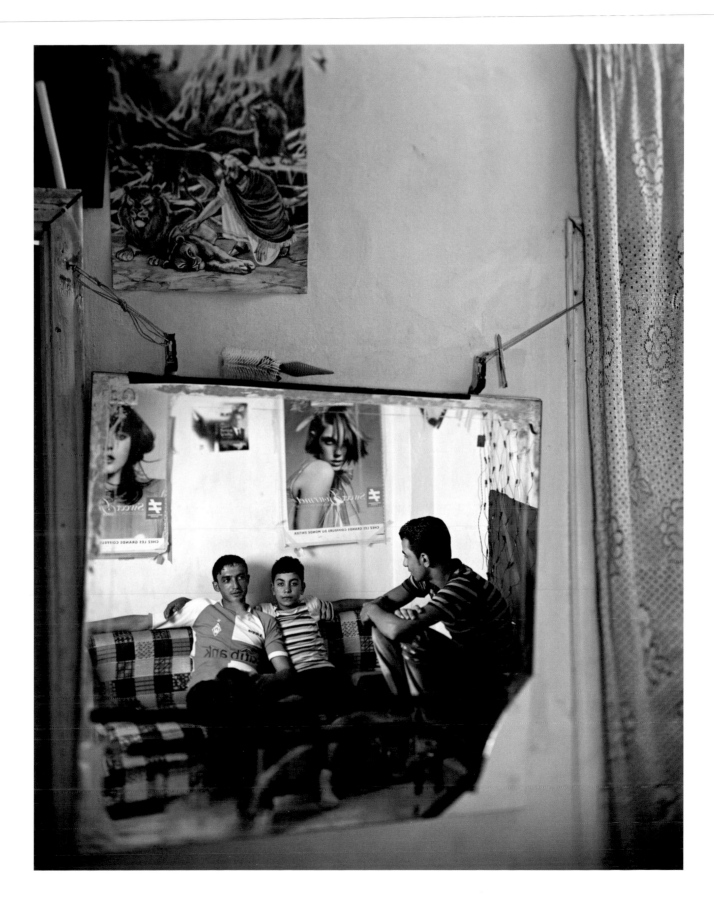

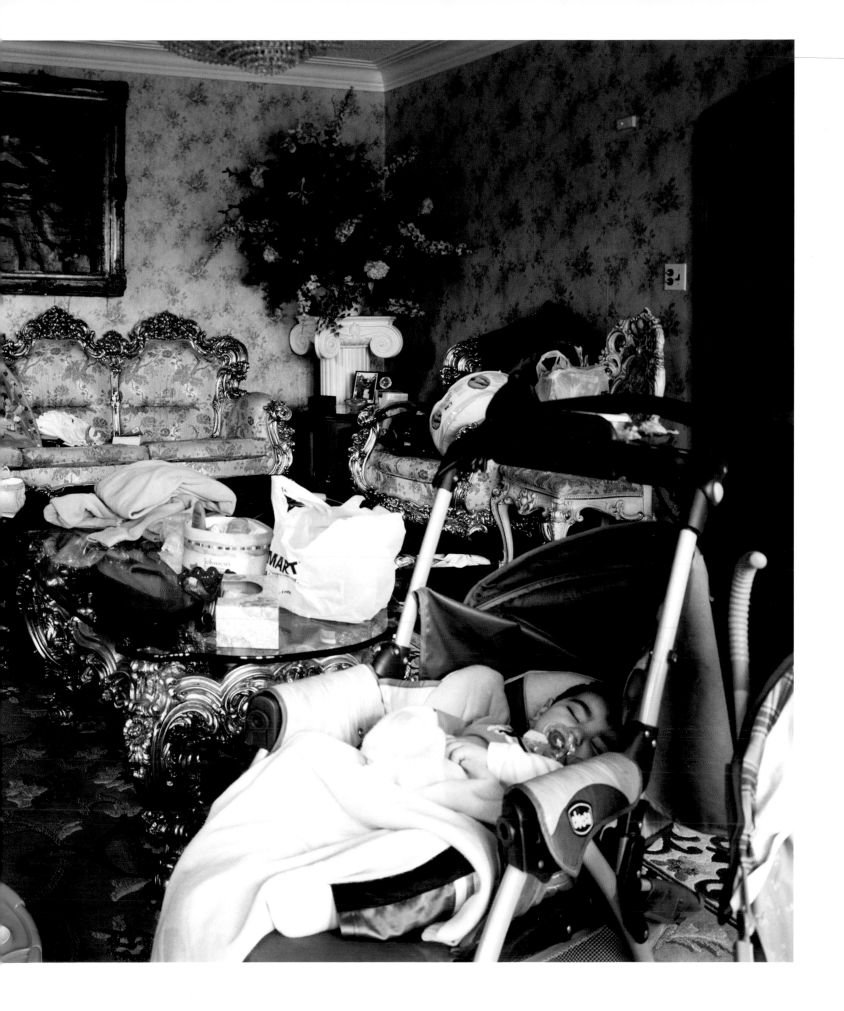

KRISTOFFER AXÉN

Sweden, b. 1984
ICP – International Center of Photography,
New York, NY, USA, 2008–2009

The language created by Kristoffer Axén relates to cinema. His world – composed with digital tools – is depicted in almost monochrome tones and gives the impression of being a non-place in a non-time. Have the characters been photographed on a film set, or in the dark corners of a city? The interaction between the scenes represented and the viewer's imagination gives way to fiction. The main protagonist of the drama is the city and its shadows which haunt its inhabitants. A heavy atmosphere prevails inside and out; no hope of a better life seems to emerge. Axén produced *At Sea At Night* in New York, at a time when the city was hit by a severe economic downturn. The series, which evokes more of a nightmare than reality, enables him to question the world in which he lives.

The Rabbit Hole. From the series *At Sea At Night*, 2009

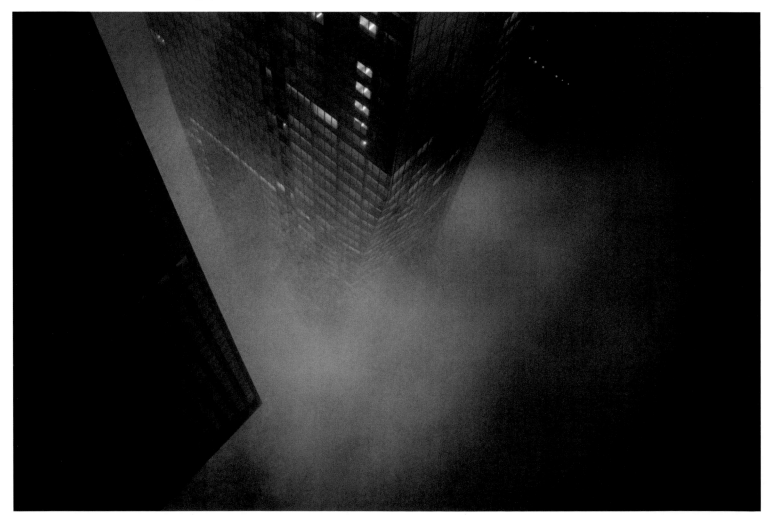

Mechanics of Solitude. From the
series *At Sea At Night*, 2009

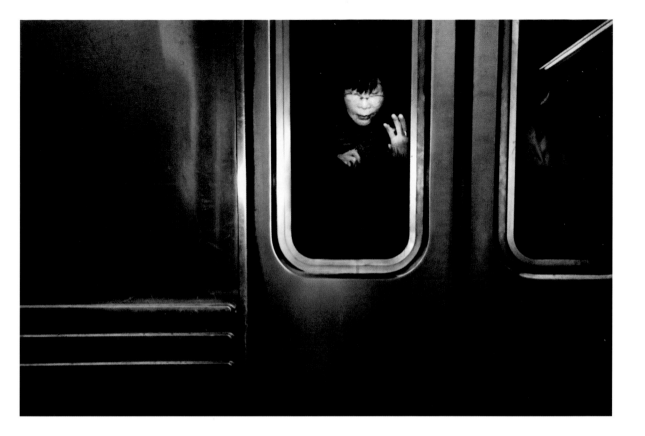

A Bowl of Candy. From the
series *At Sea At Night*, 2009

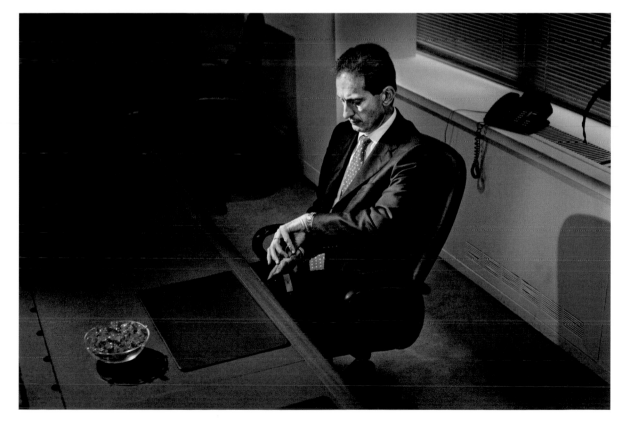

ANNA BEEKE

USA, b. 1984
ICP – International Center of Photography,
New York, NY, USA, 2008–2009

There is usually little sentimentality about the city in
contemporary photography. This is not the case with
the work of Anna Beeke, who focuses her Hasselblad
on modestly furnished interiors. These rooms appear
to be abandoned, and Beeke's picture titles are
unequivocal, yet still there is doubt. The hamburger
boxes stacked on a table prove the recent presence
of visitors. Beeke does not try to fight against the
darkness of these places, but concentrates on
their desolation. Her photographs were taken in
Amsterdam, a small town in upstate New York,
once known for its textile industry but in decline for
several decades. The photographer's point is not
to address the recent economic situation but to
observe a town which, after reaching its peak, is
on the wane, though not yet dead. Here, it is time
that gives space its rhythms.

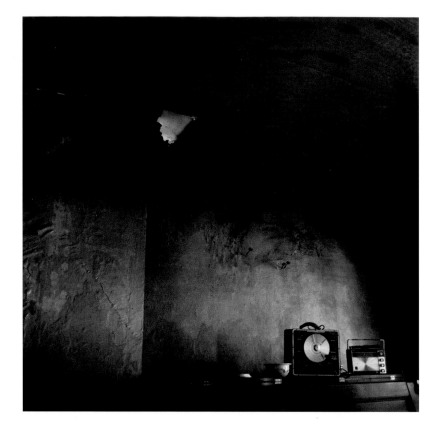

above right:
On top of the piano in an unoccupied home.
From the series *Amsterdam, New York*, 2009

right:
Stacked containers in an abandoned restaurant.
From the series *Amsterdam, New York*, 2009

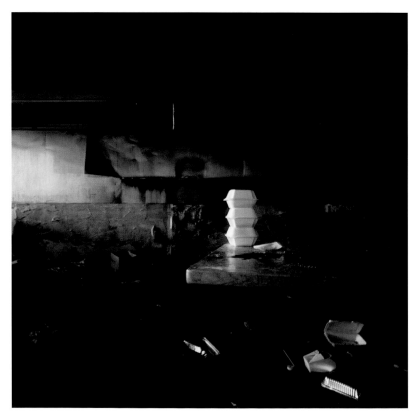

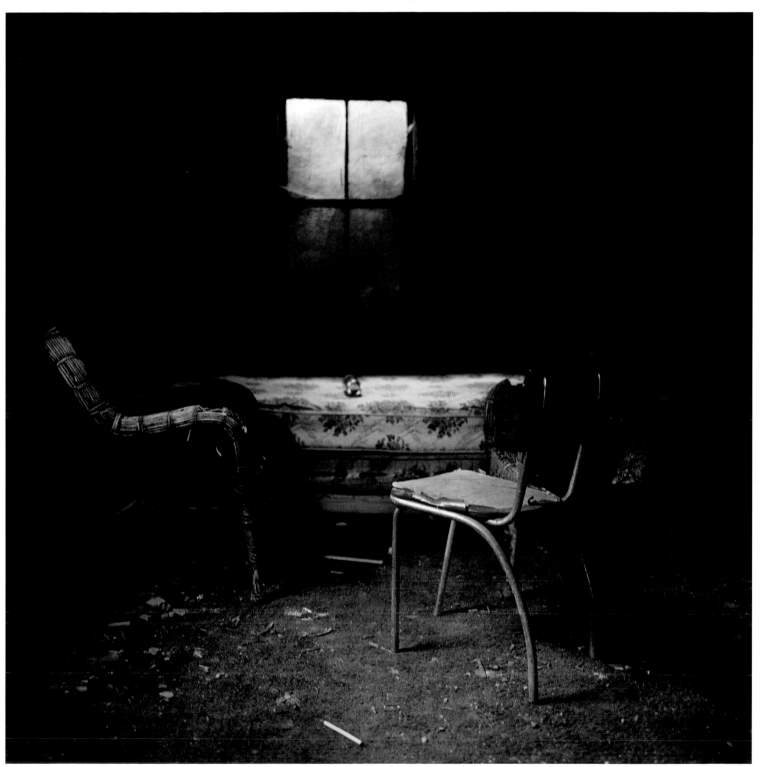

BENJAMIN BEKER

Serbia, b. 1976
Royal College of Art, London, England, 2006–2008
Akademija Umetnosti BK Belgrade, Serbia,
1996–2000

The Serbian photographer Benjamin Beker is fascinated by the vanitas of political power, shown in retrospect to be hollow at its core. His *War Memorial Installation* series is an attempt to, as he puts it, 'dehistoricize' war memorials. This he does with humour and irony, taking photographs of memorials ranging from the bombastic and monumental kind located in major Serbian cities to the modest and simple ones found in the country's towns and villages. Then, by removing the monuments from their surroundings, Beker neutralizes both their scale and their power. Thus divorced from their proper environments, we are free to contemplate them as pleasing (or not, as the case may be) sculptural objects, without the weight of strident ideology. Beker is fully aware that these memorials, despite their concrete and steel, are destined for the rubbish heap of history. Ultimately, they are as ephemeral as flowers.

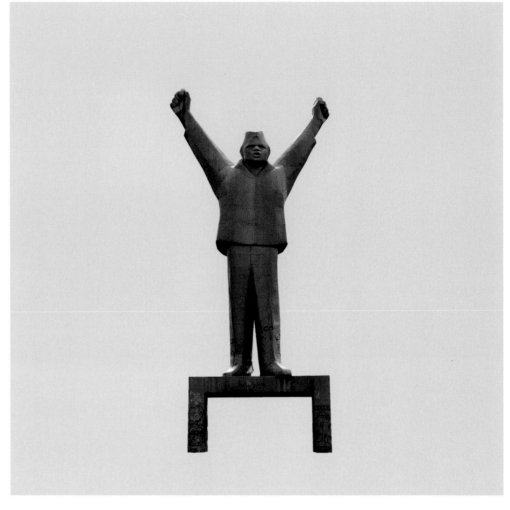

1953 Valjevo. From the series *War Memorial Installation*, 2008

opposite, clockwise from top left:

1961 Kosmaj. From the series
War Memorial Installation, 2008

1999 Valjevo. From the series
War Memorial Installation, 2008

1988 Jajinci. From the series
War Memorial Installation, 2008

1981 Kragujevac. From the series
War Memorial Installation, 2008

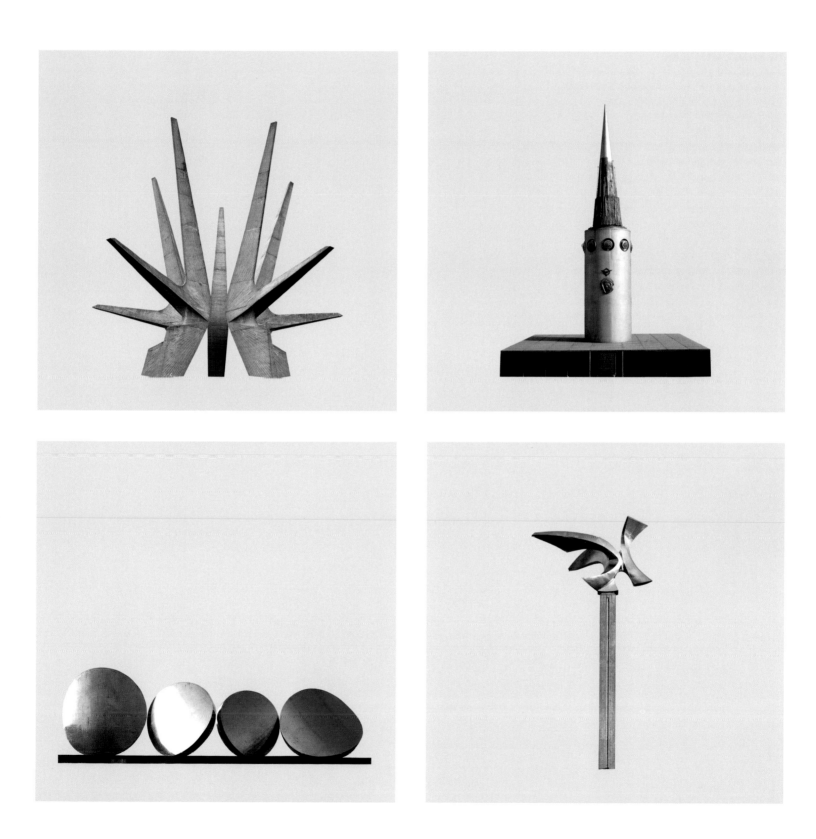

JOSHUA BILTON

UK, b. 1983

Royal College of Art, London, England, 2008–2010

London College of Communication, London,
England, 2004–2007

Joshua Bilton visited a number of prisons in Great
Britain to photograph their inmates. Isolating his
subjects in their environment and maintaining a
certain distance has paradoxically allowed the
photographer to depict the individuality of the
prisoners. Their poses always differ slightly; their
gazes and expressions vary. The individual, despite
his anonymity, expresses himself through his body.
Since the invention of photography, practitioners have
been interested in portraiture. Whether undertaken in
the studio or outdoors, with or without props, under
natural light or – as in the case of Bilton's work –
artificial light, the portrait is an exploration of the
individual and their identity through appearance.
By choosing to photograph prisoners – a stigmatized
population, which society seeks to straighten out
like a malformed limb, hence the idea of ectopia
('a displacement or malposition of an organ of the
body') – Bilton raises our awareness by showing
the physical characteristics specific to each person,
in the face of the fact that imprisonment tends to
erase distinctiveness.

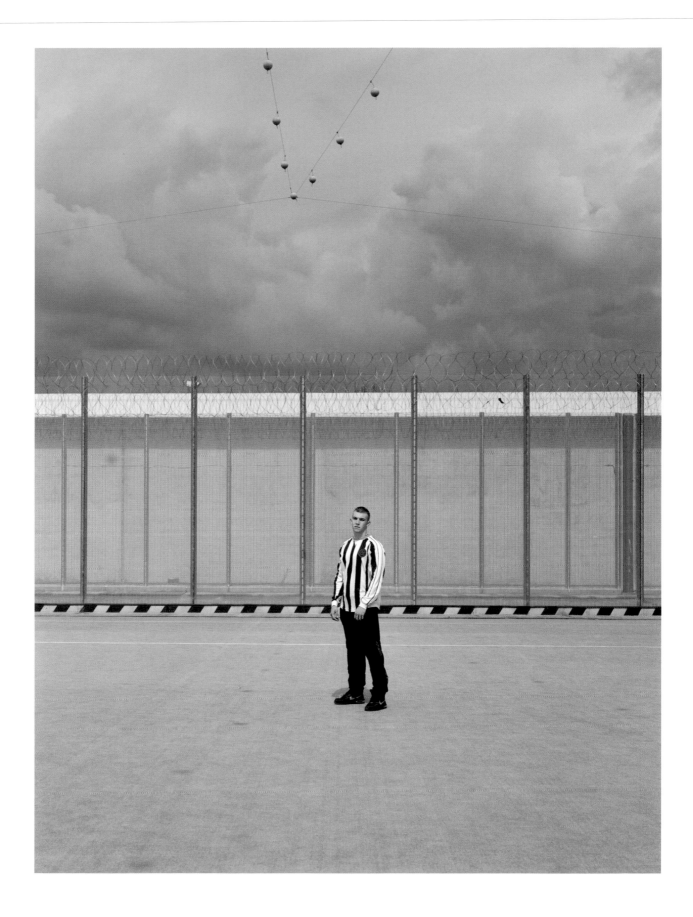

From the series *Ectopia*, 2007

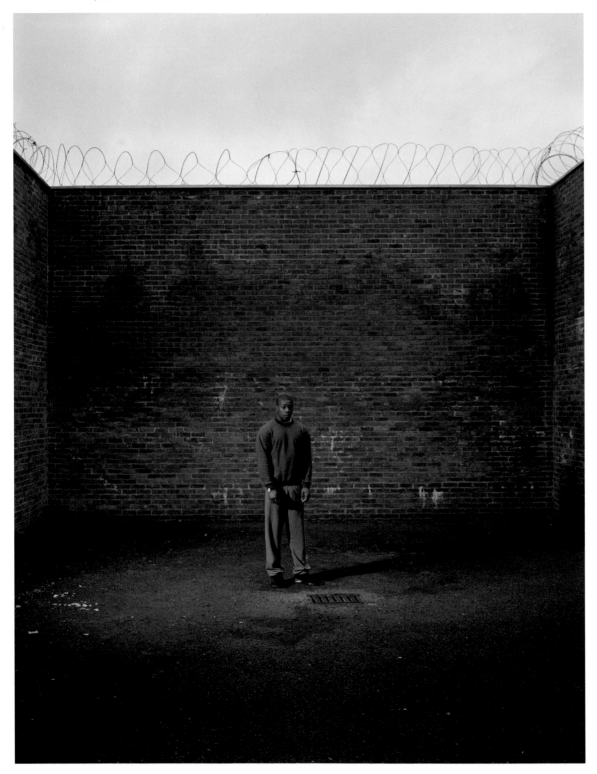

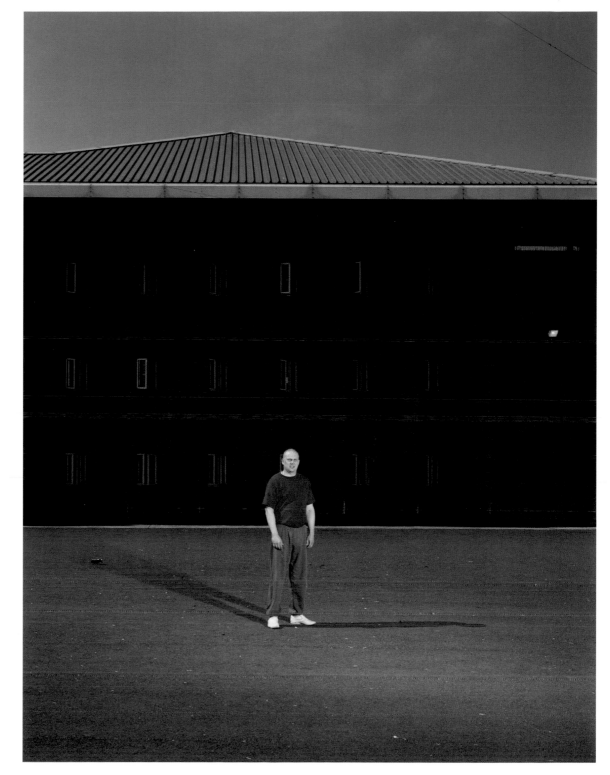

BOGDAN ANDREI BORDEIANU

Romania, b. 1983
National University of Arts Bucharest, Romania,
2001–2008

The overlapping of built space and natural space enables photographers to explore their relationship with the land. What remains of the local peculiarities of a region? Industrial expansion triumphs everywhere, and has long since ignored any borders: its impact on the environment is unequivocal. This transformation of landscape is central to Bogdan Andrei Bordeianu's work. However, Bordeianu is careful to show a patch of forest under a beautiful autumnal sun, though this glimpse is confined to a specific area of the image as if better to highlight its limited dimension. Still, the photographer keeps a certain distance from the practice of documentary photography. For him, the landscape is sometimes to be deconstructed and then reconstructed. There is therefore apparent doubt when we confront his images. Are they, in fact, collages?

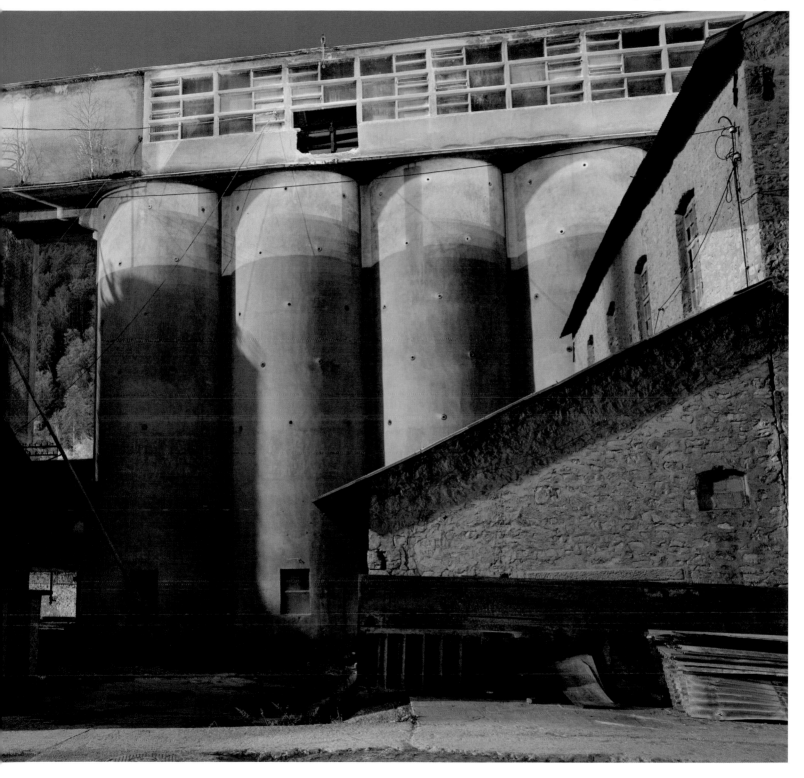

SAVAŞ BOYRAZ

Turkey, b. 1980
Mimar Sinan Fine Arts University, Findikli/Istanbul,
Turkey, 2001–2009
Konstfack, Stockholm, Sweden, since 2009
Beykent University, Istanbul, Turkey, 1998–1999

'Ben û sen' refers to a district in Diyarbakir, the largest city in south-eastern Turkey, to which many Kurds – who have fled their native villages for the relative safety of big Turkish cities – have gravitated in the hopes of finding a degree of normalcy. Savaş Boyraz's approach and style are clearly within the classic documentary tradition; he wishes to tell the story of displaced and oppressed people in a way that makes visible their humanity and their dignity, yet avoids slipping into maudlin sentimentality. Boyraz places his camera at a distance, attentive to telling detail in the environment, yet not so far as to reduce the body's forceful presence. Beyond the immediate subject, moreover, the photographer and filmmaker hopes his sustained efforts on behalf of his fellow Turkish Kurds (an endeavour he sees as visual anthropology) will also contribute to a greater understanding of the turbulent history of Turkish immigration.

Untitled. From the series *ben û sen*, 2009

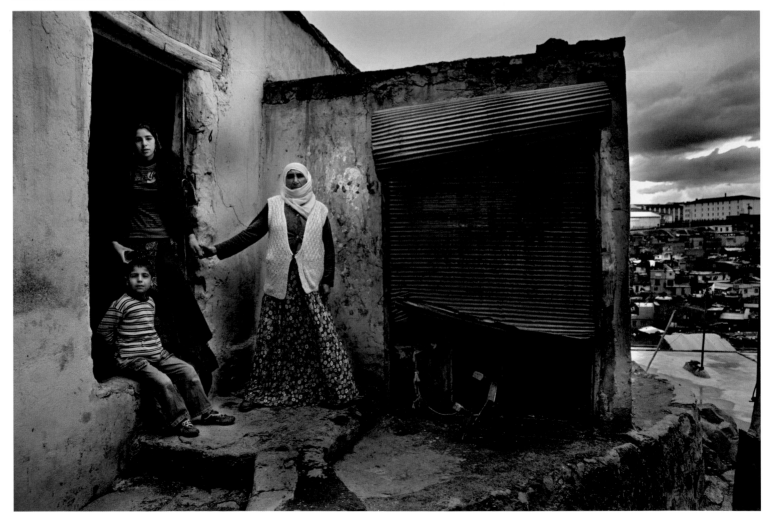

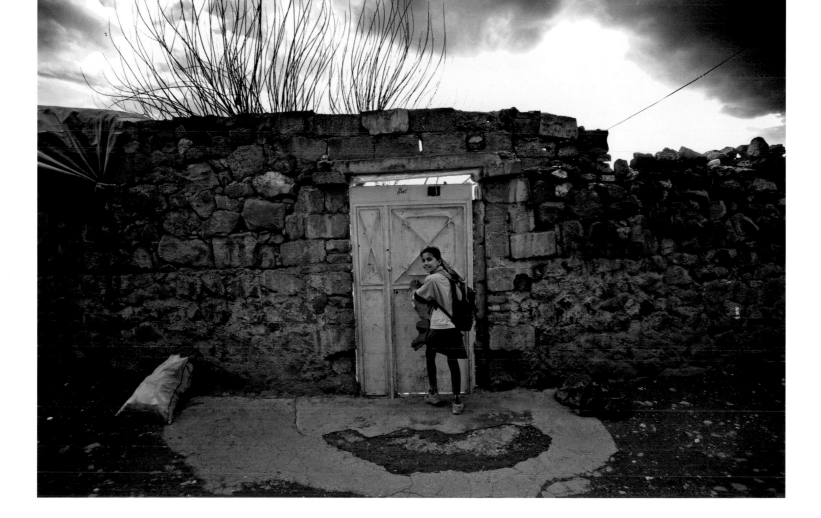

THIBAULT BRUNET

France, b. 1982
Ecole supérieure des beaux-arts de Nîmes, France,
2005–2008
Université d'arts plastiques Paul Valéry, Montpellier,
France, 2002–2005

Although Thibault Brunet's work is visually akin to
photography, it is in fact computer imaging. No
camera has been used; the images are taken from a
video game. The uniqueness of the *Vice City* series
lies in the fact that the borderline between computer
graphics and photography has been blurred. In the
world of video games the landscape generally takes
a secondary role; it is a mere backdrop against
which a player's avatar moves. But Brunet has
explored the game as a photographer, capturing
misty landscapes where he finds them. Despite
their plausibility, the locations – often industrial sites –
are purely imaginary. Computer-generated images
provide a supposed vision of reality. However, in
current times, the boundary between what is virtual
and what is real is increasingly narrow.

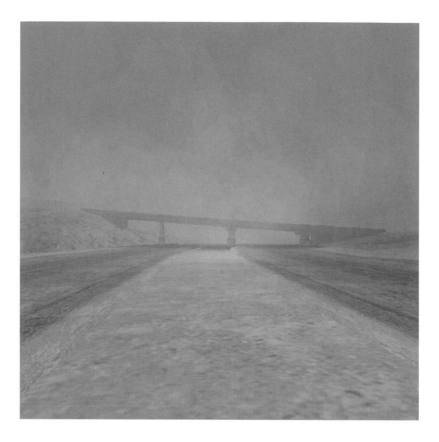

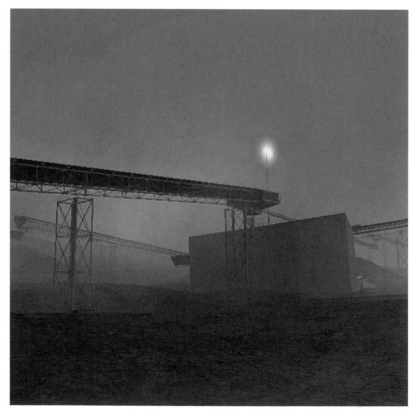

above right:
12/10/07 – 23h30. From the series *Vice City*, 2008

right:
12/10/07 – 22h40. From the series *Vice City*, 2008

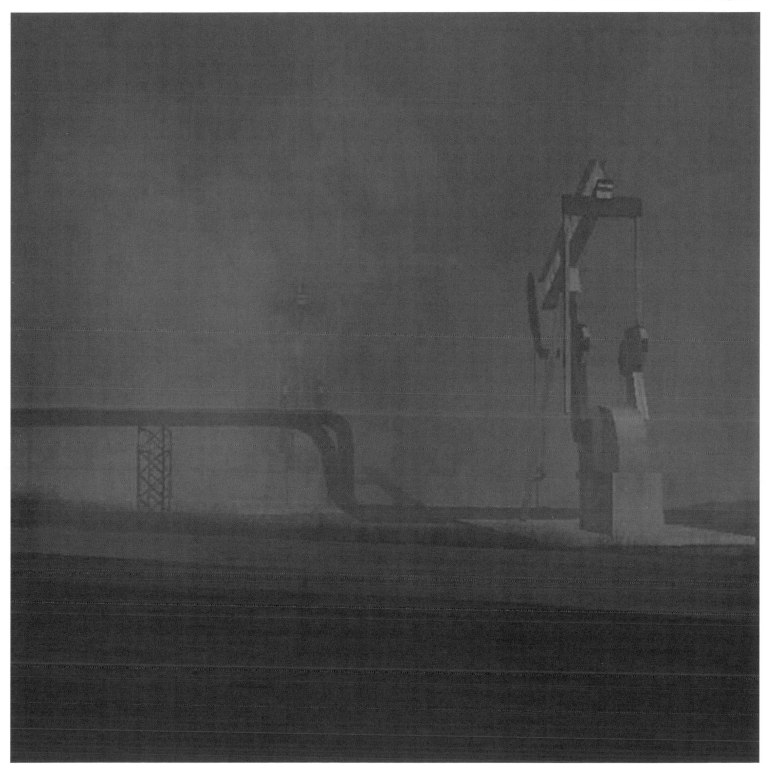

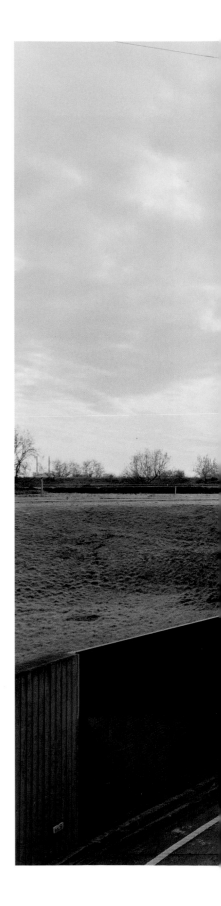

MAXIME BRYGO

France, b. 1984
La Cambre, Brussels, Belgium, 2004–2009

Urban landscape is a major genre in contemporary photography. Since the invention of the medium, architecture has been a given as a subject. The idea we have of our architectural heritage is closely linked to the images bequeathed by photographers from the nineteenth century onwards. Maxime Brygo has deliberately chosen to place his work in this tradition. Here, however, instead of celebrating a recognized and illustrious historical monument, he focuses on the brutalist architecture of a motorway tunnel. Photography has the power to make us question our relationships with objects of worship and our sense of duty to remember. Will the object shown opposite mark the history of our heritage, or is it on the contrary doomed to disappear? Such a construction, both fascinating and terrifying, is presented to us without any romanticism. It is isolated by its frontal view, the composition highlighting its symmetry. Could this image transform such a structure into one of the wonders of the world?

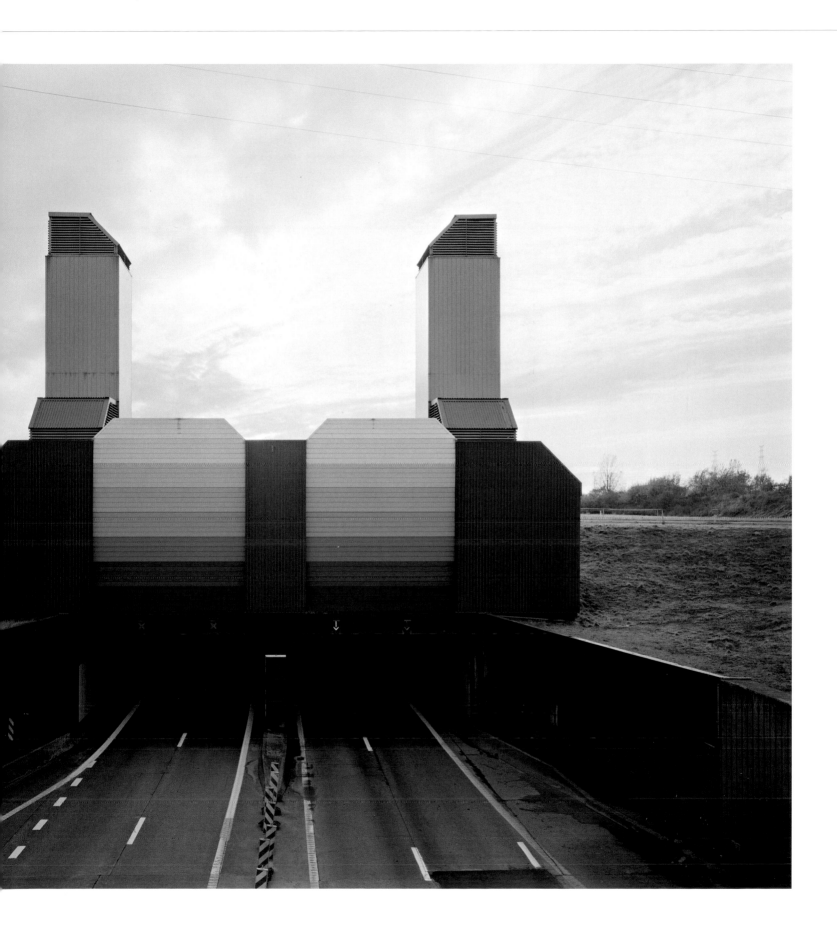

CHRISTINE CALLAHAN

USA, b. 1969

ICP – International Center of Photography,
New York, NY, USA, 2007–2009

School of Visual Arts, New York, NY, USA,
1988–1992

Christine Callahan investigates her memory through place. Her photographs of mundane and everyday locations and objects relate to childhood memories. She chooses the genre of fiction, preferring to capture here and there what could be scenes from her memory, rather than returning to the actual scene of her childhood. This type of photography – fluctuating between documentary and fantasy – is often favoured by artists, who put reality and fiction in a sort of state of significant uncertainty. In her *58 Empress Pines Drive* series, Callahan makes use of her own history, echoing the ever-present trauma of losing her family when she was a child. Photography allows her to confront her ghosts and open the door to a parallel world.

Tabernacle. From the series *58 Empress Pines Drive*, 2007

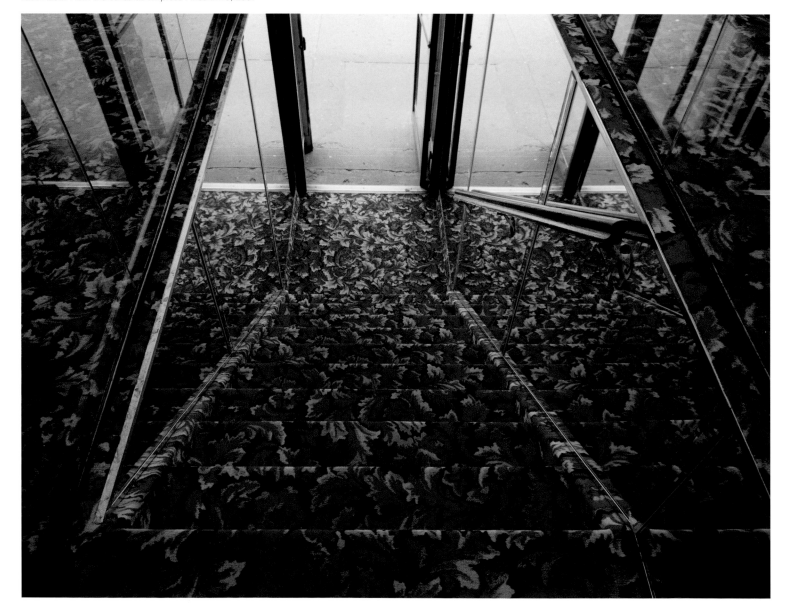

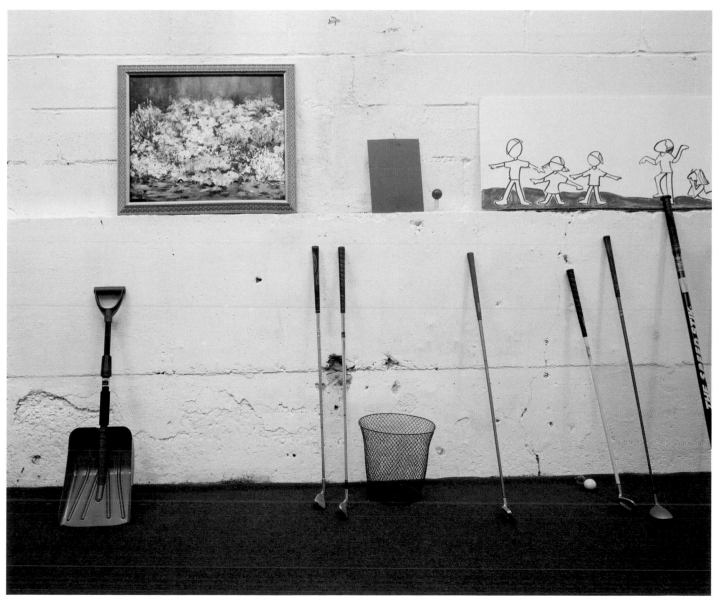

TEHILA COHEN

Israel, b. 1983

The Midrasha School of Art, Beit Berl, Israel,
2004–2008

Personal and emotional relationships also express themselves through photography. Tehila Cohen has chosen the classic genre of portraiture to observe her relatives. Photographed in their own environment, they pose before her lens. Nothing is left to chance in these carefully prepared pictures. Cohen alternates between humour and seriousness; between directing 'actors' and allowing intimate revelations. This focus on the family through staging allows the photographer to question her relationship with her family. But self-portraiture is not far away. For Cohen, by looking at others, one can gain an insight into oneself.

Untitled, 2008

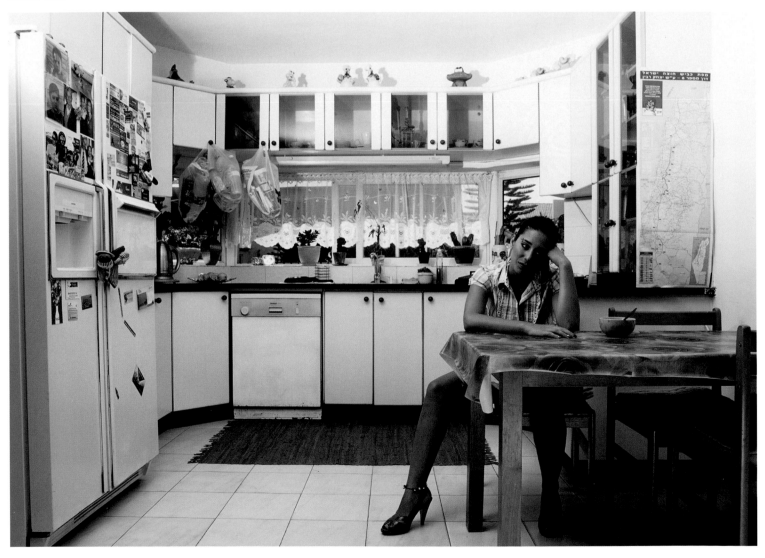

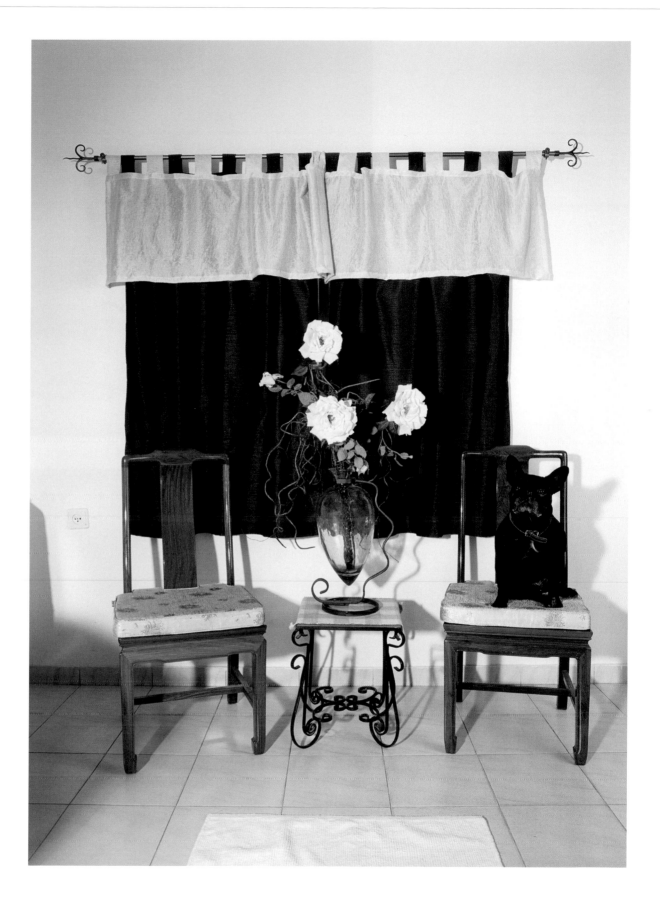

JEN DAVIS

USA, b. 1978

Yale University School of Art, New Haven, CT,
USA, 2006–2008

Columbia College Chicago, IL, USA, 1999–2002

Self-observation is central to the work of Jen Davis.
Her self-portraits show a young woman in private
moments: during the night, lying beside her imaginary
partner, of whom we see only an arm tight around her
body; during the day, sitting on her bed, alone in her
room. She is aware of the presence of the camera,
and she often stares at it, but her expression always
seems sad. In this series, Davis confronts the image
of a body whose physical appearance is hard to bear.
She assumes two roles: as subject and object, she
is both observer and observed. Scrutinizing herself,
while playing with the viewers' gaze, she invites us
to enter her bedroom. We cannot remain indifferent
to this young woman showing herself in all her
vulnerability.

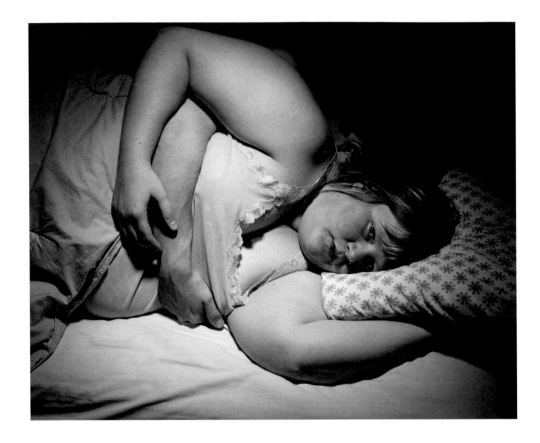

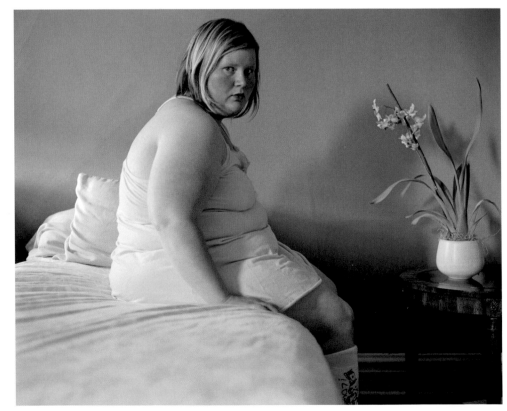

above right:
Fantasy No. 1. From the series *Self-Portraits*, 2005

right:
Untitled No. 11. From the series *Self-Portraits*, 2005

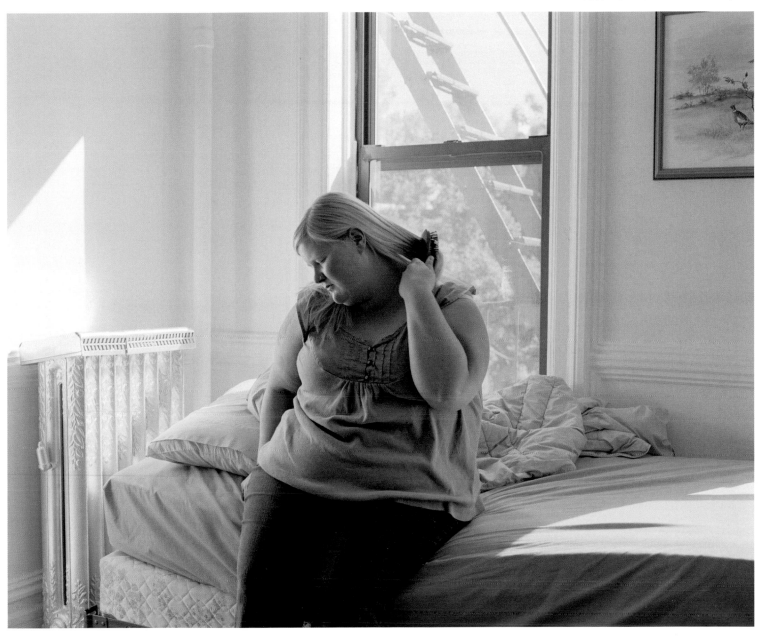

DAVID DE BEYTER

France, b. 1985
Le Fresnoy, Tourcoing, France, since 2008
La Cambre, Brussels, Belgium, 2003–2008

David De Beyter qualifies his work as 'urban country'. Like many artists today, he observes the boundaries of urban space and the changing landscape. To produce this series, he chose a place where nature has been constructed, where the artificial seems to be natural. His images function as visions, his work with light accentuating the sense of mystery that emanates from the photographs. The viewer has to indulge him- or herself in these projections. The compositions, fed by the photographer's childhood memories and his questions about landscape, give free rein to the imagination. Are these found places, or places built by the artist? De Beyter encourages us to enter these new forms of landscape, neither city nor country.

Untitled, 2008

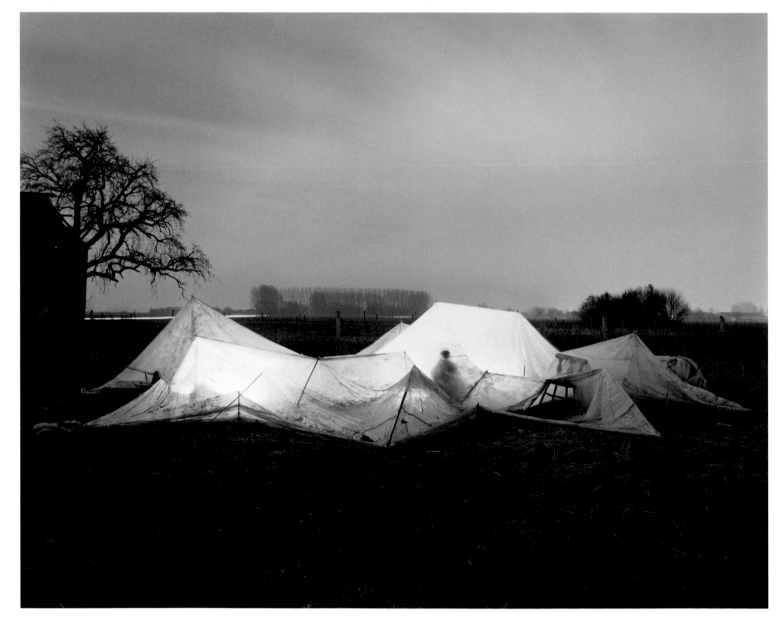

Untitled, 2008

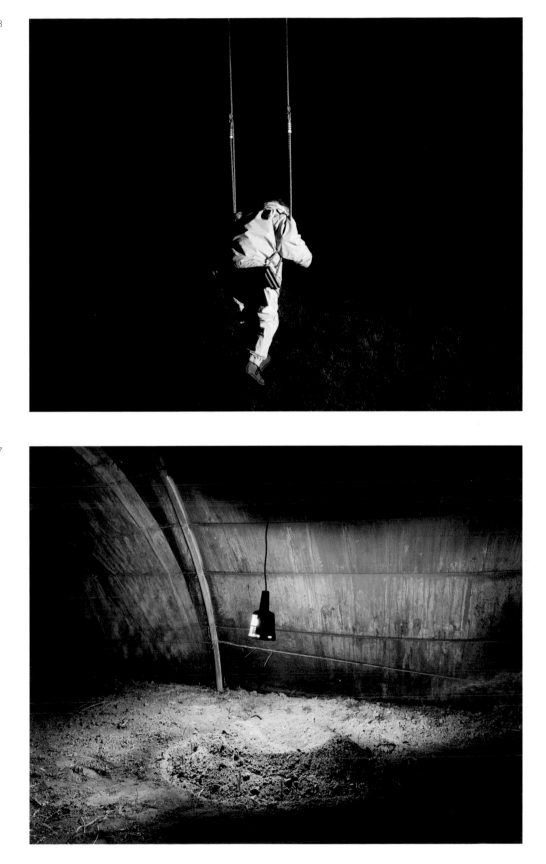

Untitled, 2007

NICOLAS DELAROCHE

France, b. 1985
ECAL – Ecole cantonale d'art de Lausanne,
Switzerland, 2005–2009

The *Capharnaüm* series was produced behind the scenes in various museums of art and history located in cities in Switzerland. But what can be said about the seemingly trivial objects that Nicolas Delaroche has photographed without any staging? The titles give us an indication. The real heroes of the picture titled 'Orchestre' may well be the mops.... Photographers know that a focus on detail can change the meaning of things and render them extraordinary. The image of an ordinary object can be transformed through metaphor and allegory into art. Historically, artists have long pushed the limits of what may be regarded as a credible visual subject. As Delaroche proves in his work, photography is a powerful trigger for the imagination.

Orchestre. From the series *Capharnaüm*, 2008

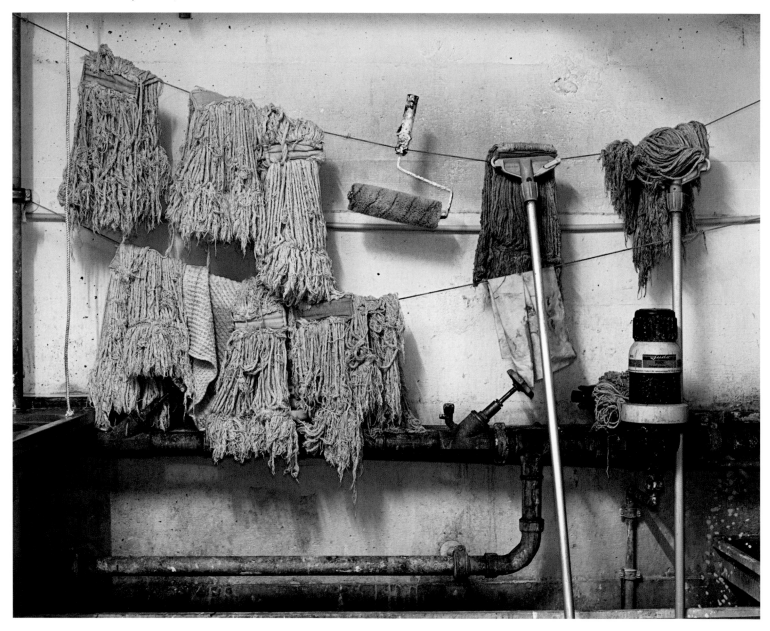

Harmonie. From the series *Capharnaüm*, 2008

SYLVIA DOEBELT

Germany, b. 1977
HGB – Hochschule für Grafik und Buchkunst
Leipzig, Germany, 2002–2009
Glasgow School of Art, Glasgow, Scotland,
2004–2005

The interiors photographed by Sylvia Doebelt are
simple and bare. There is little to discover, with the
exception of a few sheets of paper laid on the ground
or some power sockets in the wall. The eye first
notices these details, making a quick scan of what
might be called 'off screen', the area left in darkness.
But what are these white rectangles that ignore the
structure of the room and evoke the painter's white
canvas? Doebelt's aim is to photograph, from a
specific angle, the light emitted by a digital projector.
Without this carefully chosen point of view – the
frontal viewpoint of the camera superimposes itself
onto that of the projector – the rectangle of light,
like an anamorphosis, would be twisted. The illusion
is perfect. On closer inspection, one looks for the
image but nothing appears. Yet one can detect a
slight texture, a moiré effect. In highlighting the
difference between the projected image and the area
photographed, Doebelt participates in the famous
debate on the representation of reality. Playing with
the laws of perspective, blurring the distinction
between space and surface, the artist reminds us
that photography is manipulation. The rendering
in black and white emphasizes this idea of
transformation. Photography is only one system
of representation among others.

above right:
Untitled. From the series *blanks*, 2009

right:
Frame No. 3. From the series *blanks*, 2009

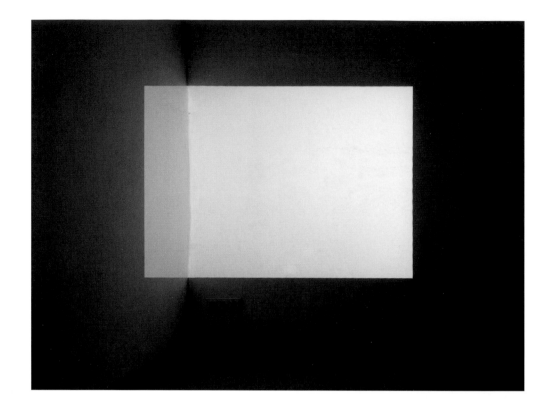

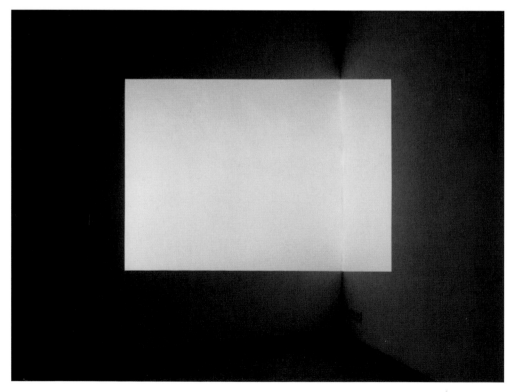

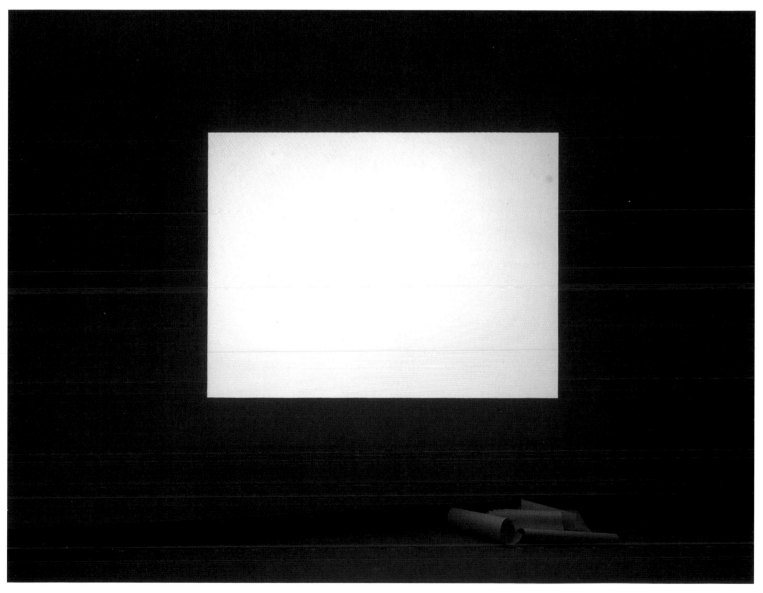

DRU DONOVAN

USA, b. 1981

Yale University School of Art, New Haven, CT,
USA, 2007–2009

California College of the Arts, San Francisco/
Oakland, CA, USA, 2002–2004

How to describe a personality through body language? The traditional genre of the portrait remains present in contemporary photography, but is often nowadays reinterpreted. Dru Donovan bases her work mainly on performance. She asks her subjects to express themselves through their bodies. Their poses, which are sometimes surprising, are intended to illustrate their emotional states or desires. Donovan encourages a certain freedom, letting her models move in front of her lens without intervention. The series was produced in the traditional 5 x 4 format, with black-and-white film, giving images of great subtlety. These images are built around shadow and light. By focusing on the physical presence – the body – of her models, Donovan manages to refresh the genre of portraiture, even when using a conventional technique.

Untitled, 2009

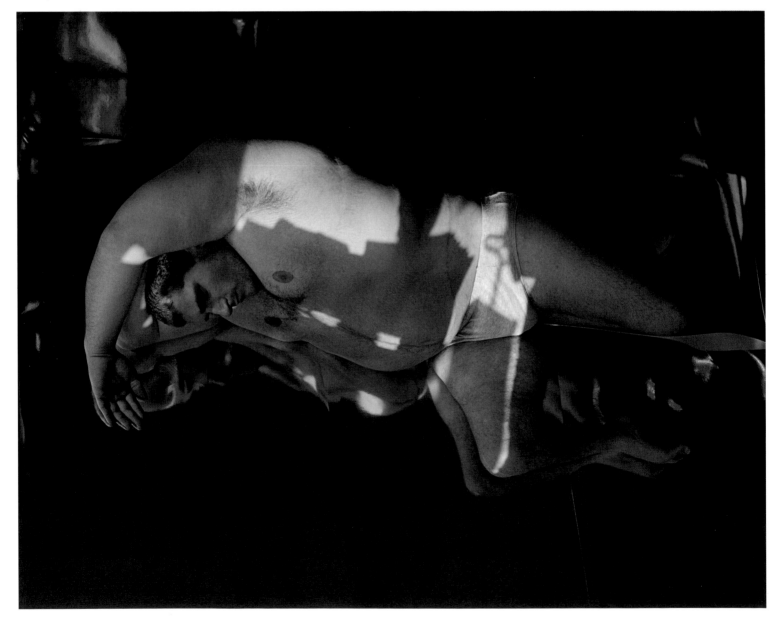

Untitled, 2007

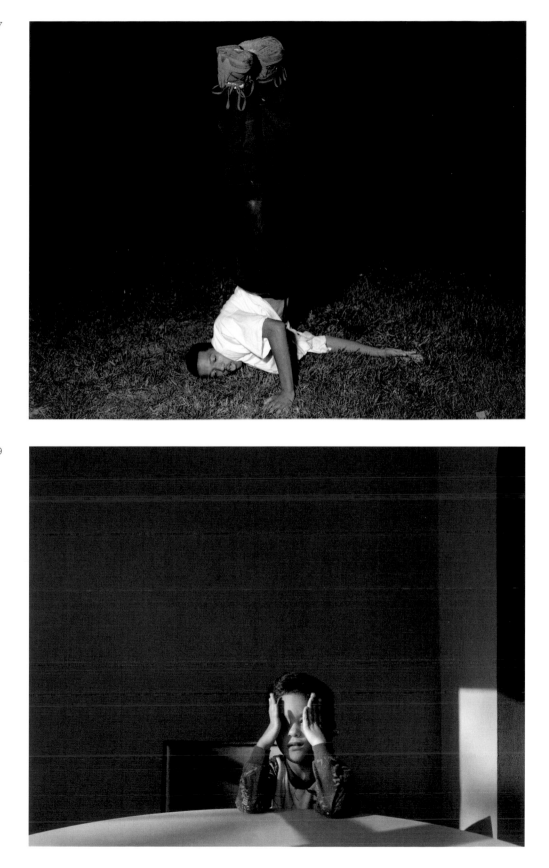

Untitled, 2009

ELIZA JANE DYBALL

Australia, b. 1986
Victorian College of the Arts, Melbourne, Australia,
since 2007

For generations, photographers have imposed their
concept of the portrait on their models, convinced
of the primacy of their own vision. The 'vulnerable'
subjects did not question the authority of the
photographer. Those days are gone. It is not
uncommon now to see a subject, such as the
young woman photographed here by Eliza Jane
Dyball, looking away with intensity, defying the usual
process ('hold the pose; do not move!). In recent
years, photographers have made portraits that lack
expression, emphasizing blank stares. They have
thus destabilized the conventions relating to the
traditional photographic portrait, which was
supposed to capture the soul of the subject.
When two people – the photographer and the sitter –
are face to face, the interaction always involves
psychological factors and mutual concessions.
Sometimes the game takes the form of confrontation.
As for the dog, he still obediently accepts having his
portrait taken.

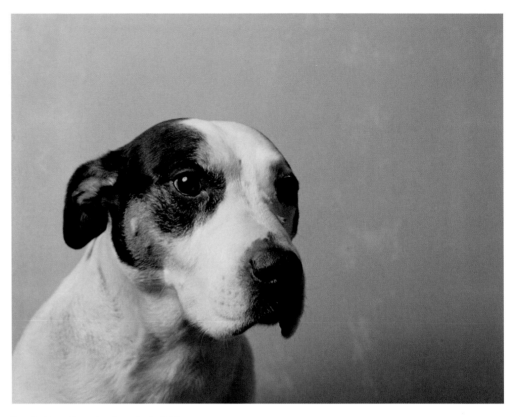

Boogie. From the series *Portrait #1*, 2008

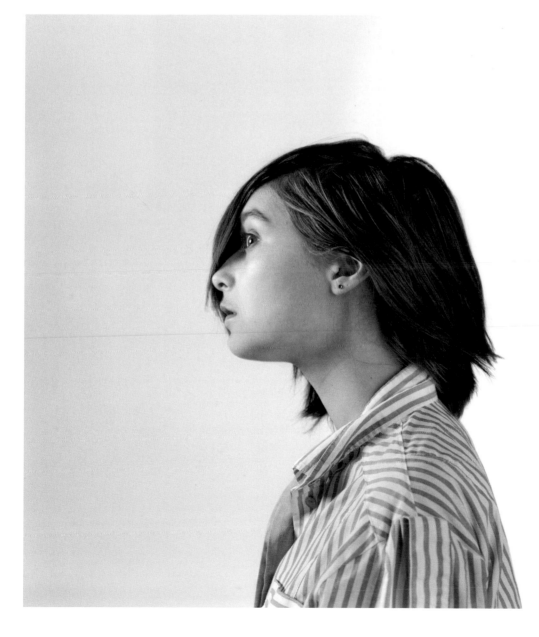

Eyes Front. From the series *Orders*, 2007

LINA EL YAFI

Sweden, b. 1978

Konstfack, Stockholm, Sweden, since 2004

Kulturama Photo School, Stockholm, Sweden,
2001–2002

These photographs by Lina el Yafi show idyllic
scenes. People proudly display their happiness, or
move at their leisure in quiet serenity. The images,
such as this portrait of newlyweds, could be in the
photo album of a happy family, and the titles of the
works confirm this peaceful life. But the photographer
has added further comments, of a different nature.
Major news events are reported in brief – the war in
Lebanon, the bombing of Iraq. The reading of the
image is suddenly affected, even though no element
of the photograph suggests gravity. El Yafi thereby
reinterprets the genre of the diary. Without using
spectacular imagery to show conflicts around the
planet, photographers can find other means to
address the complexity of the world.

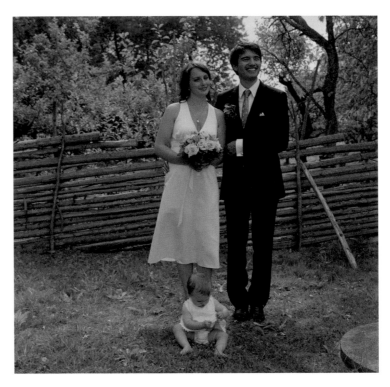

22nd of July 2006. We get married in Bjälebo, 2006

opposite:
6th of June 2003. Sweden's national day
is celebrated in Skogås. We hurry by with
our shopping bags from Konsum, 2003

12th of July 2006. Change of direction.
Lebanon is at war.

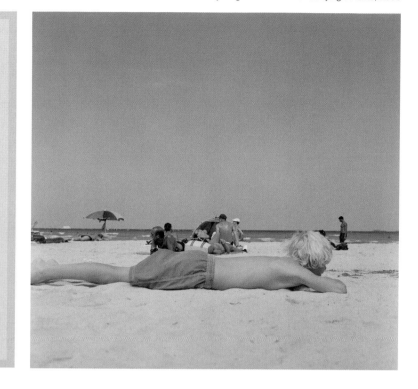

20th of March 2003. There is a green
light coming out of the television.
The USA has bombed Iraq.

SALVATORE MICHELE ELEFANTE

Italy, b. 1980
IDEP – Institut Superior de Disseny i Escola
de la Imatge, Barcelona, Spain, since 2007

In Naples, the street is a natural extension of the home. The city is crisscrossed by imperceptible borders between public and private space. The paintings and statues of religious figures that dot the streets show that the city's inhabitants make their prayers and offerings without drawing a clear distinction between interior and exterior or personal and communal. Salvatore Michele Elefante has chosen the documentary genre to explore these places of worship. His knowledge of Neapolitan culture has enabled him to observe here and there the traces of popular devotion, recognizing that Neapolitans still turn to religion to ease their passage through life. Elefante belongs to a generation accustomed to travelling and aware of the homogenization of a society that has been subjected to global monoculture. With a certain sentimentality, he shows us the icons that have long forged the identity of this particular city in Italy.

Untitled #18, 2008

Untitled #11, 2008

DAVID FAVROD

Switzerland, b. 1982
ECAL – Ecole cantonale d'art de Lausanne,
Switzerland, 2006–2009

David Favrod says that he is regarded as Japanese by the Swiss, and as Swiss – or *gaijin* (foreigner) – by the Japanese. Born in Kobe, to a Japanese mother and Swiss father, he moved to Switzerland when he was very young. Raised mainly by his mother, who instilled in him her culture, he was denied Japanese nationality when he applied for it at the age of eighteen. The *Gaijin* series results from both the sense of rejection he felt and his willingness to assert his Japanese culture. Favrod does not specialize in one genre: he alternates between staged composition, still life and landscape photography to express his quest for identity. In the way of narrative, he creates evocative images based on his memories of travelling in Japan, his knowledge of Japanese popular culture, stories told by his mother, and war stories told by his grandparents.

Untitled. From the series *Gaijin*, 2009

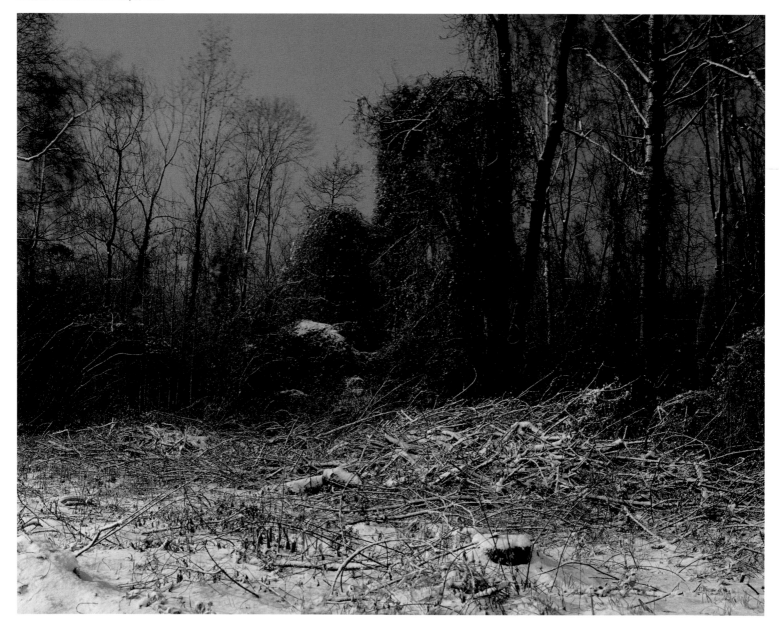

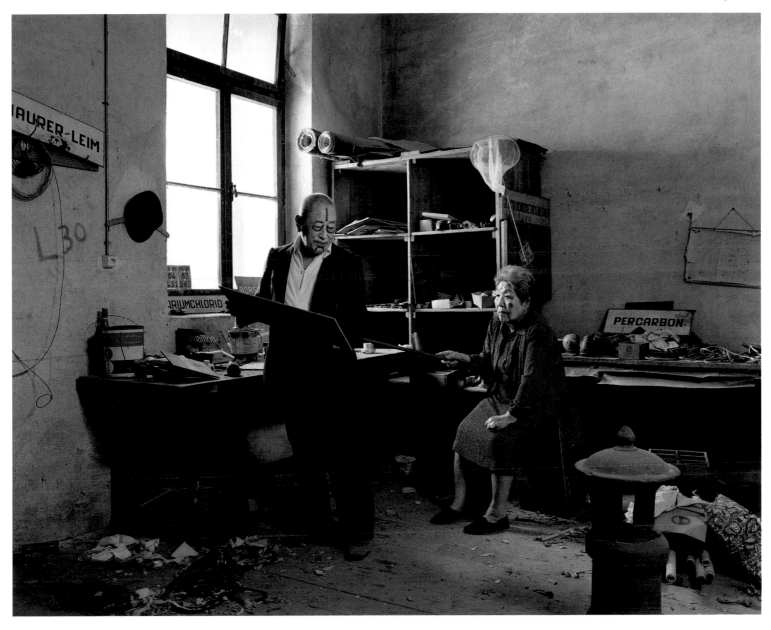

Untitled. From the series *Gaijin*, 2009

DANIELA FRIEBEL

Germany, b. 1975
HGB – Hochschule für Grafik und Buchkunst
Leipzig, Germany, since 2002

Daniela Friebel's installations take their part in the debate inherent to the photographic image. Her works question the ability of photography to represent reality. She has chosen a particular technique – trompe-l'œil. The tradition of trompe l'œil is particularly rich in the history of painting. It aims to create the illusion of a real object in relief through artificial perspective. Friebel's trompe-l'œil images consist of wallpapers applied to walls. To produce her visual experiences, the artist works with the theme of space – extending a room, changing a wall, placing a curtain in front of an opening in a wall. She positions her wallpapers in order to destabilize our perception of real space. Creating confusion, her images blur the reality of space through optical illusion.

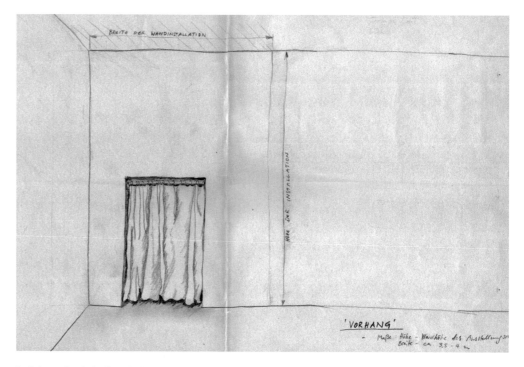

Preliminary sketch for Curtain, 2009

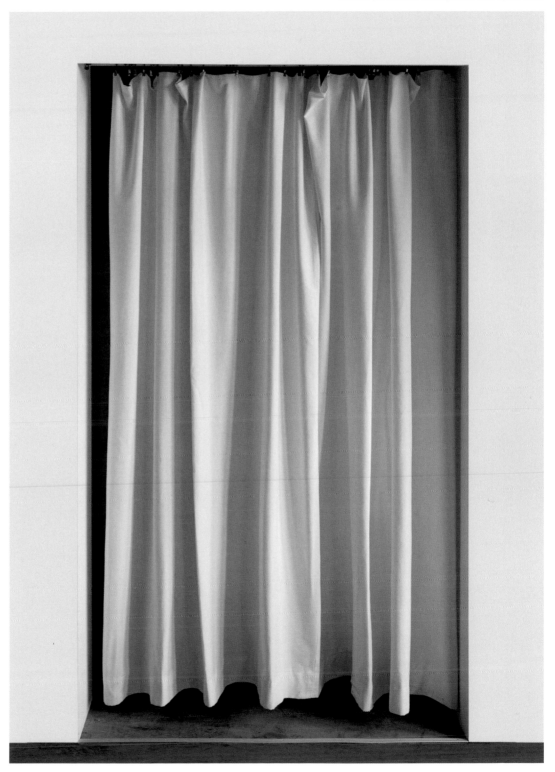

ROBIN FRIEND

England, b. 1983
Royal College of Art, London, England, 2007–2009
University of Plymouth, England, 2003–2006

Many photographers today base their work on the interaction between a documentary image and the viewer's imagination. Playing with the evocative power of photography and seeking a delicate balance between dream and reality allows them to question the world around them. Robin Friend creates his images by using a large-format camera, which enables him to work accurately with light, colour and focus. With his landscapes, he seeks to share a physical encounter. Through his work, he questions our relationship with the earth, examines the place of the human in nature, and explores space through the act of seeing, without omitting the experience of sublime beauty.

Untitled (rock). From the series *Belly of the Whale*, 2009

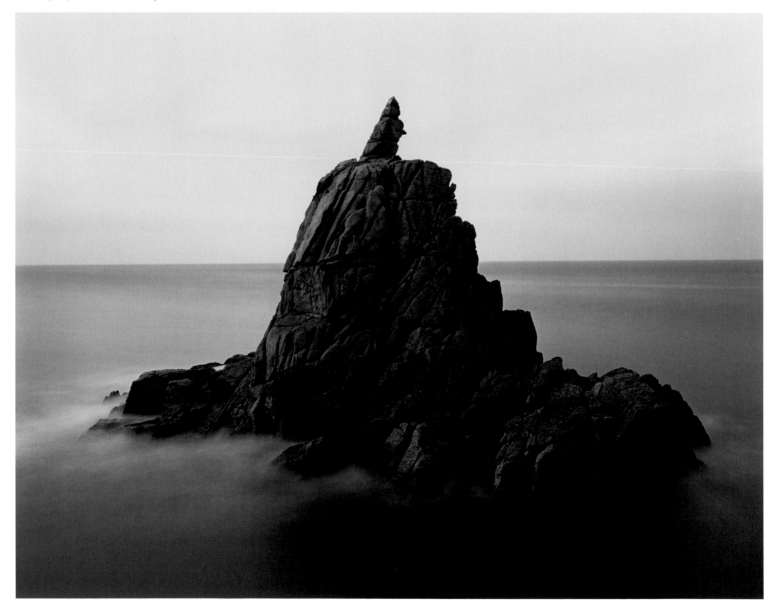

Untitled (shipwreck). From the series *Belly of the Whale*, 2008

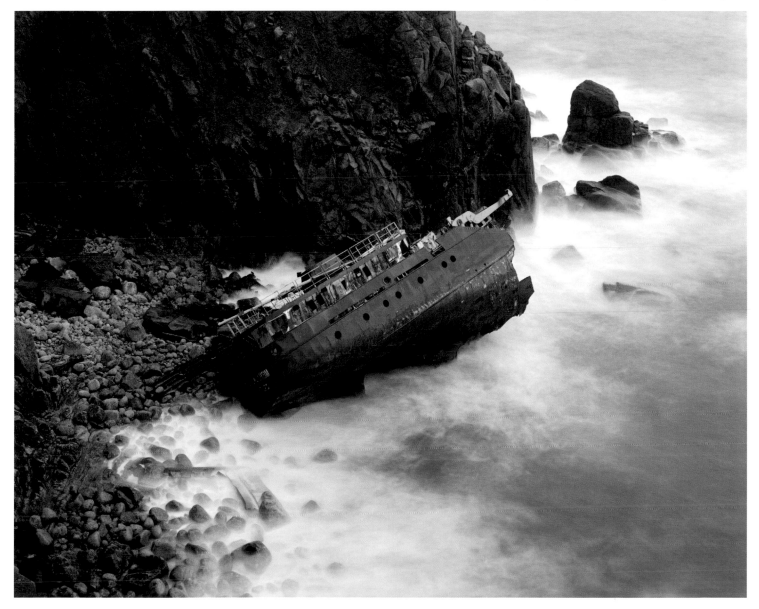

MATTHIEU GAFSOU

Switzerland/France, b. 1981
CEPV – Ecole de photographie de Vevey,
Switzerland, 2006–2008

Globalization is a frequent topic among the younger
generation, accustomed to long-haul travel and
discovering more and more similar references in
different parts of the world. Matthieu Gafsou's work
is about urban space, environments with no place for
the human being or other natural forms. The smooth,
modern and manufactured constructions captured by
the photographer during his travels are characterized
by excessive clarity. Reflecting the detrimental effect
of international style, they show only their contours.
It is impossible to detect a human presence behind
these walls. 'Surface and pretence are two sides of
my photographs,' says Gafsou about his work
undertaken in Tunisia. The photographer focuses
on over-represented construction all the better to
show its alienation.

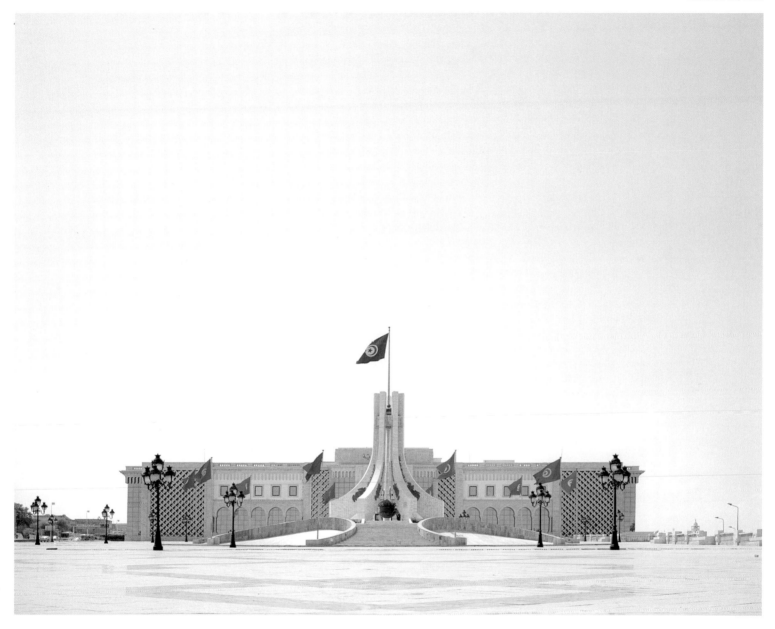

Surfaces #25, 2008

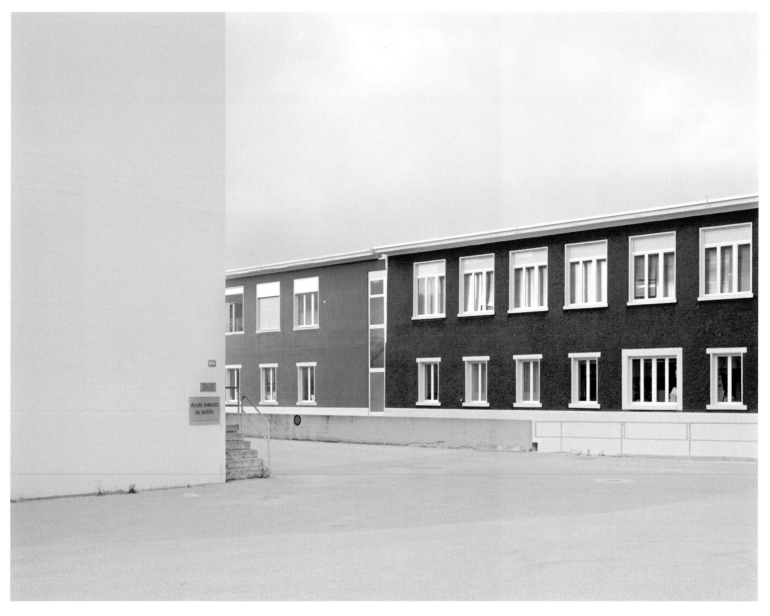

ANNE GOLAZ

Switzerland, b. 1983
CEPV – Ecole de photographie de Vevey,
Switzerland, 2004–2008

Scènes rurales is a series devoted to the rural world. The figure of the peasant, usually represented at work – that is to say, in the fields – is shown here in his home, at rest. However, there is some anxiety in the work of Anne Golaz, an atmosphere enhanced by the darkness of her images. Somewhere between theatricality and realism, her scenes question the representation of rural communities. Her photographs show lonely and vulnerable individuals and entities emerging from obscurity. They represent a disappearing world, which is defined by its richness and also by its fragility and its shadows. Golaz has noted that this series does not result from any social or political concerns. While working in the documentary genre, she has managed to create personal and evocative photographs with a subtle aesthetic.

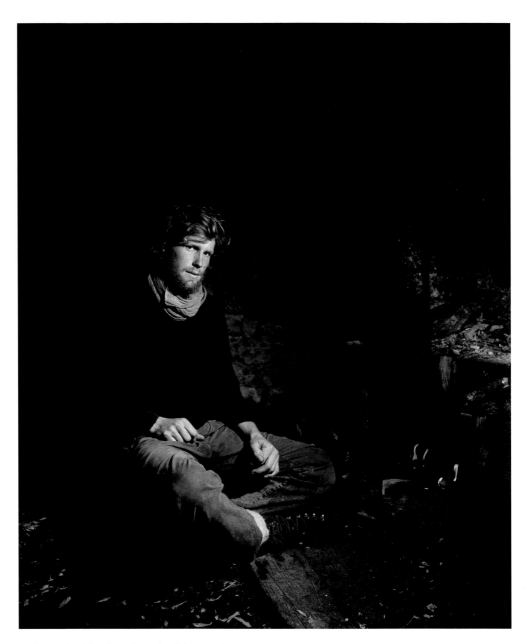

Le rêve de Stanislas. From the series *Scènes rurales*, 2007–2008

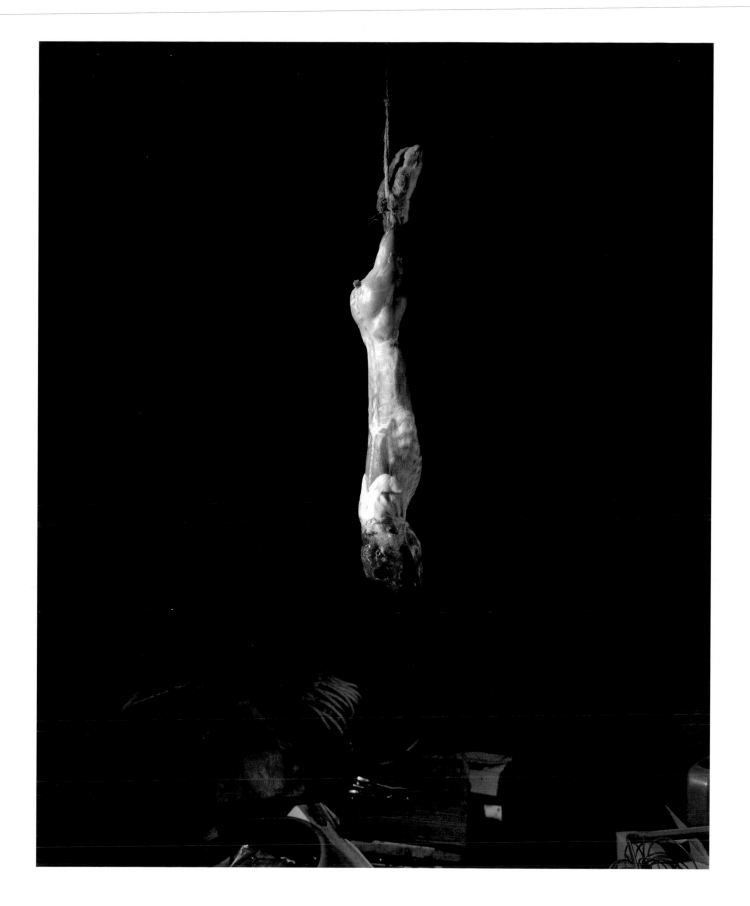

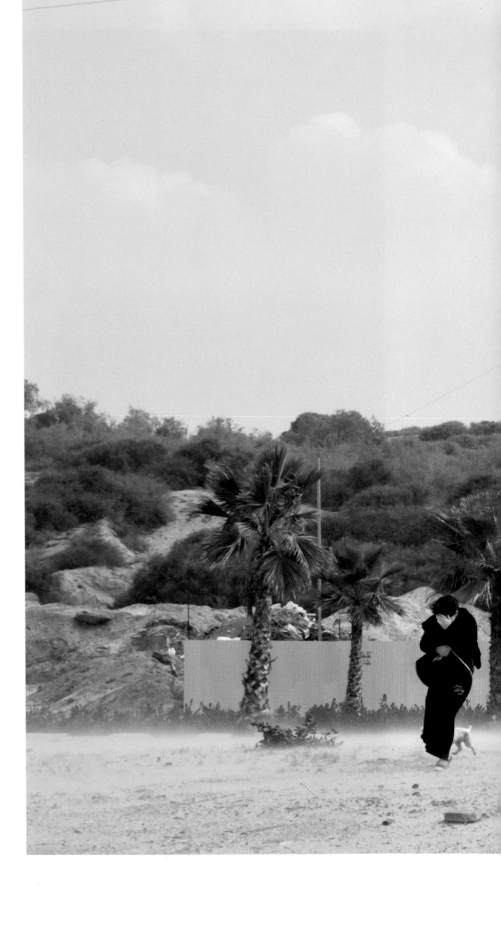

LENA GOMON

Ukraine, b. 1978
Bezalel Academy of Art and Design, Jerusalem,
Israel, 2005–2009

Lena Gomon's work focuses on the urban area of
Ashdod, Israel. Photographing exclusively in the city,
the locus of both her childhood and adult life, she
directs her lens on the streets, buildings and cars
– mundane subjects, most often ignored by the
residents, who consider them of little interest.
Gomon is not looking for beauty while exploring
Ashdod. She has no illusions. Indeed, hers is, rather,
a quest for identity. In this city, with its rich and poor
neighbourhoods, its houses under construction or
in decline, she observes herself, like the figures that
pass through the landscape, driven by the wind.
They suddenly seem very vulnerable.

Untitled. From the series *Ashdod*, 2007

NICK GRAHAM

England, b. 1986
Edinburgh Napier University, Edinburgh, Scotland,
2005–2009
Ryerson University, Toronto, Canada, 2007–2008

The eyes of Nick Graham's subjects avoid ours. We feel a certain discomfort addressing the portraits. Do these models feel vulnerable, stripped of their being? We do not know much about them. The only pieces of information provided are their first names, which make their isolation all the more poignant. *Immediate Futures* features the faces of a particular age group – those in their early twenties. The photographer asked them to talk about their future, their childhood dreams, their passions and ambitions. The vulnerability of the subjects is underlined by the close-up, the flash and use of colour filters. Graham seems to be saying that young people today no longer have traditional social anchors – a stable job, security for the future, a family on which to rely. Is an uncertain and lonely life all that remains for them?

Matt. From the series *Immediate Futures*, 2009

Jonny. From the series *Immediate Futures*, 2009

Danny. From the series *Immediate Futures*, 2009

AUDREY GUIRAUD

France, b. 1986
Ecole supérieure des beaux-arts de Nîmes, France,
2004–2009

While architectural photographers usually try to be
as representational as possible in their work, Audrey
Guiraud rejects both frontal and perspective views.
When one looks at her images, one can see that she
seeks visual impact. But unlike architects, who prefer
photographs that give a positive and realistic view
of their buildings, Guiraud refuses to show 'reality'
and instead offers up her vision of architectural
construction. She reminds us that this can rarely be
expressed from a single viewpoint. Architecture is
also movement, action, the body in motion through
space. The fragments of textures and shapes that
she shows in her pictures seem to have merged.
The juxtaposition of these structural elements, which
Guiraud emphasizes by retouching her images, forms
a strange architecture. By choosing this unique point
of view, she reinforces the enigmatic character of her
constructions.

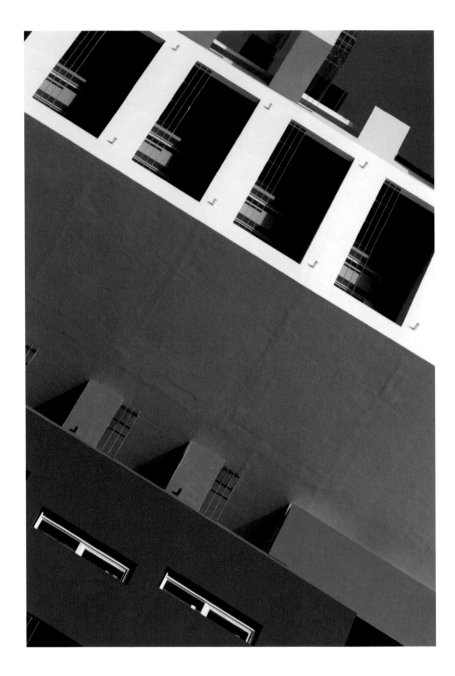

above right:
Untitled, 2008

opposite:
Untitled, 2007

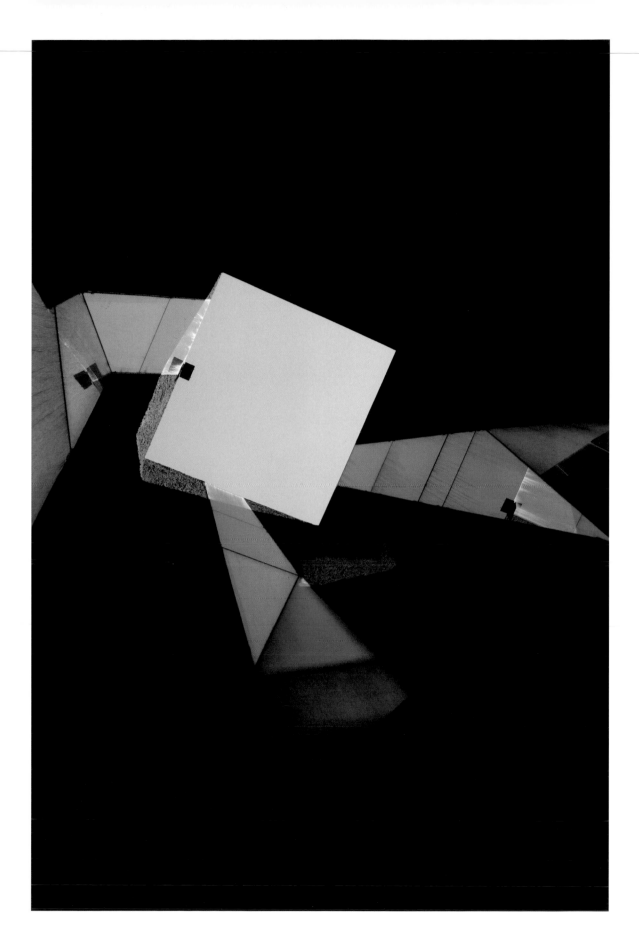

CLAUDIA HANIMANN

Switzerland, b. 1984

ZHdK – Zürcher Hochschule der Künste, Zurich,
Switzerland, 2005–2009

Akademie der bildenden Künste Wien, Vienna,
Austria, 2007

Focusing attention on one detail can make something inconsequential look unusual and unique. Photography is central to this process. An ordinary object is suddenly transformed by a photograph. This tradition is rich in the history of photography, starting with the German New Objectivity movement. The work of Claudia Hanimann pushes the limits of what can be regarded as a visual subject. Her photographs seem incongruous, but they fascinate us with the optical illusions they contain. There has been no retouching, and yet they seem like collages. The confusion is particularly due to the juxtaposition of textile patterns. Hanimann knows how to attract the eye, excite the vision and fill the viewer with wonder. Whatever the subject, only the image counts.

Untitled, 2006

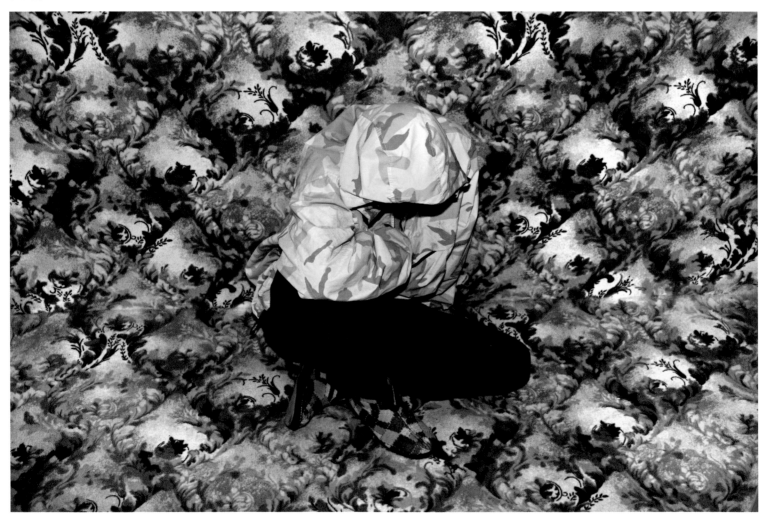

FLORIAN JOYE

Switzerland, b. 1979
ECAL – Ecole cantonale d'art de Lausanne,
Switzerland, 2002–2008

Dubai is known for its architectural follies – in the city, the sea and the desert. The vision of its architecture alternates between utopia and excess, seduction and vanity. Florian Joye, who is fascinated by science-fiction and other novels that anticipate the future while remaining closely tied to reality, decided to travel to the emirate to explore the margins of the built environment. His photographs show the back streets of a city that mainly imagines itself through computer-generated imagery and grand models. Joye discovers that, in Dubai, 'the virtual seems to be a dimension of reality, about to defy its limits'. As he works his way through the gigantic building sites, he suddenly stumbles upon a suburban wasteland. Under the thin layer of dreams, dystopia is waiting.

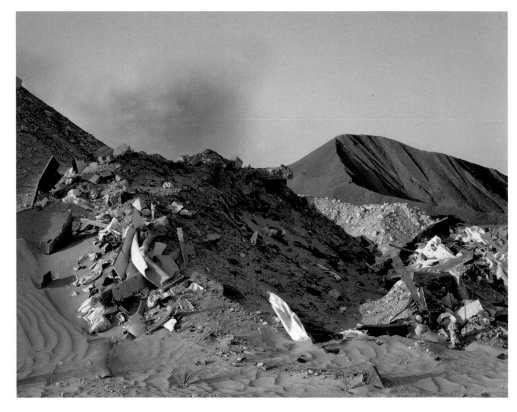

Desert II. From the series *Desert Gate*, 2009

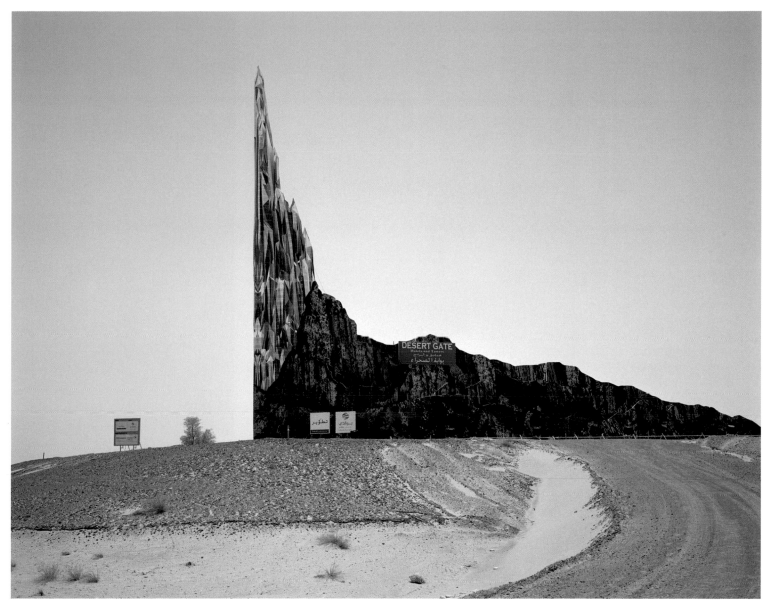

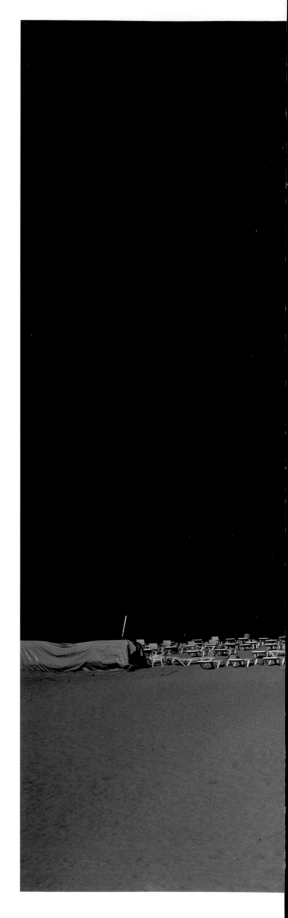

Shepherd, 2008

KALLE KATAILA

Finland, b. 1978
TaiK – University of Art and Design Helsinki, Finland,
since 2006
Lahti Polytechnic, Lahti, Finland, 1999–2004
University of Central England, Birmingham, England,
2001–2002

Kalle Kataila's work evokes the landscapes of the
German Romantic painter Caspar David Friedrich.
There is a melancholy in the photographs. As in
Friedrich's paintings, a figure, seen from behind,
stands at the centre of the landscape and seems
fascinated by the spectacle he is observing. The
setting varies from one image to another – from the
snowy plains of the far north to a sandy beach on
a cold night; from the roofs of an outspread Arabian
city to the skyscrapers of a developing metropolis.
Kataila's protagonists change, but they all seem
frozen in contemplation. What do they feel in front
of these vistas, which seem to disregard the human
being? The characters themselves appear absent
from the scene. A feeling of loneliness and
helplessness emanates from these images.

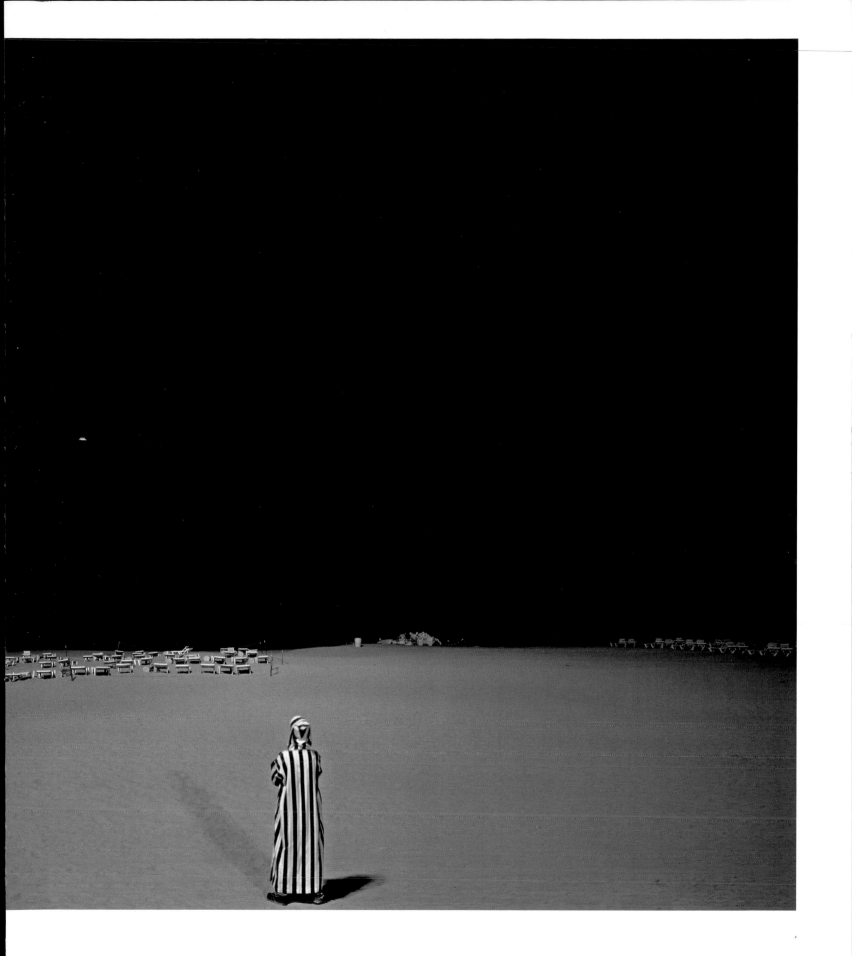

DANIEL KAUFMANN

Vietnam, b. 1974
University of New Mexico, Albuquerque, NM,
USA, 2004–2008
Studio Art – Florida State University, Tallahassee,
FL, USA, 2003

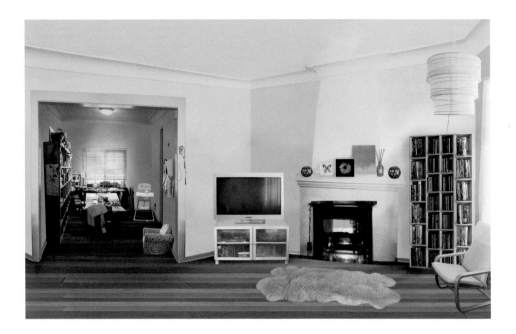

In 1956 the English artist Richard Hamilton made a
collage heralding the arrival of the Pop Art movement,
'Just What Is It That Makes Today's Homes So
Different, So Appealing?' More than half a century
after Pop Art, artists still draw their inspiration from
popular culture, and this small collage may have
inspired Daniel Kaufmann in his *House Home* series.
Kaufmann uses digital tools to create his own strange
collage work. Combining different elements from
photographs taken in his home, in his friends' houses
and in furniture stores, he composes interiors that
resemble in every way those presented in interior
design magazines. However, like any good consumer,
he reverses roles. He is now the one who is 'selling'
his dream house. His images, never as 'perfect' as
those in magazines, stigmatize the world of
consumerism.

top right:
House Home 9. From the series *House Home*, 2008

above right:
House Home 1. From the series *House Home*, 2008

Temples, Best Buy #2. From the series *Temples*, 2009

CHANG KYUN KIM

South Korea, b. 1974
Parsons The New School for Design, New York,
NY, USA, since 2008
Brooks Institute of Photography, Santa Barbara,
CA, USA, 2007–2008

Consumerism is a pervasive issue, frequently
associated with alienation. Chang Kyun Kim's
Temples series addresses this subject. The
photographer focuses on industrial areas in New York
and New Jersey. Working only at night, he trains his
lens on department stores and brand logos. In his
work, the windowless façades aimed at attracting
consumers appear as iconic objects, detached
from their environment. When photographers work
in urban areas, they often use large-format cameras,
associated with high-precision, frontal images of
architecture, as developed by the Düsseldorf School.
Kim's warehouses – presented in an artificial light of
high intensity – are stripped down to a combination
of geometric lines and bright colours. Leaning
towards abstraction, with their flat tonal areas,
they appear devoid of their original meaning.

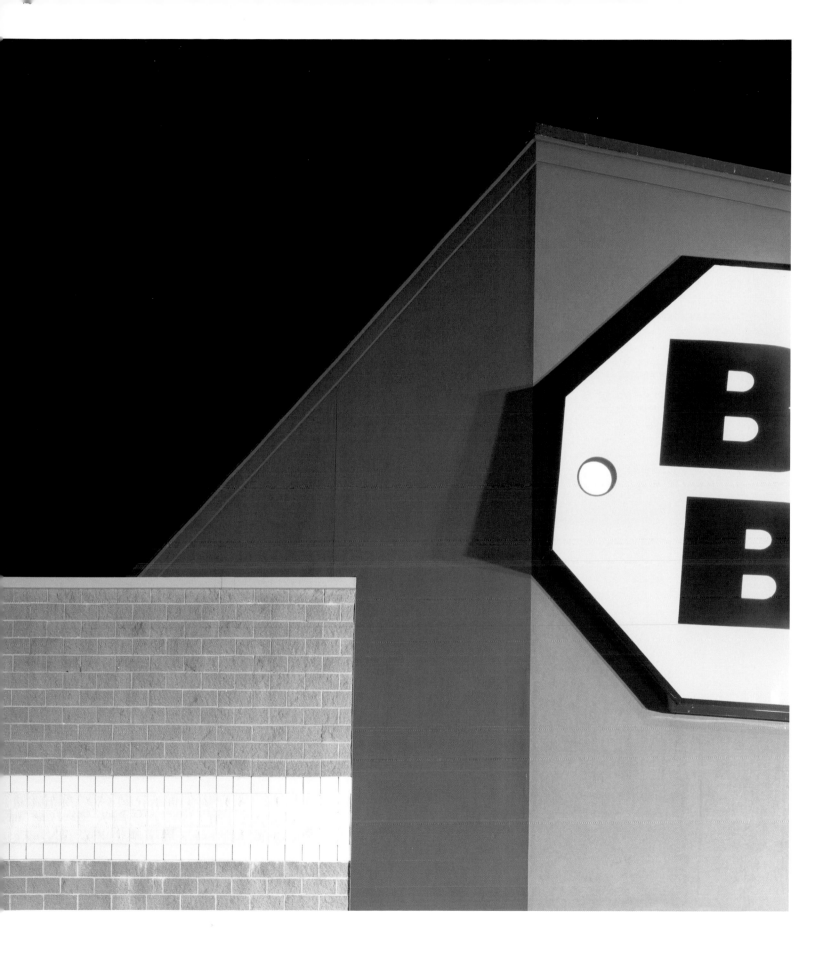

ANI KINGTON

USA, b. 1986
Tisch School of the Arts, New York, NY, USA,
2005–2009

It has become common for Western students to
spend some time travelling the world, often to remote
and exotic destinations. Whether studying a language,
sightseeing or just wandering from place to place, this
is seen as a personal experience, a rite of passage.
Because of its duration and the fact that it is about
more than just a change of scene, such travel differs
from mass tourism. As an indicator of openness and
curiosity towards other cultures, it implies self-
observation and an escape from routine. Thus Ani
Kington, who spent six months studying in Ecuador,
takes her photographs while discovering the country.
Her series is tinged with melancholy. The overview
she chooses to photograph a sports field symbolizes
her solitude – a quality often associated with the
figure of the traveller, who attempts to preserve his
or her separateness.

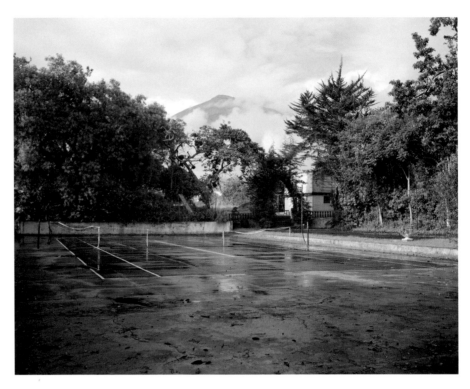

Tennis court in a *hosteria*, Ibarra. From the series *Whatever will be,* , 2008

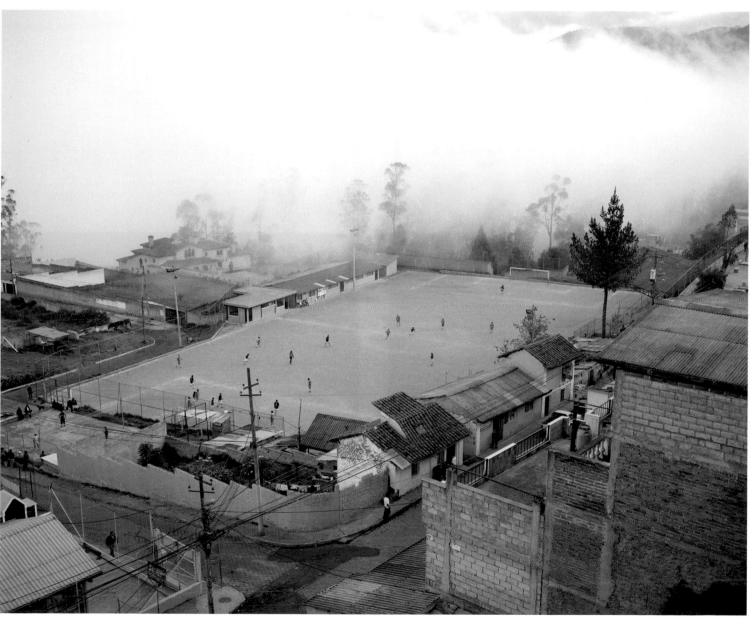

Sunday in Bellavista. From the series *Whatever will be,* , 2008

MARKUS KLINGENHÄGER
Germany, b. 1976
Fachhochschule Bielefeld, Germany, 2001–2009

Between 1907 and 1930 the American photographer Edward S. Curtis published what was then regarded as the most extensive photographic study devoted to American Indians: *The North American Indian*. His project, comprising two thousand photographs – mostly portraits – has had considerable influence down to the twenty-first century. Markus Klingenhäger, in turn, decided to focus his attention on the American Indian. Inspired not only by the work of Curtis, but also by the Hollywood film industry, which has long portrayed American Indians as warriors and savages, Klingenhäger questioned the stereotypes that have shaped our understanding of these peoples. His posed portraits, made with a 6 x 6-format camera, show the subjects in their own environment and subtly reveal the traces of assimilation of 'white' culture.

Untitled #15. From the series *DarkWhite*, 2009

Untitled #3. From the series *DarkWhite*, 2009

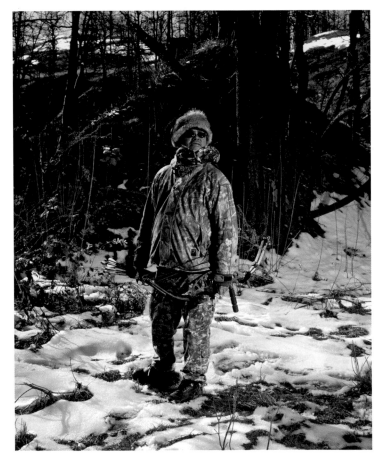

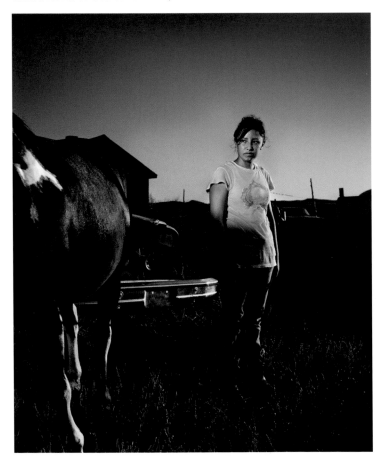

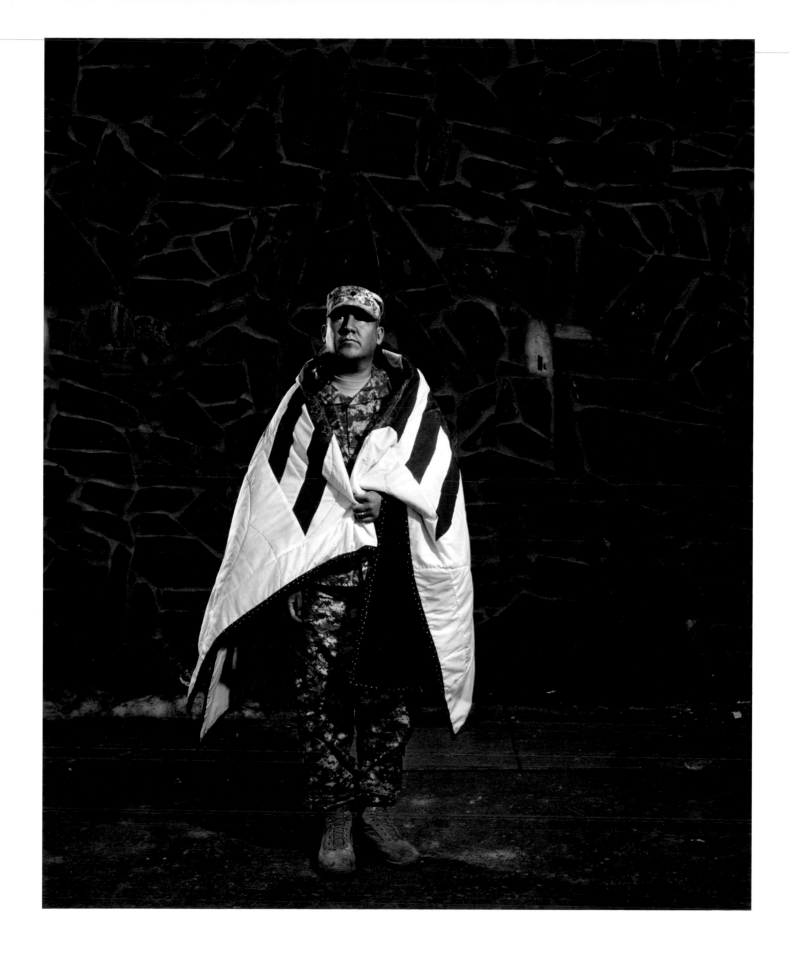

RICHARD KOLKER

England, b. 1964
London College of Communication, London,
England, 2007–2008

Digital technology influences our daily lives. We read, hear, see and write differently because of it. The boundary between the real world and the virtual world, which includes the flood of images that surrounds us, is constantly pushed to new limits. With digital technology, our sense of belonging to a community has also changed. Richard Kolker drew his inspiration from the Internet site 'Second Life', which went online in 2003 and is said to have had more than fifteen million users in 2009. Kolker's scenes, however, show no action. They show the places frequented by everyday 'heroes', and their point of view is that of the player – which is also our point of view, as spectators. In the *Night* series, digitally edited images are created using traditional photography and computer graphics. By combining these elements, Kolker takes us into a world where the virtual can be as innocuous as real life.

Dinner. From the series *Night*, 2008

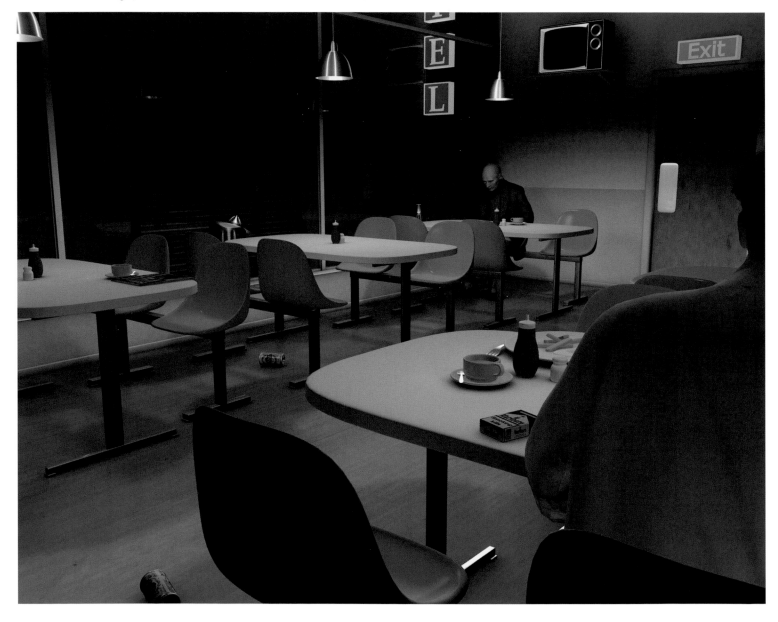

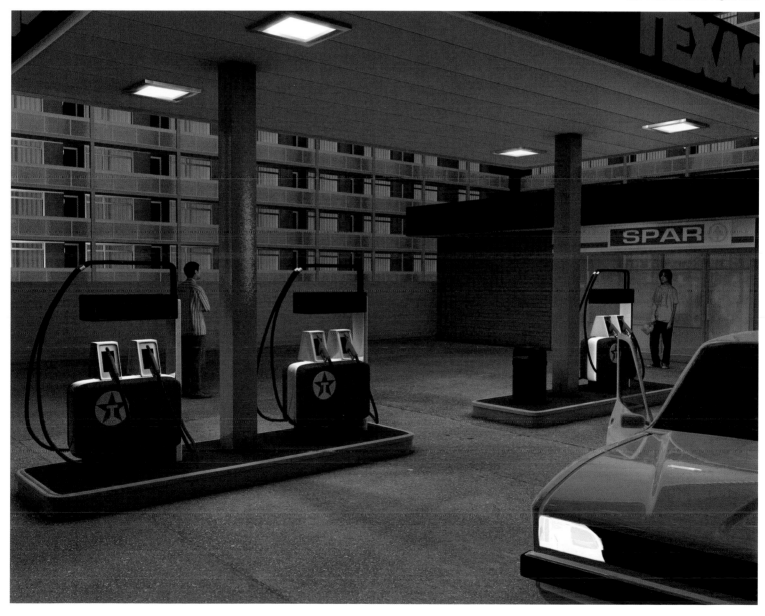

SYLWIA KOWALCZYK

Poland, b. 1978
Edinburgh College of Art, Edinburgh, Scotland,
since 2008

Sylwia Kowalczyk specializes in the genre of
portraiture. She says that she is inspired by the
post-mortem portrait, a popular practice among
painters of the seventeenth century, used again in
the nineteenth century by photographers, but then
abandoned in the twentieth century. Kowalczyk is
receptive to this genre because she is fascinated
by the distorted features of the deceased. To obtain
expressions that are not artificially fixed, the
photographer asks her models to lose themselves
in their thoughts. She even compares her shoots to
meditation sessions. She explains that she manages
to make her subjects feel comfortable when they
forget her presence and accept showing their
vulnerability. Their faces do not reveal any sign
of social status or any information relating to an
occupation. They have no identity. Character,
personality, temperament are all concepts that
are constantly reinterpreted by photographers.

above right:
Untitled 4, 2009

right:
Untitled 1, 2009

116

ANIA KRUPIAKOV

Ukraine, b. 1983
The Midrasha School of Art, Beit Berl, Israel,
2004–2008

Two crows lying on the ground, a few berries mingled
with bloodstains, a gold clock and a Hebrew sign...
The photography of Ania Krupiakov is ultimately
mysterious. Some viewers may even find it disturbing.
What message does she want to convey with this
image of two dead birds? Her history could give us
a clue. Born in the Ukraine, she emigrated to Israel
at the age of eight. The Zionist dream gave her
family the courage to escape a totalitarian regime
synonymous with fear. But what remains of the
dream among immigrant communities? According
to Krupiakov, mentalities stay the same, despite the
change of location. The photographer may suffer
from many wounds yet to heal, but she reminds us
that myths, belief and stories sweeten life. Is there
perhaps a link with the martyrdom or victorious
revolt of the Maccabees, as represented by the blue
symbol? 'Time is at the centre, and death at the
periphery,' says Krupiakov. We won't know any more.

Crows, 2008

118

IVAR KVAAL

Norway, b. 1983
University of Wales, Newport, Wales, 2006–2009
Norwegian University of Science and Technology,
Trondheim, Norway, 2005–2006
Arbeiderbevegelsens Folkehøgskole, Ringsaker,
Norway, 2003–2005

Norway has one of the best-performing hospitals in Europe – the Akershus University Hospital. Ivar Kvaal followed the construction process of the new hospital building. His photographs of interiors, revealing unusual spaces, do not, however, say anything about the medical equipment that will be installed. The clinical sobriety of the setting is highlighted by the 'neutral', objective and impersonal aesthetics of the work and by the frontal viewpoint employed. Kvaal follows in the tradition of a type of photography characterized by precision, a style developed by the followers of the Düsseldorf School, renowned for the visual strength of their work. In Kvaal's images – which at first glance appear monochrome – one can discern a few subtle touches of colour. The photographer also adds a certain theatricality with his astute working of light.

Untitled, Dvale, 2008

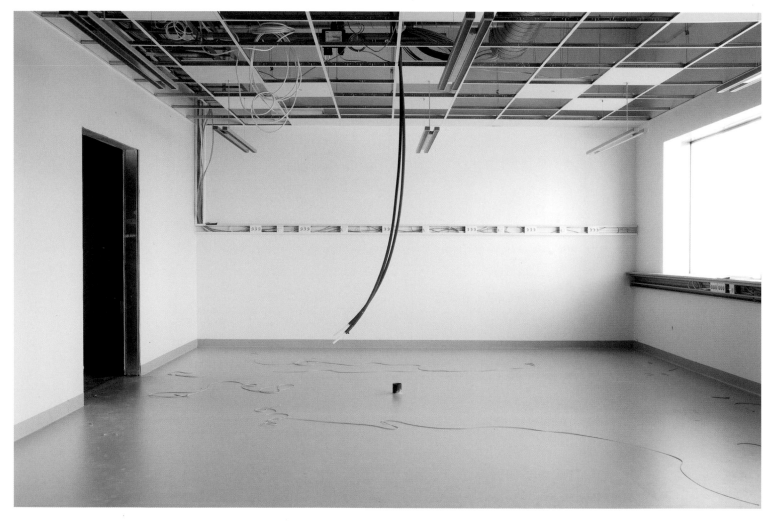

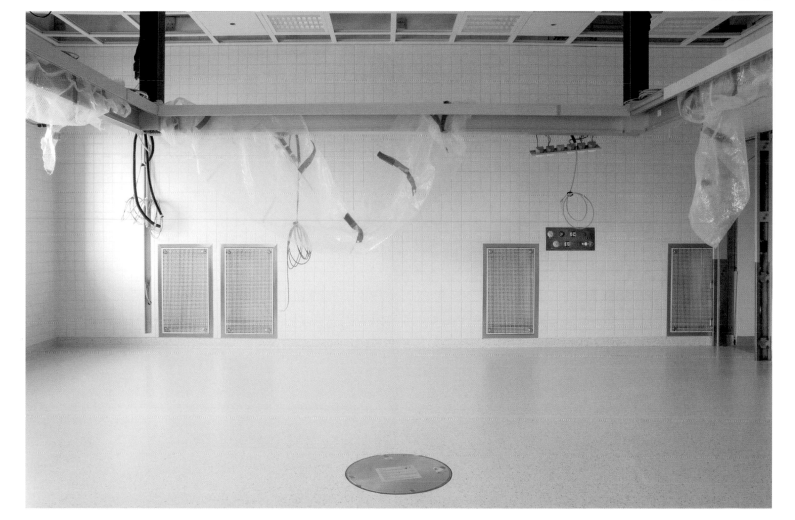

Untitled, Dvale, 2008

ELISA LARVEGO

Switzerland/France, b. 1984
HEAD – Haute école d'art et de design Genève,
Geneva, Switzerland, 2005–2009
CEPV – Ecole de photographie de Vevey,
Switzerland, 2002–2005

The still-life photographs of Elisa Larvego are
fascinating. They hit us first with the objects they
present – actually carts belonging to street vendors
in Mexico. The photographer, fascinated by these
'ready-mades', wanted to portray the sellers
through the way in which they arranged their wares.
Photography transforms these somewhat mundane
objects into something extraordinary. Carts become
sculptures by the mere fact of having been taken from
the overloaded streets where they belong: no other
staging is required. Larvego realized that just by
separating the carts from their context, they would
take on the appearance of unusual objects, and,
when taken together, would even come across like
an art installation. They thus lose the banal meaning
that would have been attached to them when they
were simply being wheeled around the city.

above right:
Sculpture 1. From the series *Mobile Sculptures*, 2007

right:
Sculpture 2. From the series *Mobile Sculptures*, 2007

opposite above:
Sculpture 3. From the series *Mobile Sculptures*, 2007

opposite below:
Sculpture 4. From the series *Mobile Sculptures*, 2007

SHANE LAVALETTE

USA, b. 1987
SMFA – School of the Museum of Fine Arts Boston,
MA, USA, 2005–2009

The city of Vrindavan, India, is regarded by Hindus as
the physical manifestation of the spiritual heaven. It is
also where Krishna is said to have taken human form.
Shane Lavalette, who has been resident in this holy
place, has made a series of photographs based on
the site. Although it has countless temples and many
pilgrims that flock to them, the photographer chose
to capture the essence of the place with pictures
that express tranquillity. Taken at sunrise, the image
of the hazy landscape reproduced opposite is
more like an abstract painting than a documentary
photograph. Artists have always been faced with
the representation of the mystical. In the history of
painting, the landscape has often been used as
a medium to represent religious events. Lavalette
continues this tradition by choosing to emphasize
the mysterious aura of the site by reinforcing the
effects of atmospheric light.

Yamuna, Vrindavan, India, 2009

SUNGHEE LEE

South Korea, b. 1974
Ecole Nationale Supérieure de la Photographie,
Arles, France, 2005–2008

We live in a society in which nature appears
domesticated – shrubs neatly trimmed, pets well
groomed, ponds with neat contours... What remains
of the natural in this perfectly constructed world?
SungHee Lee questions this obsession with order.
His 'Domestiqués' series – produced in France,
Thailand and Vietnam – is an affirmation of an overly
ordered society that has reduced nature to a
decorative role. The artificial takes precedence over
the natural. The photographer sees this as a desire
for humans to protect themselves against nature,
which is regarded as threatening if it returns to
wilderness. Do humans fear for their survival?
By subjugating the world, do we risk completely
eliminating nature and the species that inhabit it?

Domestiqués 001, Château de Chantilly, France, 2007

JACINTHE LESSARD-L.

Canada, b. 1978
Banff Centre, Banff, Alberta, Canada, 2009
Glasgow School of Art, Glasgow, Scotland, 2004
Concordia University, Montreal, Canada,
2003–2006 / 1997–2001

The work of Jacinthe Lessard-L. explores the
aesthetics of everyday life, while paying homage to
the abstractions of artists such as Piet Mondrian.
Basing her work on the democratization of design,
the photographer focuses on the exacerbation of
the 'convenience' of mass-produced furniture. To
make her *Two-minute sculptures* series, she brought
together ten participants, whom she asked to
construct their own sculpture by assembling a
dismantled chair in a given time. More recently, she
has worked with polymeric materials used for the
packaging of everyday objects. Directing her lens on
colours, textures and patterns – which she highlights
with her expert knowledge of light – she likes to
accentuate the abstract shapes of the objects,
however mundane they may be. In this game of
abstraction, the photographer pushes the limits of her
medium – using it purely as a tool for documentation
– though she also calls upon our collective memory
with images that show she is not devoid of humour.

above right:
Untitled. From the series *Two-minute sculptures*, 2005

right:
Untitled. From the series *Two-minute sculptures*, 2005

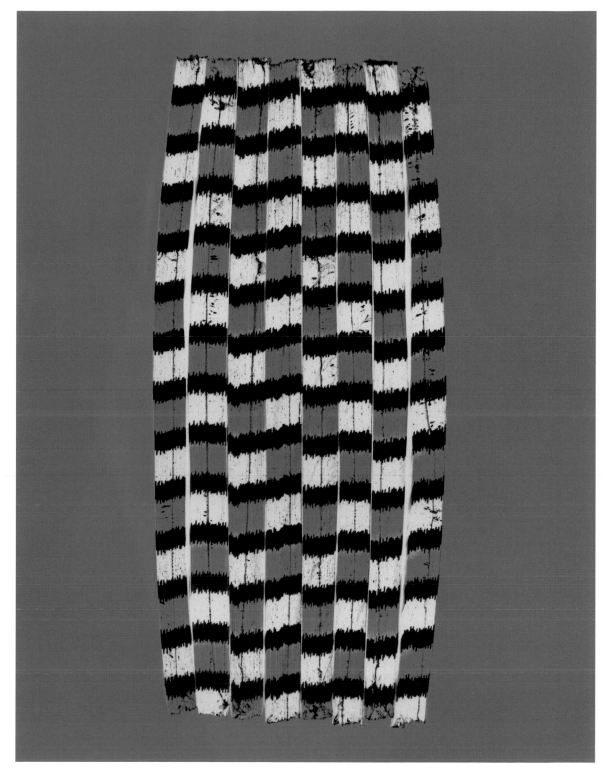

DI LIU

China, b. 1985
CAFA – China Central Academy of Fine Arts,
Beijing, China, 2005–2009

It would be a mistake to dismiss Chinese artist
Di Liu's bloated urban creatures as mere whimsy.
For the most part, they are 'cute' animals, rather
than the kind that inspire fear or trepidation, but they
sit rather stoically in their urban 'cages', as oblivious
as the human insect colonies around them. These
mammoth creatures, one begins to see, are very
beautiful, and their beauty makes the habitations
around them seem all the more squalid and pathetic.
Di Liu is interested in what he sees as the violation
of natural principles by social forces, specifically the
phenomenal rate of Chinese urbanization. As cities
in China pop up like mushrooms, they sweep nature
away. Di Liu seems to be warning us that the animals
(as bloated as the cities) will not go quietly, and have
a few surprises in store for a complacent humanity.

Animal Regulation n° 4. From the series *Animal Regulation*, 2009

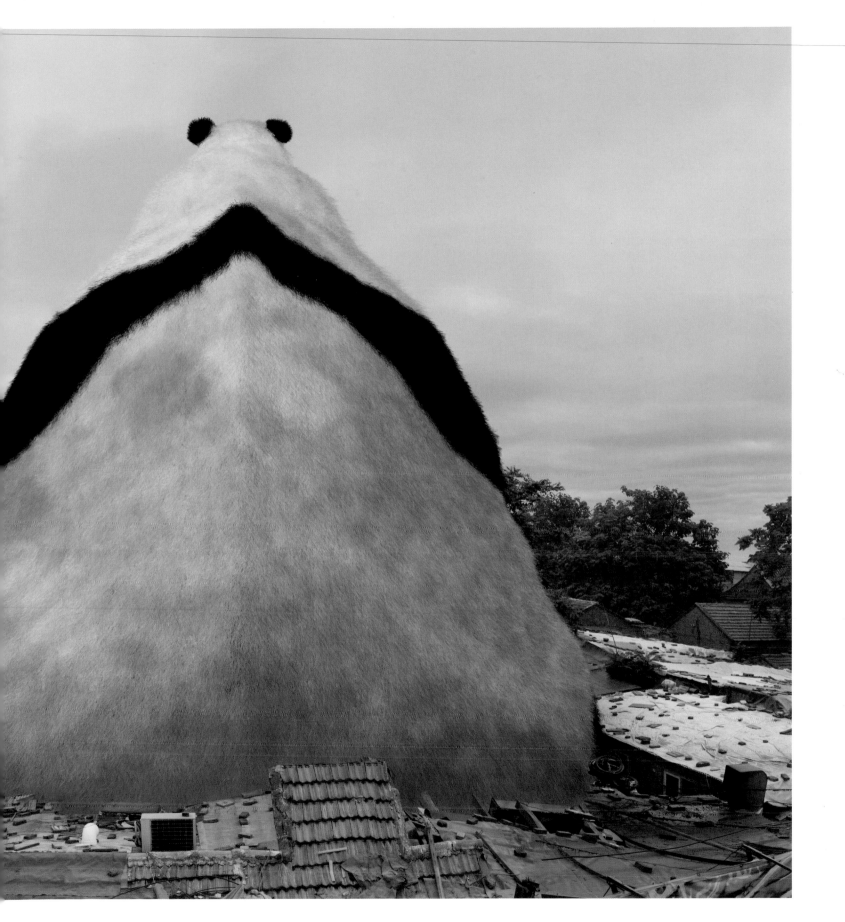

SOPHIE T. LVOFF

USA/France, b. 1986
Tisch School of the Arts, New York, NY, USA,
2004–2008

Sophie T. Lvoff likes to refer to literature to describe
her work. 'Most of my stories, it seems to me, could
take place anywhere. So I suppose it's an emotional
landscape I'm most interested in.' These words,
spoken by the writer Raymond Carver, might serve as
an introduction to Lvoff's photography. She chooses
to work with a view camera, using medium and large
film formats to produce her 'emotional landscapes'.
The technique allows her to create images that are
based on the mastery of colour and light. In the
Nothing is Stirring series, she focuses her camera on
trees, which she observes at night under artificial light.
Through her work with colour, Lvoff manages to give
the impression of suspended time. Doesn't this birch
forest evoke the Russian light described by Leo
Tolstoy, who is in fact her ancestor?

With Alex. From the series *Nothing is Stirring*, 2006

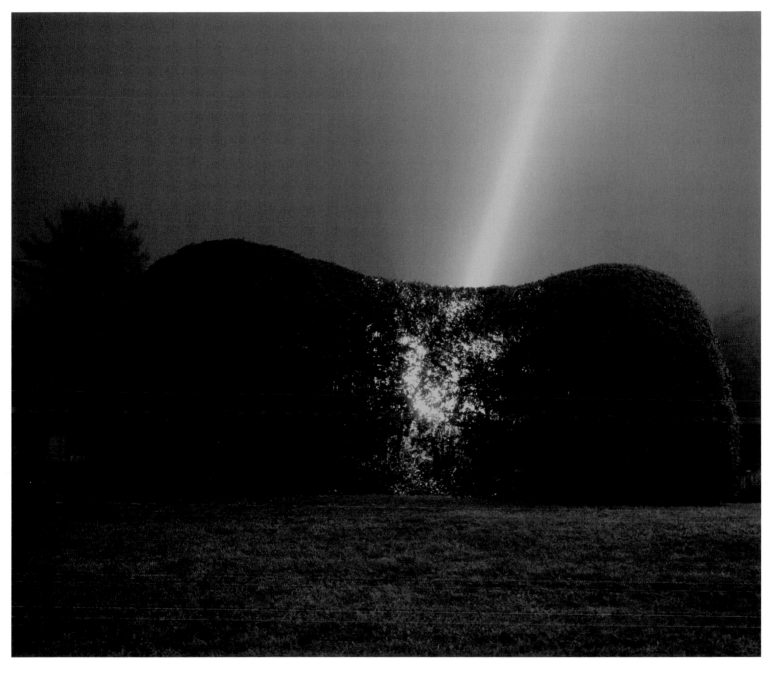

Outside Berlin. From the series *She's Going Down*, 2008

AGATA MADEJSKA

Poland, b. 1979

Royal College of Art, London, England, since 2008

Folkwang School, University of Duisburg-Essen,
Germany, 2000–2007

What is the meaning of a playground at dusk when
children have deserted it and night has enveloped
the place? Agata Madejska gives us an answer in
her *kosmos* series. Studying the geometric shapes
that emerge in urban areas, she photographs her
subjects when the light changes to see if this affects
their meaning. The objects here strike us with their
strangeness. They remain identifiable – who is not
familiar with the playground? – but they look
somewhat unreal. The boundary between the
actual world and the realm of fantasy is blurred.
The hemisphere on the carpet of dead leaves is
particularly unusual. We can only wonder about its
presence. Some would bet on its being a UFO…

kosmos #3. From the series *kosmos*, 2006–2007

kosmos #8. From the series *kosmos*, 2006–2007

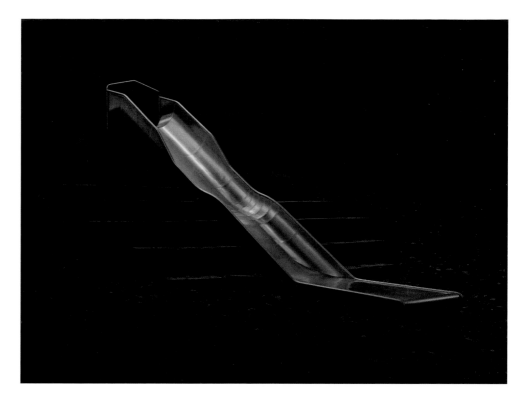

kosmos #7. From the series *kosmos*, 2006–2007

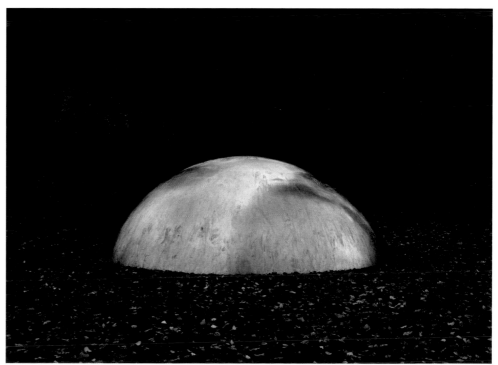

ÁGNES ÉVA MOLNÁR

Hungary, b. 1980
MOME – Moholy-Nagy University of Art and Design
Budapest, Hungary, 2003–2008

Many young photographers focus on self-exploration – that is to say, the exploration of their identity – through their photographic work, but their portraits are rarely taken in a traditional way. This, however, is the style chosen by Ágnes Éva Molnár in her 'SELFTIMER' series. She covers her tracks but, if one looks closer, one can see the cable-release in the hand of one of the young women portrayed. The photographer reveals her presence in the image through this little device, with which one can take a photograph of oneself. The construction of the scenes is the result of complex staging. By her movement, Molnár varies her position in space, her size and the importance of her presence. In her eyes, the most important thing is the interaction between the young women who are getting ready.

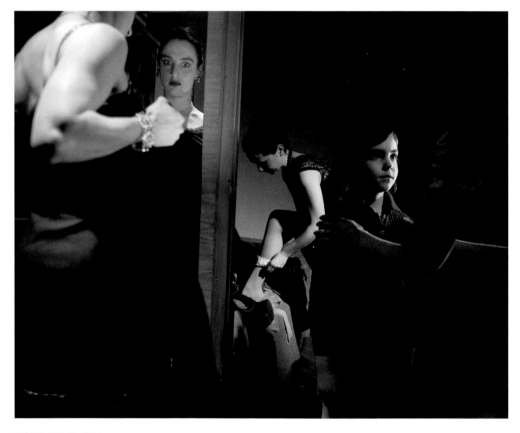

SELFTIMER 08, 2008

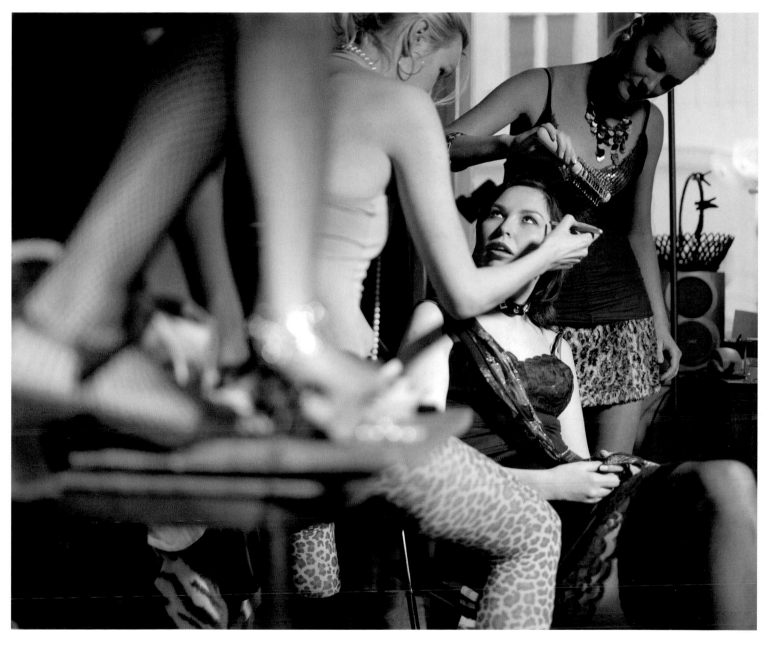

RICHARD MOSSE

Ireland, b. 1980
Yale University School of Art, New Haven, CT,
USA, 2006–2008
Goldsmiths, University of London, England,
2004–2005
London Consortium, London, England, 2002–2003

Power, threat and destruction are concepts that have been reinterpreted by artists since the eighteenth century. In our own time, the air disaster is – among other things – a reality of the entertainment industry. Indeed, the image of a plane's vertical descent could symbolize the failure of modernity. Discovering how air disasters fascinate and horrify us, Richard Mosse has made the subject his own. He photographs planes that simulate air disasters. The absence of jostling and panicking passengers, or inanimate bodies being taken away on stretchers, shows us that these scenes are fake. For Mosse, however, documenting the spectacle of terror means exploring the history of the real and imaginary disasters of our civilization. His series also questions the additional sense of fear associated with such catastrophes. Has human progress been defeated by these killing machines, as some recent terrorist events seem to prove? Full-size replicas of real planes, these 'toys' for adults are both sublime and terrifying. But what will happen next, to this debris of the future?

737 San Bernardino, 2007

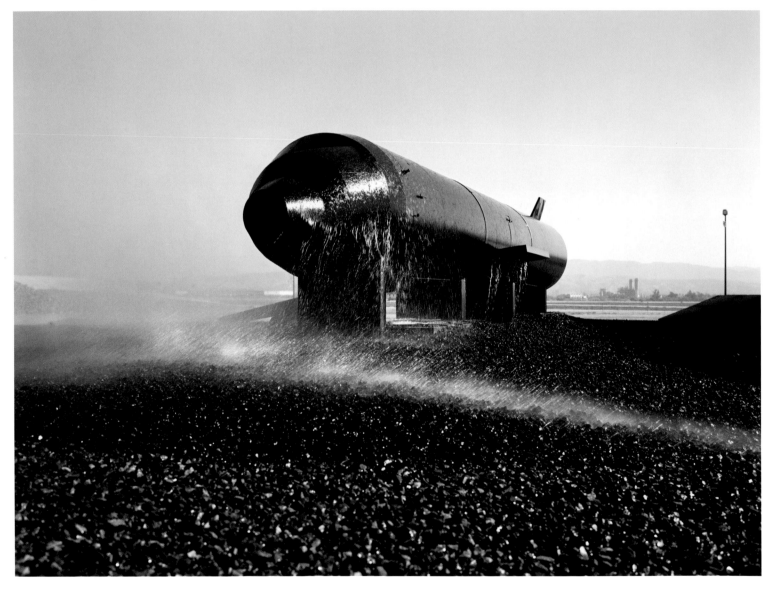

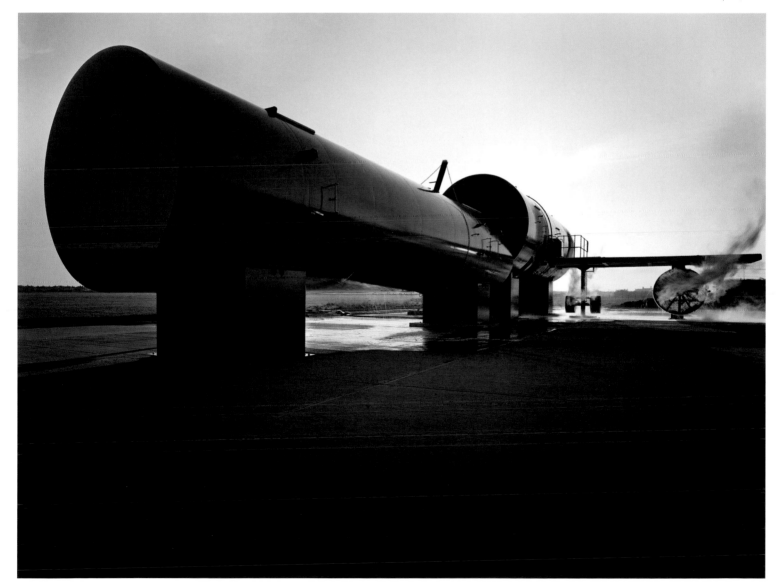

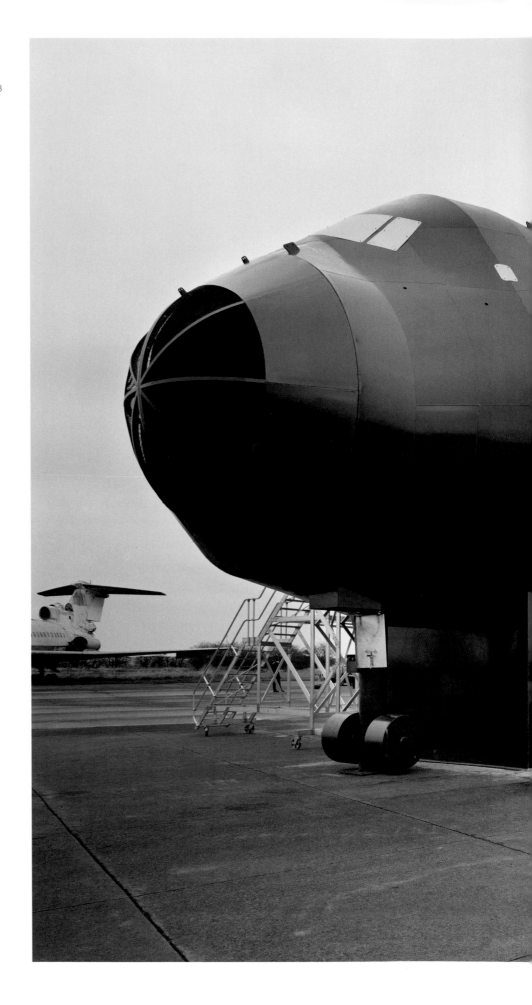

A380 Teesside, 2008

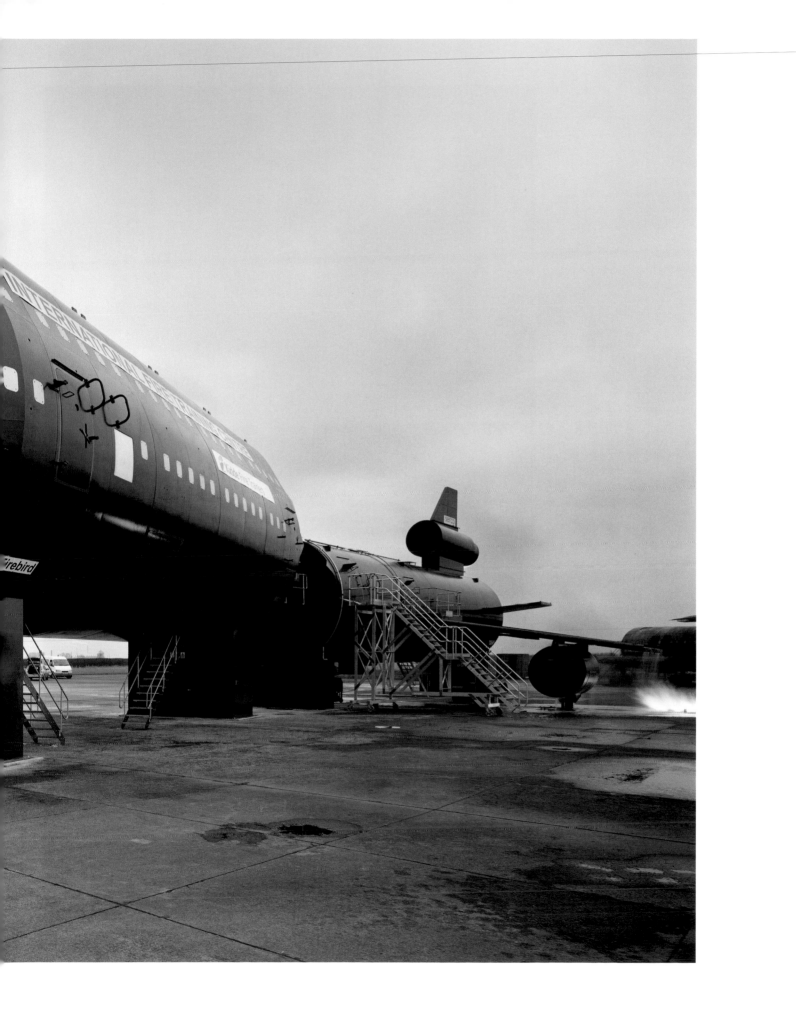

MILO NEWMAN

England, b. 1986
University of Wales, Newport, Wales, 2005–2008
Arts Institute Bournemouth for Art and Design
Foundation, Bournemouth, England, 2004–2005

The majority of Milo Newman's photographs in the series he calls 'Till the Slow Sea Rise' – a line from Swinburne – are taken in half-light, at the beginning or end of a winter's day, when, as the writer W. G. Sebald has put it, 'night is drawn like a black veil across the earth'. Newman uses this light to melt the corporeal world into shadow, suggesting loss as much as change. He would never claim, however, that the tranquil places he venerates are 'timeless' – far from it. They are all low-lying areas of British coastline threatened by the inexorable rise of sea levels due to climatic change. Newman sees his images as both critique and meditation on the concepts of transience and fragility, and he hopes to shatter the illusions of permanence we have built up around our dubious societal endeavours.

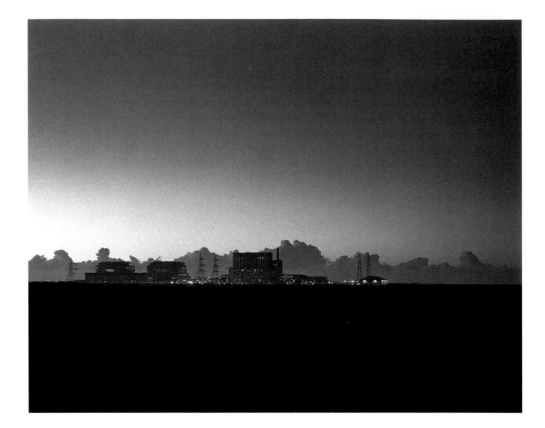

above right:
Dungeness power station, Kent.
From the series *Till the Slow Sea Rise*, 2008

right:
The North Sea, Norfolk.
From the series *Till the Slow Sea Rise*, 2008

Pink-footed geese, Norfolk. From the series *Till the Slow Sea Rise*, 2007

YUSUKE NISHIMURA

Japan, b. 1981
School of Visual Arts, New York, NY, USA,
2005–2008
Tisch School of the Arts, New York, NY, USA,
2001–2004

The photographs of Yusuke Nishimura – which
evoke the colour fields of the painter Mark Rothko –
record the changing colour of sunlight throughout
a particular day. Nishimura's generation of
photographers loves playing with the ambiguities
of photography, alternating between aesthetic
construction and documentation. Nishimura's
approach is one example of this: his photographs
are the result of a combination of several exposures.
They represent the colours of light that the artist has
patiently observed from sunrise to sunset, through
paper attached to a window. Each shot is from a
specific time, given in the caption, in addition to the
date and place. Depending on the season, weather
and hour, the sun emits light differently, its colour
subtly varying during the day and from day to day.
After shooting, Nishimura creates a new computerized
image, whose vertical axis represents the hours
between dawn and dusk. Like the painter who covers
his blank canvas in layers, Nishimura inserts each of
his photographs at the level that corresponds to the
hour of shooting. The result is a 'landscape of a
particular day'.

08:02:55, 09:03:11, 09:59:59, 10:07:44, 11:21:59, 12:13:05, 14:32:03, 16:51:04, 17:25:34, 17:43:00, 17:49:01
10/22/07, Jackson Heights. From the series *DAYSCAPES*, 2007

06:45:00, 07:38:44, 11:47:08, 14:33:55, 18:59:06
4/9/08, Jackson Heights, From the series *DAYSCAPES*, 2008

YA'ARA OREN

Israel, b. 1982
The Midrasha School of Art, Beit Berl, Israel,
2005–2009

Photographers have accustomed us to 'seeing'
so-called trivial and visually uninteresting objects.
Revisiting the genre of landscape and still life, they
have opened our eyes to environments that are
often reduced to the role of decoration. Ya'ara Oren
photographs restaurants, shops and hotels, places
that are characterized by their over-decorated
interiors. Neither the identity nor the location of
the places photographed is provided. The style of
decoration is culturally non-specific and can be
found in widely disparate parts of the globe. Oren
shows us familiar places, while giving them a sense
of strangeness. Synonymous with progress, beauty
and wealth, they are a reflection of a world of over-
representation.

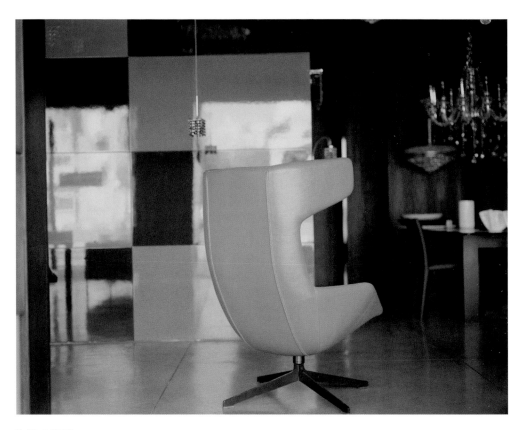

Untitled, 2009

Untitled, 2008

Untitled, 2009

גן החיות בגן האם
HAIFA ZOO in Gan Ha'em
خريطة الحيوانات في حديقة الأم

ANNA ORLOWSKA

Poland, b. 1986

The Polish National Film, Television and Theater
School, Łódź, Poland, since 2006
Institute of Creative Photography, Silesian University
in Opava, Czech Republic, since 2008
Academy of Fine Arts, Poznań, Poland, 2005–2006

Anna Orlowska's photographs make us enter a cinematographic world. The prominent narrative dimension is fuelled by dramatic tension. The nocturnal scenes, all built around a female figure, contrast with the image commonly associated with 'pretty' young women: in addition, the female here is pregnant. The tension is further built up by the artist, who prefers darkness. What is this iconic figure feeling, she who seems locked in her own loneliness? Fear? Longing? The title of the series – 'The day before' – implies that a change is about to happen. But Orlowska does not reveal to us what will follow. Only the viewer's imagination can help fill the void. It is up to us to imagine the beginning and end of the scenario.

From the series *The day before*, 2008–2009

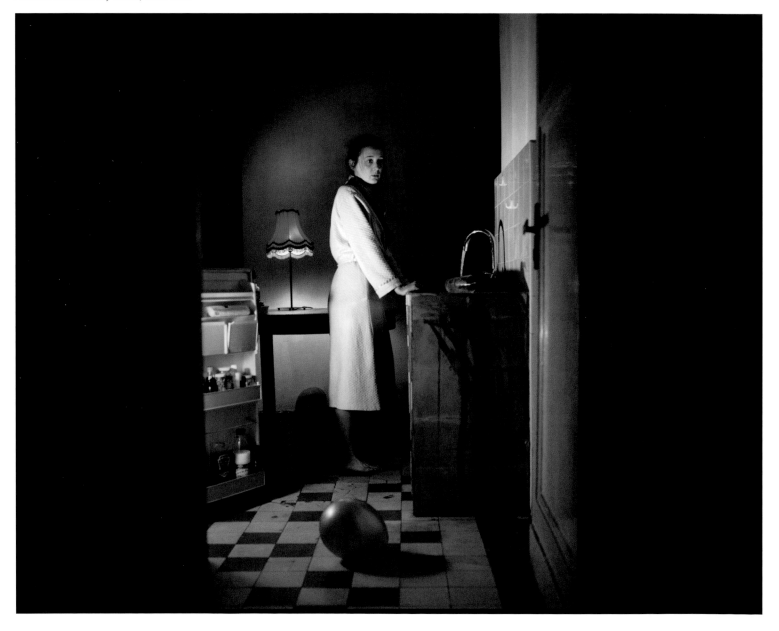

154

From the series *The day before*, 2008–2009

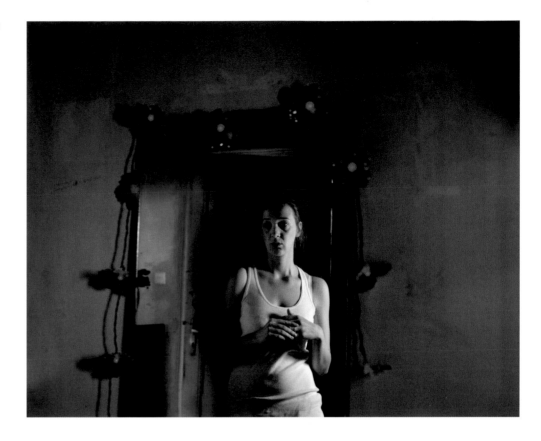

From the series *The day before*, 2008–2009

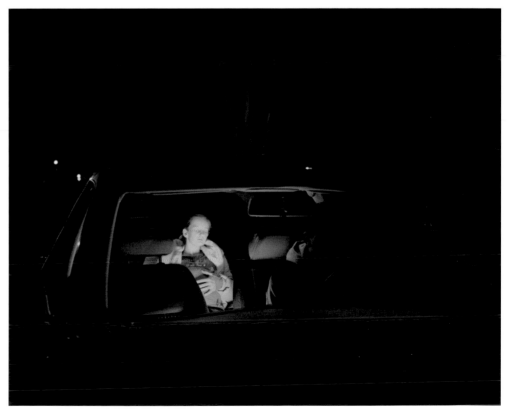

JENNIFER OSBORNE

Canada, b. 1984
Fabrica, Catena di Villorba, Italy, 2008–2009
Langara College, Vancouver, Canada, 2003–2005

Jennifer Osborne specializes in documentary
photography. Unlike many photographers of her
generation, she does not see the medium as a tool
for introspection. She focuses on people who live in
hardship. Her travels have led her to countries such
as Brazil, where poverty, crime and delinquency
affect people her own age. In Brazil, Osborne
followed three young women who had just left
prison. We learn that one was convicted of cocaine
trafficking, another of kidnapping a tourist, and that
the third, also prosecuted for kidnapping, is still on
day release. The photographer, who met her subjects
in the Bangu prison near Rio de Janeiro, shows us
their new experiences of freedom. After incarceration,
domestic abuse and violence, they have lives to
rebuild.

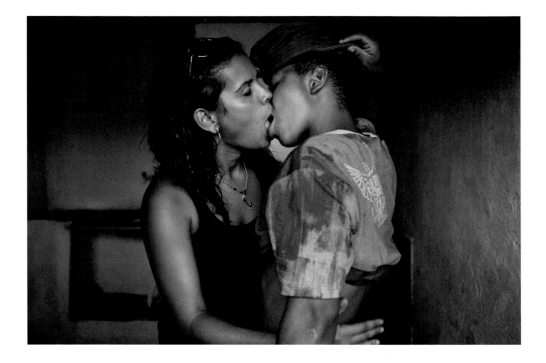

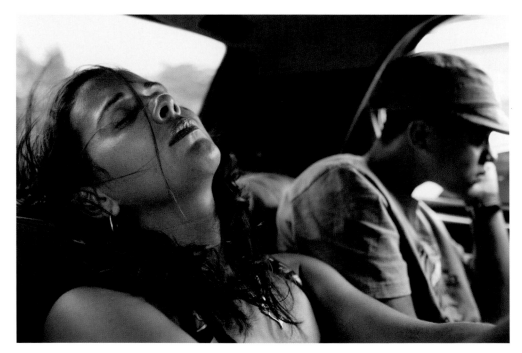

above right:
March 17, 2009, Rio de Janeiro, Brazil, 2009
Minutes after Barbara moves possessions into her
new apartment (just a room really), her estranged lover
Michelle begs for a kiss. Barbara was recently released
from an all-women's prison while Michelle is required to
return to confinement each night.

right:
March 20, 2009, Rio de Janeiro, Brazil, 2009
Barbara and Michelle began a complicated love affair
in jail over two years ago after both were convicted of
unrelated counts of kidnapping.

March 10, 2009, Rio de Janeiro, Brazil, 2009
Barbara, a 21-year-old convict, exits the front gates
of Talavera Bruce Women's Prison for the first time in
3 years. This ends Barbara's second sentence. She
was caught kidnapping a German tourist with a group
of friends and was released a few months ahead of
schedule due to overcrowding in Rio's prison system.

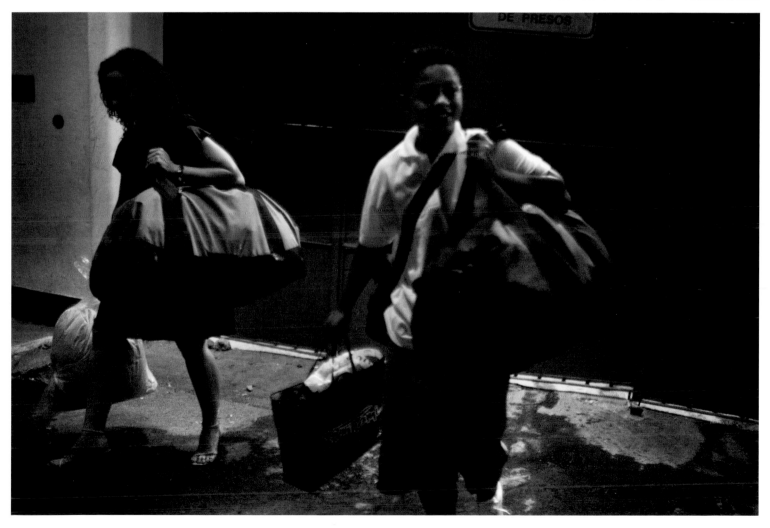

MARGO OVCHARENKO

Russia, b. 1989
Rodchenko Moscow School of Photography
and Multimedia, Moscow, Russia, since 2008

Margo Ovcharenko explores the genre of portraiture.
She focuses on Russian youth, with whom she
shares early experiences of adult life. She therefore
photographs young people with whom she has
become friends or with whom she has a close
relationship. She often establishes eye contact
with her models, though she lets them move at
will, refusing to force poses that are too artificial or
frozen. She also chooses to work under natural light
to communicate the affection of the bond that links
her to her subjects. She never tries to be too close,
too intrusive – or, conversely, too remote. Her portraits
are meant to be sincere. The freshness of emotion,
the tranquillity, the summer heat and the feeling of
eternity that characterize these images allow the
viewer to share moments of intimacy. Personal
and emotional relationships are directly expressed
through photography.

From the series *Without Me*, 2008

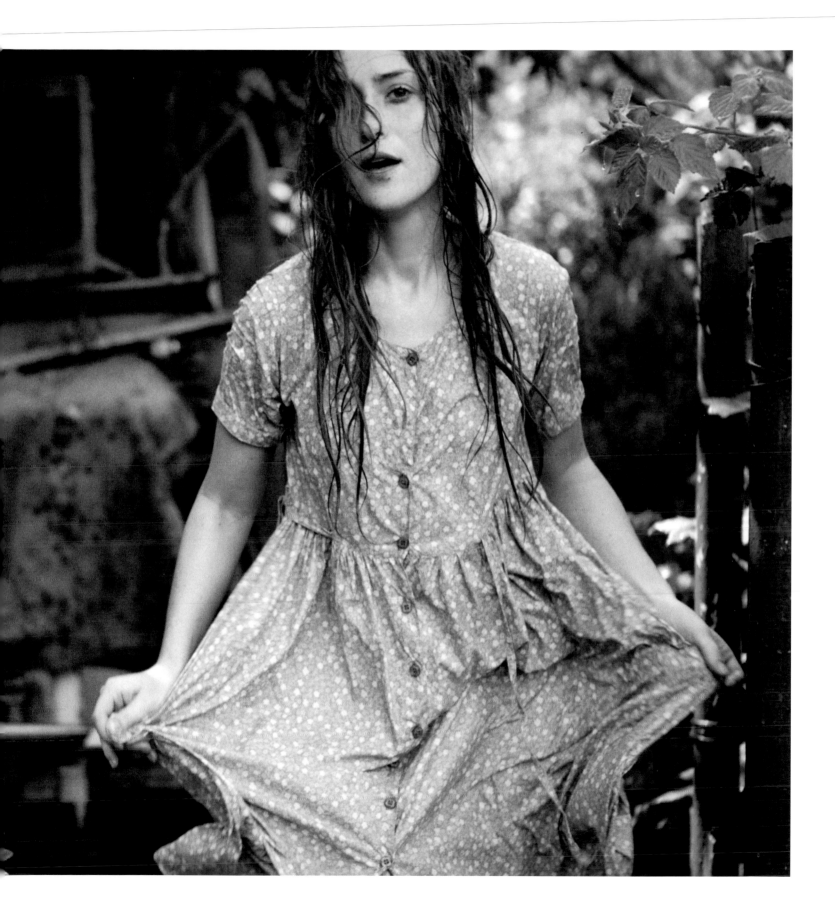

NELLI PALOMÄKI

Finland, b. 1981
TaiK – University of Art and Design Helsinki, Finland,
since 2008
Arts Academy of Turku University of Applied
Sciences, Turku, Finland, 2004–2008

What are the power relations that underlie a portrait?
Is it the photographer or the model who imposes
their rules? Do photographers turn the genre to their
advantage, or do models only show a 'mask' of
themselves? Nelli Palomäki questions the definition
of portraiture, which she has chosen to work with
in conventional black and white. Something always
escapes her. She states that her models remain
elusive. The portraits may bear a certain relationship
to their subjects' features, but their faces look
different. Palomäki questions the notion of identity
and resemblance by sharing her doubts with us. She
sees her portraits as pieces of a puzzle that might
represent her memory. She will forget some of her
models; others she will see again. In contemporary
photography, the face remains a subject as
inexhaustible as it is fascinating.

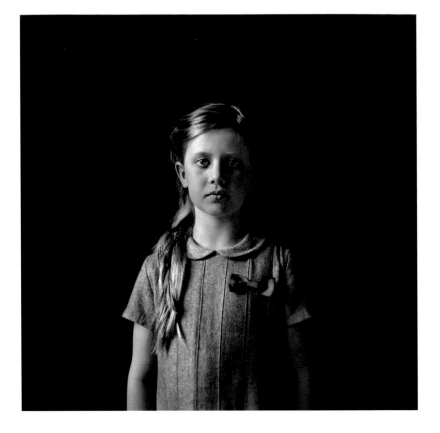

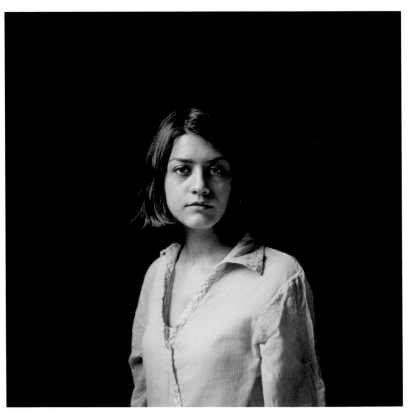

above right:
Dora at 7. From the series *Elsa and Viola*, 2009

right:
Ladan at 26. From the series *Elsa and Viola*, 2009

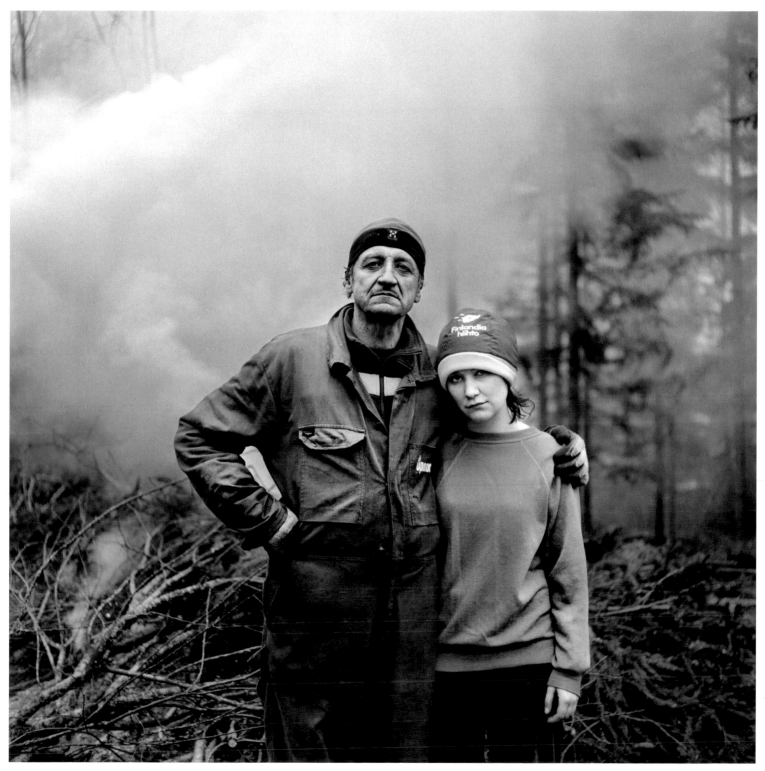

REGINE PETERSEN

Germany, b. 1976

Royal College of Art, London, England, 2007–2009

University of Applied Sciences, Hamburg, Germany, 1999–2006

Regine Petersen bases her work on the vagaries of her own thoughts. She covers many different topics in a wide variety of genres, thereby emphasizing the ambiguity of photography, which similarly cannot be pinned down. Observing Petersen's works – whether landscapes, portraits or interior scenes – is akin to setting out on a walk that follows the photographer's dreams, which she lets drift freely. Following the photographer's wanderings, the viewer is encouraged to return to his or her own thoughts. Contemporary photography does not have a unique style; it is as diverse as its processes and influences. Diary, narrative, documentary, exploring the environment – the medium lends itself to all forms. The genres are mixed; the ground is fertile.

Pigeon, 2009

AUGUSTIN REBETEZ

Switzerland, b. 1986
CEPV – Ecole de photographie de Vevey,
Switzerland, 2007–2009

Augustin Rebetez's *Gueules de bois* [Hangovers]
series documents the excesses of a young generation
to which he himself belongs: 'Because parties are
not only glitz and glitter. Because behind the laughter
there is often bitterness.' Rebetez dives into the heart
of the binge-drinking culture he shares with his
friends. His work, in addition to its immersive and
documentary approach, includes staged photographs
– conceived as photographic performances – and still
lifes. All of these photographs form a vast network of
images that talk to each other. By focusing on masks
and disguises, Rebetez tries to represent the feelings
of the body and mind during the drowsiness or rage
of drunkenness. His photographs – raw images that
hover between reality and fiction – carry a spontaneity
characteristic of a generation often photographed in
its misery, melancholy and distress.

right:
Untitled. From the series *Gueules de bois*, 2009

opposite above:
Untitled. From the series *Gueules de bois*, 2009

opposite below:
Untitled. From the series *Gueules de bois*, 2009

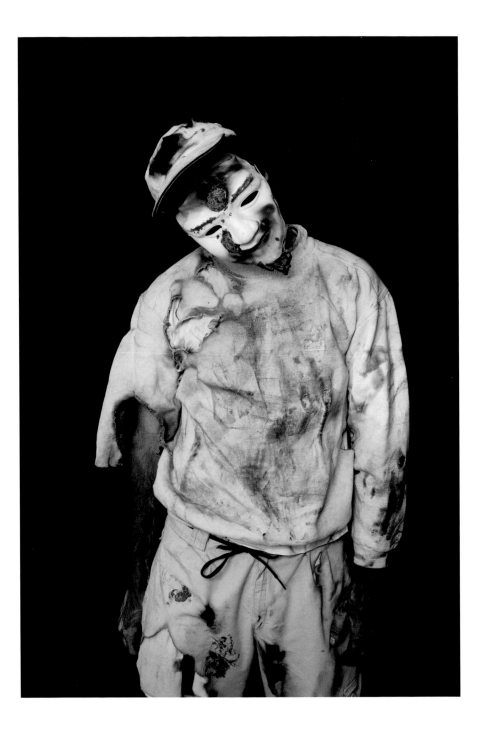

Chuck (street name) on the wall of his home in New York City's Amtrak Tunnel. Lisa (street name), a long-time companion, is just behind him. Cleared of illegal residents in the 90's, the tunnel was resettled by a small number of homeless men and women more than seven years ago, according to Chuck. From the series *The Urban Cave: the other side*, 2008

ANDREA STAR REESE

USA, b. 1952
ICP – International Center of Photography,
New York, NY, USA, 2007–2008
CALARTS – California Institute of the Arts,
Valencia, CA, USA, 1976–1983

With her documentary series *The Urban Cave: the other side*, Andrea Star Reese takes us into the intimacy of homeless New Yorkers. Produced with the consent of people willing to share their stories, the series exposes to natural light the places in which they live – or, rather, survive. If these places are dark, it is because they are former underground train tunnels. The photographer – fascinated by the beauty and dignity of people on the street – has chosen to work in a widescreen format, similar to that of film cameras. Her images are characterized by a broad field of vision. Among various encounters, the photographer has followed Lisa and her partner Chuck in the train tunnel they have occupied for several years. As part of a wider reflection on the homeless, Reese offers a poignant testimony of people who have been forgotten by society and whose dwellings are being destroyed by the city.

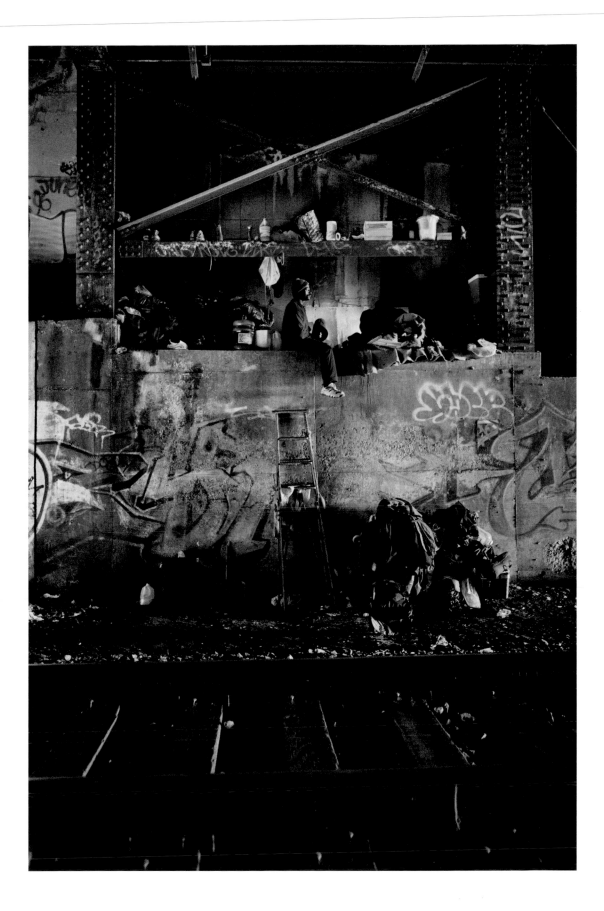

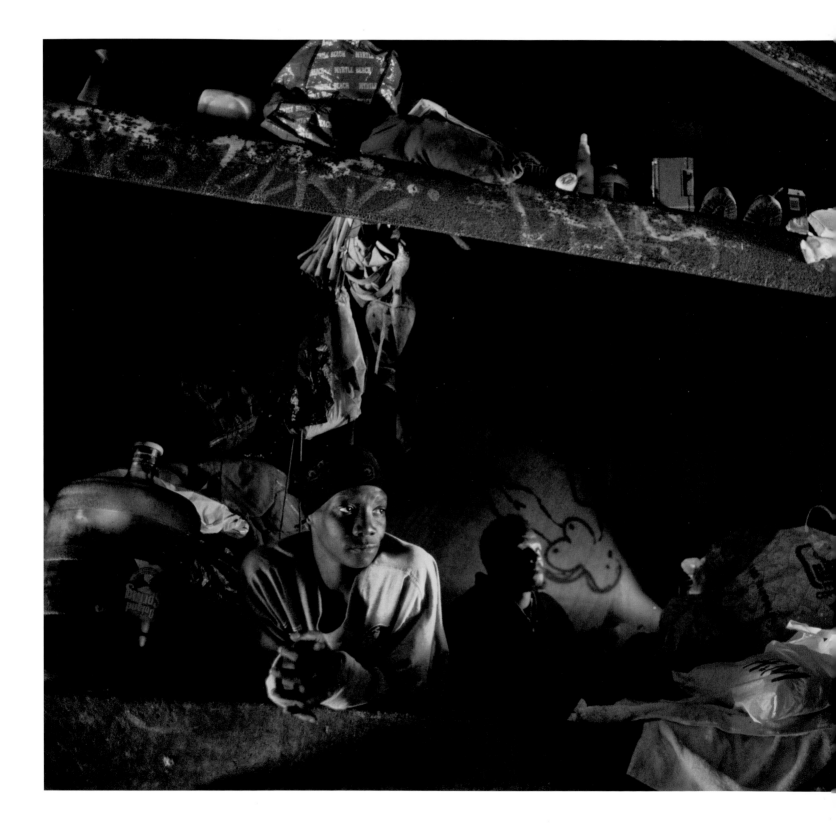

Chuck and Lisa – in their makeshift home, New York City's Amtrak Tunnel – watch as curious outsiders come to view the graffiti painted on its walls. The transportation link is also known as 'The Freedom Tunnel', after one of its older murals. According to Lisa, while encampment residents are concerned that visitors and graffiti writers will trigger another eviction, the larger problem is occasional harassment and theft. From the series *The Urban Cave: the other side*, 2009

A photograph of Lisa, Chuck, and Charles born in October 2007, now in foster care. From the series *The Urban Cave: the other side*, 2009

NICOLE ROBSON

Australia, b. 1972
Tasmanian School of Art – University of Tasmania,
Hobart, Australia, since 2003
Central Metropolitan College of TAFE, Perth,
Australia, 1991–1995

Nicole Robson examines domestic life by
photographing people at home. However, if we look
closer, a sense of strangeness begins to emerge
from the work. The light seems too bright, the decor
too contrived and the characters too rigid. These
images – seemingly everyday – in fact depict carefully
composed scenes, the photographer working as if
on a film set. The setting is created from scratch,
the furniture is purchased at second-hand stores,
and the models are dressed, made up and directed
in order for the image to appear like an ordinary
snapshot from family life. There seems to be no
contact between the characters, who look bored or
seem overwhelmed by the burden of life. As viewers,
we have every opportunity to observe their interior
world, which will probably bring to mind thoughts
relating to our own domestic circumstances.

Fátima in the kitchen. From the series *Simulacrum*, 2008

CAMILA RODRIGO GRAÑA

Peru, b. 1983
Forma, Centro Internazionale di Fotografia, Milan,
Italy, since 2009
Centro de la Imagen, Lima, Peru, 2006–2008
Pontificia Universidad Católica del Perú, Lima,
Peru, 2001–2005

The work of Peruvian photographer Camila Rodrigo
Graña hovers between objective documentary and
commercial fashion photography. It also evokes stills
from some film dealing with an intense, revolutionary,
urban subculture. The photographer admits to being
very much one of her own subjects – that is, a group
of young Lima inhabitants who are searching, albeit
without much of a compass, for an alternative lifestyle
that is opposed to the solid mainstream. Rodrigo
Graña realizes that her peer group is intensely self-
conscious, acting out roles ordained by ubiquitous
commercial imagery, and that much of the reality of
their world is mere façade – hence the title of her
series, 'Simulacrum'. She also uses the camera as
both a form of note-taking and a means of getting to
grips with the complex, shifting codes of her fellow
'Limeños'.

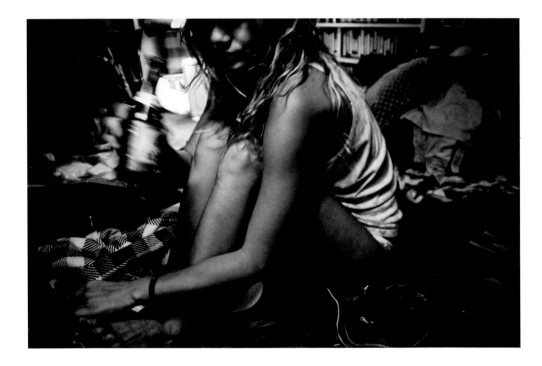

above right:
Juven's wolf. From the series *Simulacrum*, 2008

right:
Roxy. From the series *Simulacrum*, 2007

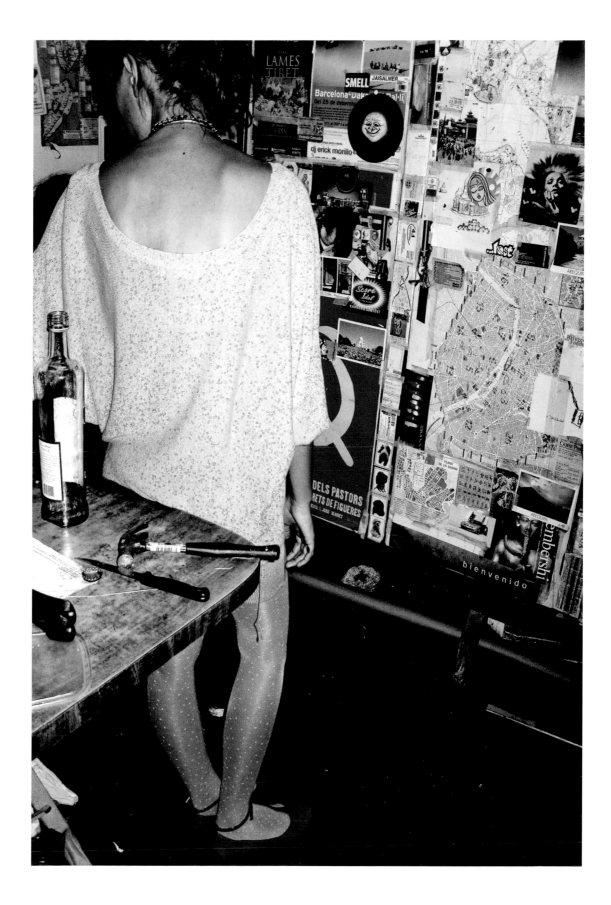

SIMONE ROSENBAUER

Germany, b. 1977
COFA – College of Fine Arts, University of New
South Wales, Paddington, Australia, since 2008
Fachhochschule Dortmund, Germany, 2000–2006

In Australia there are numerous museums dedicated
to Australian culture and history. Simone Rosenbauer
has visited forty or so around the country. Most are
small museums intended to preserve local history
and provide an insight into Aboriginal heritage,
showing its influence on Australian identity. The
guardians of these regional institutions – that is, their
keepers and the officers who bring the museums to
life – are often people who have an attachment to
the site and are willing to share their memories.
They try to hold particular objects in their archives,
often on the basis of oral histories. The range of
items collected and the personal involvement of
the museum staff fascinate Rosenbauer. Her
documentary series, which includes portraits of
people as well as photographs of galleries, offers
striking evidence of the care that humankind takes
to preserve its heritage.

#009 Land of Beardies/History House. From the series *Small Museums in Australia*, 2009

SASHA RUDENSKY

Russia, b. 1979

Yale University School of Art, New Haven, CT,
USA, 2006–2008

Wesleyan University, Middletown, CT, USA,
1997–2001

Sasha Rudensky has empathy for her subjects. She recognizes a part of herself in her portraits. Her landscapes and interior views evoke her own feelings. A park in the snow, a young mother lost in thought, a boy studying in his kitchen … each image is a piece of the photographer's puzzle. A puzzle that is her personal story – a childhood in Russia, emigration, visits to her country of origin – and a puzzle that poses questions about the human condition, the misunderstandings between Russian and American culture, the search for a place to call home, for the true place of origin. Rudensky's work – conducted under natural light, which highlights the softness of the encounters – offers a vision of contemporary Russia, while also portraying a person in search of her own identity.

Park by Mariinsky, St Petersburg, Russia, 2005

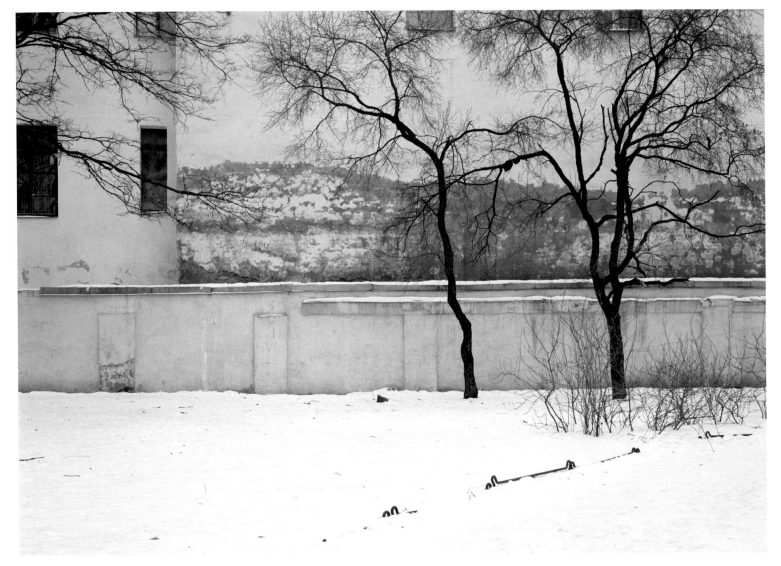

Masha Nedelkina, Sevastopol, Ukraine, 2009

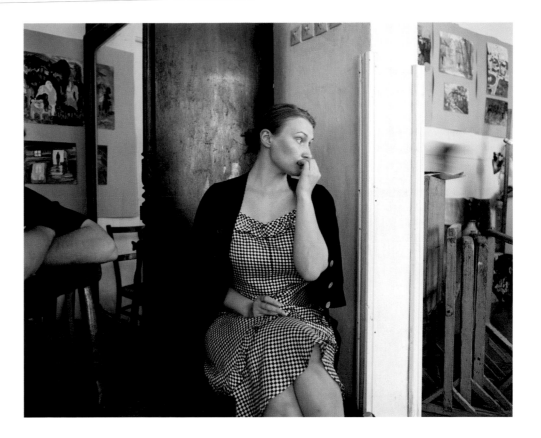

Vasilievs, Nikolaev, Ukraine, 2009

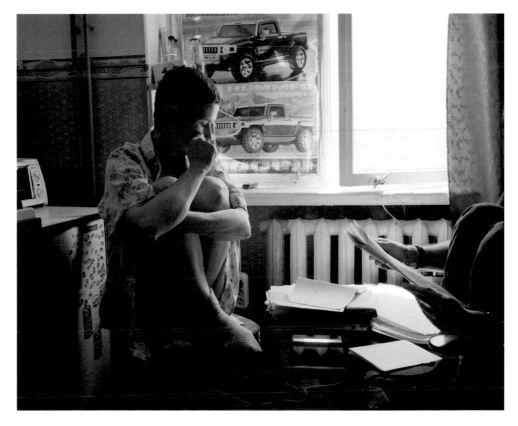

CATHERINE RÜTTIMANN

Switzerland/France, b. 1979
ECAL – Ecole cantonale d'art de Lausanne,
Switzerland, 2005–2009

On 4 November 2008 John McCain conceded defeat
to Barack Obama in the race for the White House.
Catherine Rüttimann was present that day in Phoenix,
Arizona, where the Republican camp gathered on
the evening of their defeat. Never had an election
mobilized so many media resources. It was this
infatuation of the press that the photographer chose
to represent in her series *Off the record* – an
infatuation shared by journalists working in many
media across the United States as well as the rest
of the world. Rüttimann takes us behind the scenes
to watch the media frenzy during those few hours.
Her images document the 'factory' in operation,
busy producing information, sometimes reaching
overload. On 4 November the soldiers of journalism
brought out the artillery. The action began; history
was being written.

Untitled. From the series *Off the record*, 2008

SU SHENG

China, b. 1979
Xi'an Institute of Fine Arts, Xi'an, China, since
2007 / 1999–2003
ENSBA – Ecole nationale supérieure des beaux-
arts, Paris, France, 2006

The 'little emperors' of China are only children, born
into wealthy families and surrounded by the many
toys that fill their bedrooms. While their parents work,
the children are masters of the house. Su Sheng
approached the 'little emperors' and 'little princesses'
of urban China, asked them to talk about their lives,
then photographed them. Their home is indeed their
kingdom, but it is also a protective armour against
the outside world. A heavy burden seems to weigh
on the shoulders of these boys and girls. The only
representatives of their generation in the house, they
symbolize the aspirations of their parents, who grew
up with many brothers and sisters. The photographer,
born in 1979 – the year in which birth control became
law – captures particularly well the boredom and
loneliness of these little ones, who are experiencing
a family life that has no precedent.

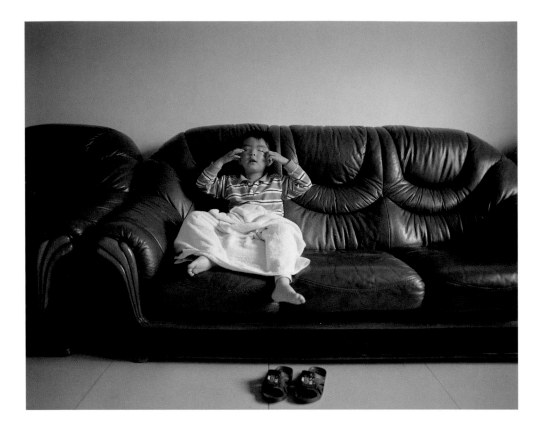

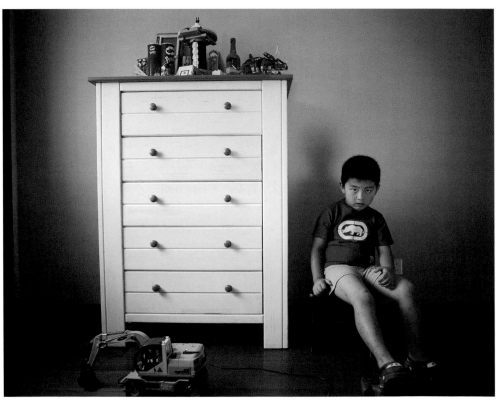

above right:
Zehao Song. From the series *Chinese childhood*, 2009

right:
Ke Bei. From the series *Chinese childhood*, 2009

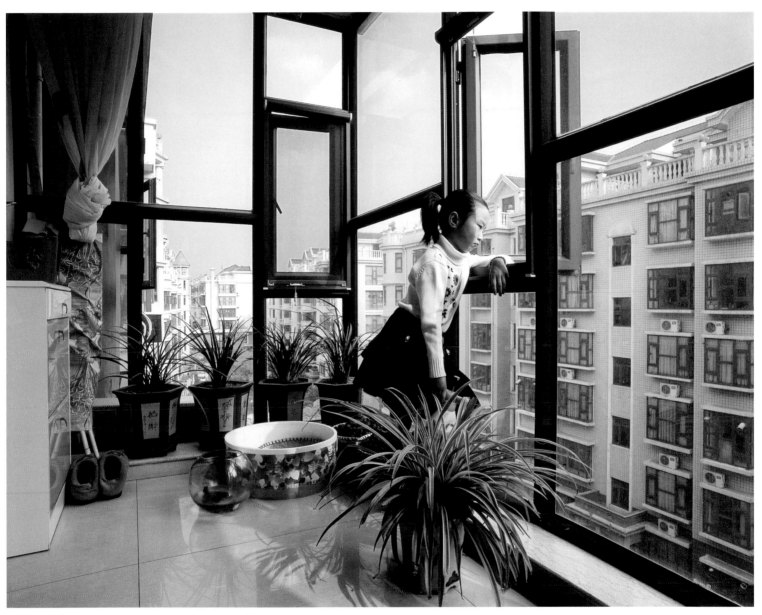

ADY SHIMONY

Israel, b. 1969
The Midrasha School of Art, Beit Berl, Israel,
2005–2008
Bezalel Academy of Art and Design, Jerusalem,
Israel, since 2009

The artificial and the natural love to come together in our society. Textures, surfaces, shapes, colours play hide and seek; they appear, conceal themselves, expose themselves and withdraw. Ady Shimony's work is based on this game of seduction, and on the rejection that is a part of it. In his eyes, the objects are similar to humans. They pose in front of his camera; they try to seduce. Shimony favours high-intensity light (either sunlight or flash) to highlight the brilliance of his subjects, which take on the appearance of models coming to pose in a photographer's studio. This device has the effect of flattening the objects photographed, and gives the image a collage effect. From this, the still life opposite – showing artificial grapes – derives a strange aesthetic quality.

Untitled. From the series *Body, Gestures*, 2009

Alligator. From the series *The Black Works*, 2008

GEOFFREY H. SHORT

New Zealand, b. 1962
Elam School of Fine Arts, University of Auckland,
New Zealand, 2008–2009

Geoffrey H. Short subtitles the enigmatic series shown here 'The sublime, the terror and the allusion' – three concepts he questions in his work. First, there is the undeniable visual beauty of the explosions. Through this, Short encourages contemplation, but also inspires us to express the feelings that are aroused by such images and to think about the various allusions associated with them – principally, violent death. He thereby questions the concepts so often debated in the field of photography – illusion and allusion. Although Short's photographs document events that actually took place – these particular ones required the collaboration of special-effects technicians – they also refer to other explosions: the Big Bang of course, a terrorist bombing, an atomic explosion... The framing chosen by the photographer prevents us from identifying the location. We do not know where these explosions happened. We can only return to our own thoughts and appeal to our cinematic memory.

Untitled Explosion #8CF5. From the series *Towards Another Big Bang Theory*, 2007–2009

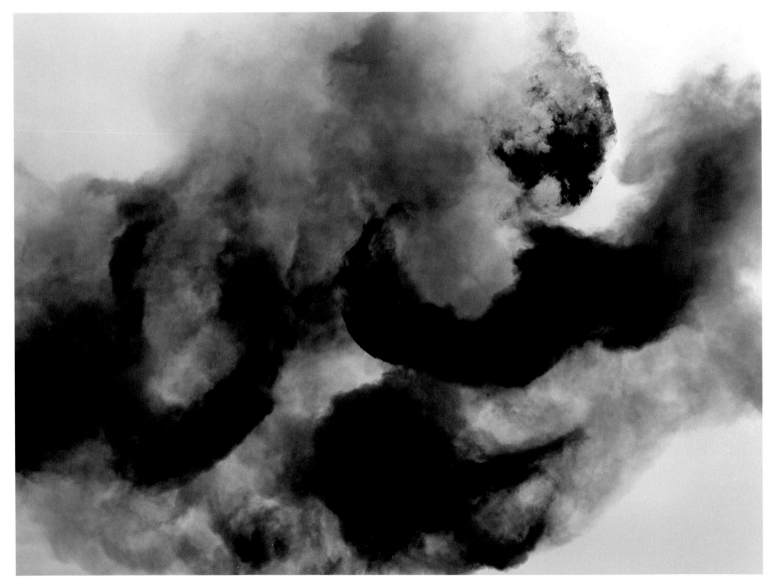

Untitled Explosion #1CF2. From the series *Towards Another Big Bang Theory*, 2007–2009

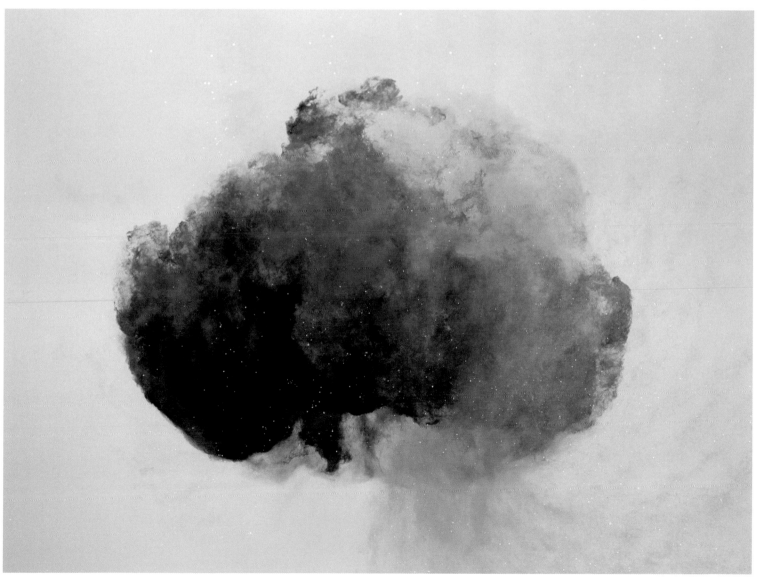

SHIMIN SONG

China, b. 1983
Beijing Film Academy, Beijing, China, since 2007

Childhood is a topic often debated in contemporary
China. Shimin Song belongs to the first generation
of the 'one-child' policy. This experience has no
doubt influenced the series presented here. Children
carrying the dreams and expectations of the family
around them are prepared early for a challenging adult
life. Little room is left to dream, in this world where
success and education outweigh well-being. The
photographer re-enacts her childhood memories to
create and stage her images. She notably recalls that,
during childhood, the boundary between reality and
dream seems blurred. A feeling of sadness and
sorrow emanates from her images. The adults have
deserted the home; the child has been left alone
with its anxieties.

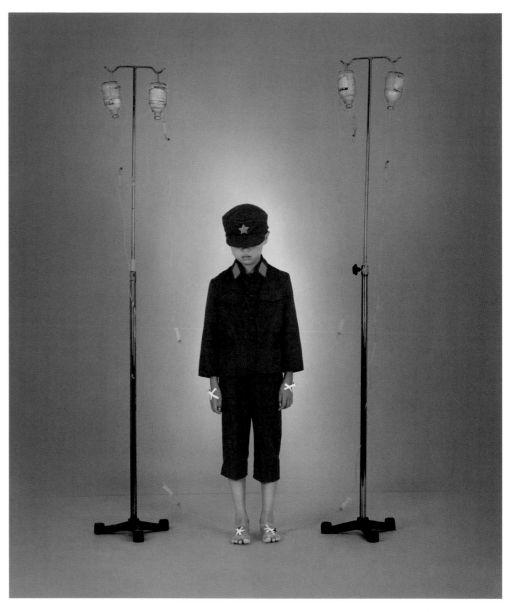

Between reality and fantasy No. 005, 2008

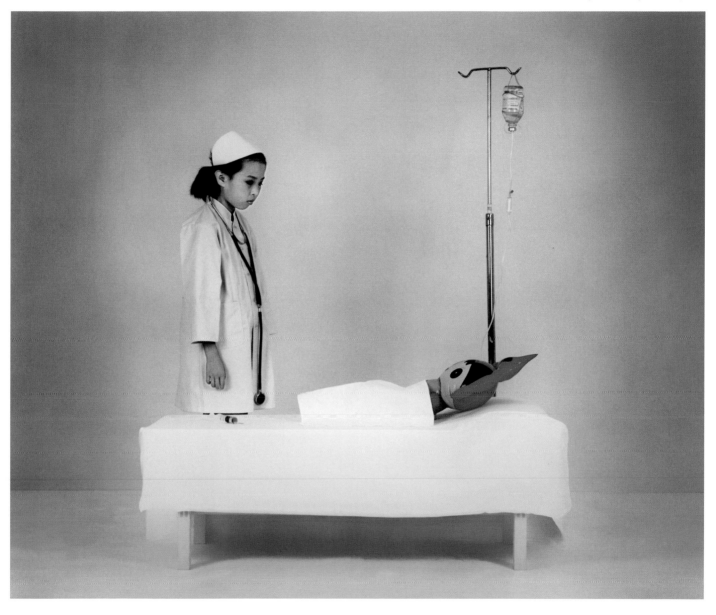

MEGUMU TAKASAKI

Japan, b. 1980
Tokyo College of Photography, Yokohama, Japan,
since 2009
Aoyama Gakuin University, Tokyo, Japan,
1999–2003

Unused for nearly two decades due to the popularity
of digital technology, the negative – the transitional
medium of analogue photography – has regained its
beauty and its trace of mystery in the eyes of some
contemporary photographers. Associated with the
origins of the photographic process, the negative is
gradually being appreciated by the first generation
of photographers to rediscover in it the idea of the
reversed image. It was in the mid-nineteenth century
that photographers began to note the aesthetic
qualities of the reversed image, even praising its
blackness. Periodically throughout the history of
photography the visual power of the negative has
resurfaced. Megumu Takasaki, who works exclusively
with the digital process, has chosen to return to the
reversed image in order to reveal the negation of light.

right:
genesis #3, 2009

opposite left:
genesis #5, 2009

opposite right:
genesis #7, 2009

JAMIE TILLER

England, b. 1979

Royal College of Art, London, England, 2006–2008

Manchester Metropolitan University, Manchester, England, 1998–2002

Precise framing, colour rendition and darkness characterize the work of Jamie Tiller. The image below, photographed in ambient light from the backstage of a theatre, is the result of a meticulous shooting process. The backstage area, which is intended to remain unseen, has, in his view, its own sense of drama, as expressed here in the saturated colours – the result of a long exposure time (Tiller sometimes extends this to ten minutes). He knows that night further increases a supernatural effect. When working in the street, he uses the cold luminosity of street lights, which are there to reassure people, as they are supposed to remove any areas of darkness. Paradoxically, their bright light makes dark areas even darker. Using such devices, the photographer creates works that exude a strong sense of unreality and cause the viewer to question the existence of the places represented. These places become just like film sets.

Outside In #12, 2007

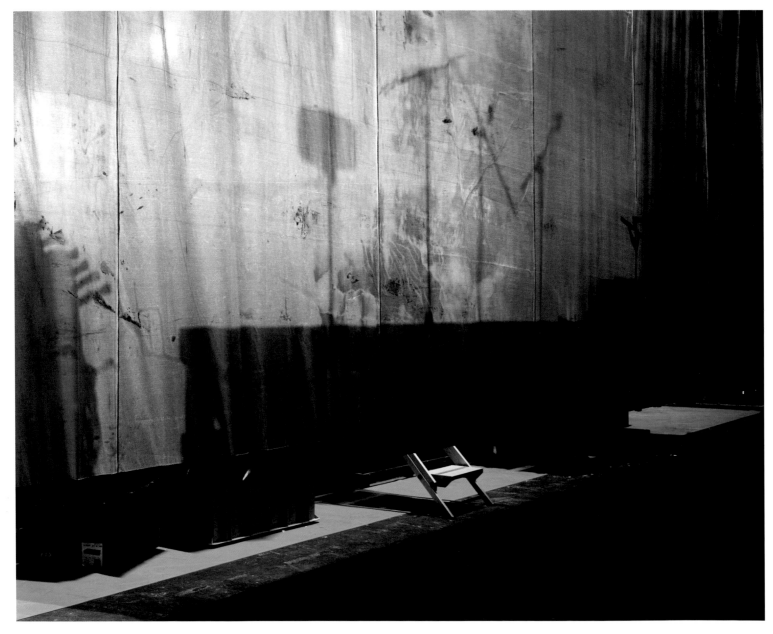

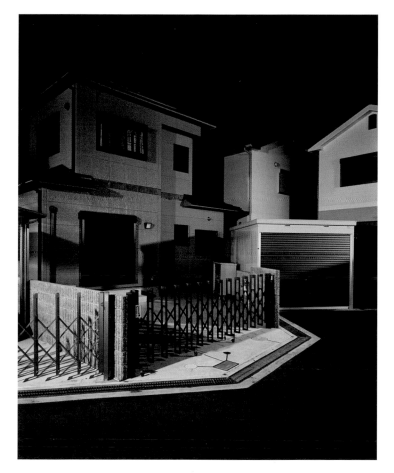

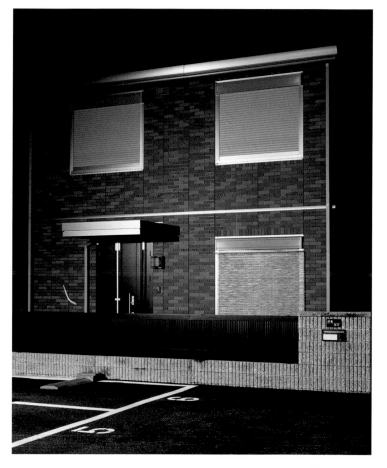

Black Box #28, 2009

Black Box #03, 2007

JANNEKE VAN LEEUWEN

Netherlands, b. 1980
Gerrit Rietveld Academie, Amsterdam, Netherlands,
2005–2009

Janneke van Leeuwen's strange sculptures challenge us. Isolated against an identical white background, they give the impression of being bizarre laboratory experiments. 'Darkroom' – a title the artist says she chose as a tribute to photography – shows a closed box in a way that makes it seem completely sealed, though its locks evidently still allow it to be opened. Mystery remains. Will it be solved? Van Leeuwen provides no answers to the questions raised by this mysterious 'darkroom'. She doesn't give us any more clues to the riddle of the object reproduced opposite either. It is difficult to understand the meaning and the function of this item, held up by cables. In Van Leeuwen's work, scientific and artistic research intersect. Is not the exhibition space – the famous 'white cube' – an artistic laboratory? These two 'inner rooms' make us waver between science and art, between reason and emotion; two worlds in a state of constant interaction.

Darkroom #1, 2008

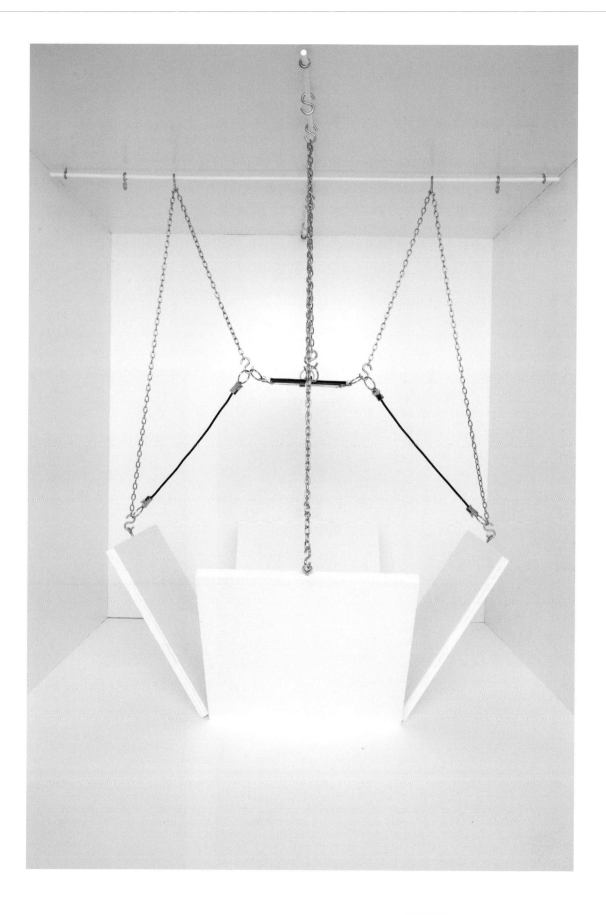

FREDERICK VIDAL

Germany, b. 1977

Kunsthochschule Kassel, Germany, since 2002

Phillips-Universität Marburg, Germany, 2000–2002

This work – like many other works of the new generation – plays on the ambiguous status of photography, a medium that oscillates between documentary and art. Faced with an image that is meant to 'explain' the world, Frederick Vidal offers a visual and reflective response. The underground world that he photographs is part of urban reality, but the framing he adopts propels it into another genre. The viewing experience becomes an artistic experience and prompts fresh thoughts. Through the image, the beauty of the objects seduces us. Their identity is transformed by the act of photography. The image slips into abstraction, and shape and colour predominate. Vidal continues to offer us a testimonial of reality, though its boundary is blurred. It is up to us to choose which direction to follow on this bridge spanning documentary and art.

Morbus. From the series *Suburbia*, 2007

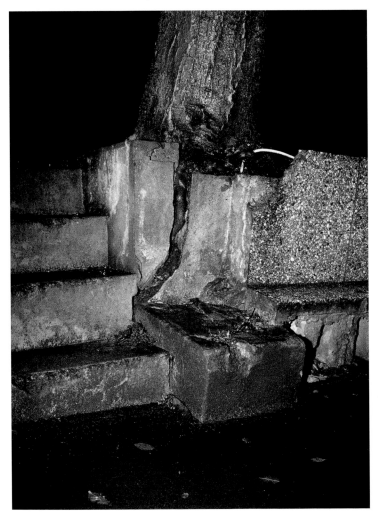

Peristalt. From the series *Suburbia*, 2007

TEREZA VLČKOVÁ

Czech Republic, b. 1983
Institute of Creative Photography, Silesian University
in Opava, Czech Republic, since 2004
Tomas Bata University, Zlín, Czech Republic,
since 2003

Twins fascinate us. The question of resemblance
– inherent in doubles – is a particularly intriguing
subject for a photographer. But the fascination
with twins is also accompanied by an uneasiness
surrounding the subject. The reflection, the alter ego,
the doppelgänger, the nature of individuality … these
are among the many issues raised by a portrait such
as the one opposite, apparently of two young
creatures as disturbing as they are strange – indeed,
verging on monstrous. Tereza Vlčková is undoubtedly
passionate about the ethereal. Her series *A Perfect
Day, Elise...* shows various young girls who seem to
have been bewitched by the spirit of the place in
which they find themselves. We are amazed by the
phenomenon we see. Even though religious painting
has already accustomed us to such scenes, how can
the experience of levitation be photographed? Since
we often think of photography as a testimony or
a memory of reality, Vlčková makes us doubt
what we witness.

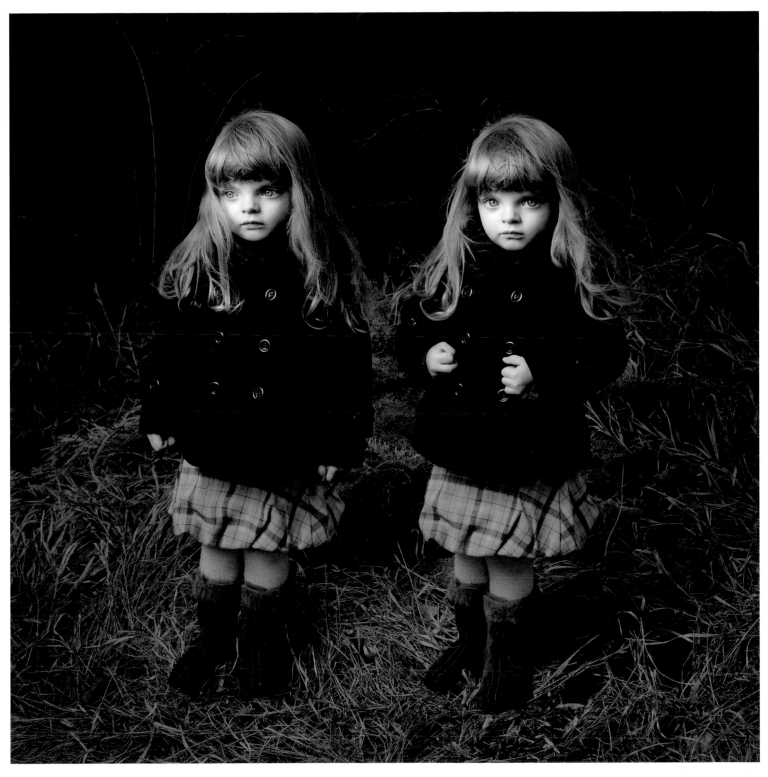

From the series *A Perfect Day, Elise...*, 2007

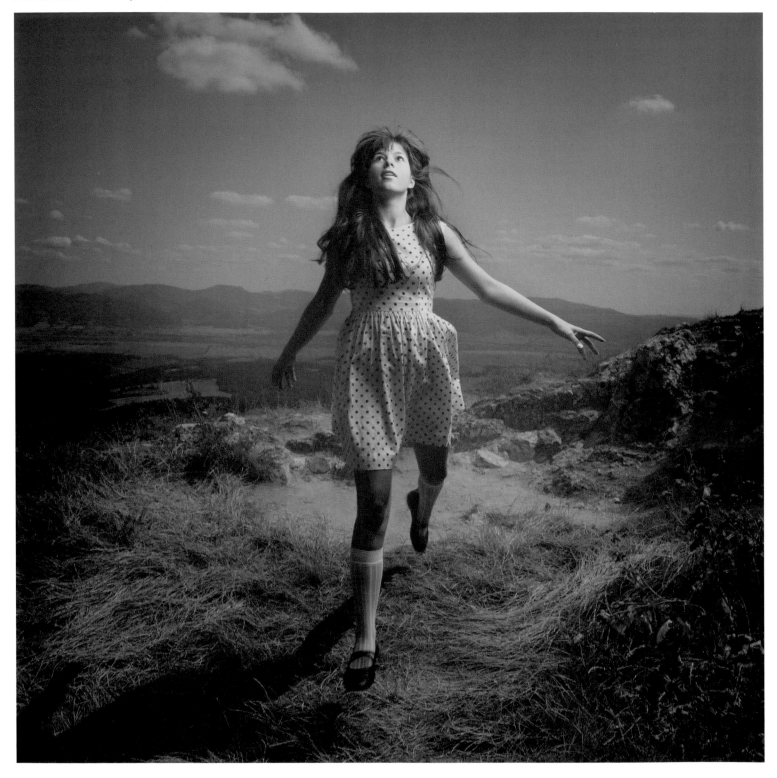

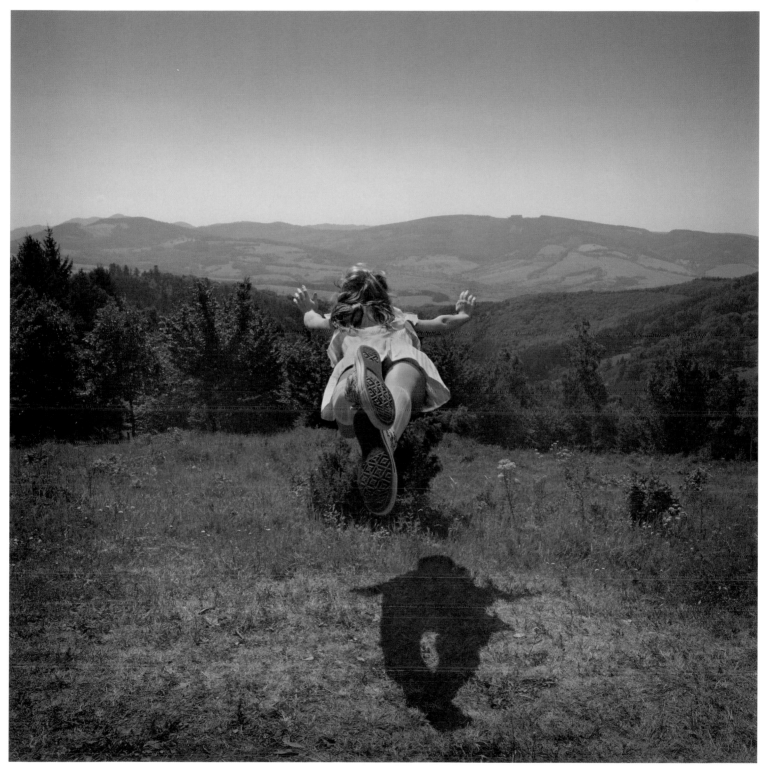

SAANA WANG

Finland, b. 1979
TaiK – University of Art and Design Helsinki, Finland,
since 2007
School of Visual Arts, New York, NY, USA,
since 2009
Gerrit Rietveld Academie, Amsterdam, Netherlands,
2000–2004
Ravensbourne College of Art and Design,
Ravensbourne, Kent, England, 1999–2000
Västra Nylands Folkhögskola Karjaa, Finland,
1998–1999

For many years, Beijing has been implementing a
major reconstruction programme. The transformation
brought about by urban planning has involved the
demolition of many working-class neighbourhoods.
Saana Wang has focused on one of them: Hujialou.
No trace of modernization is visible in her interior
shots, taken in a housing estate dating back to the
Revolutionary era. The old street seems to shrink as
the surrounding tower blocks grow. Wang's work is
in line with the documentary tradition, but she keeps
a distance from convention, as shown in several of
her photographs that contain mysterious-looking
figures. The photographer uses her medium to
create imaginary stories inspired by the reality she
discovered during her stay in Beijing. The painted
masks on her subjects' faces – a tradition of the
Beijing Opera – transform them into fictional
characters. The real world and the mythical
thus attain an interesting ambiguity.

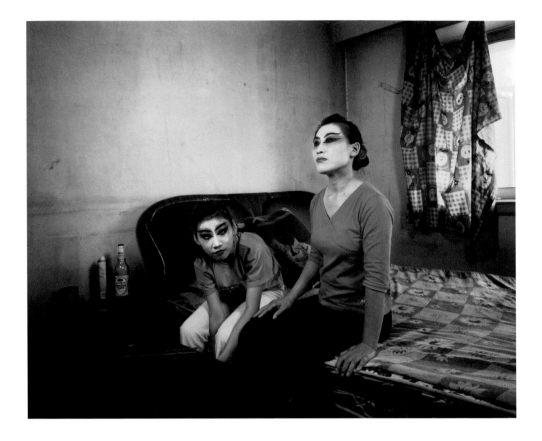

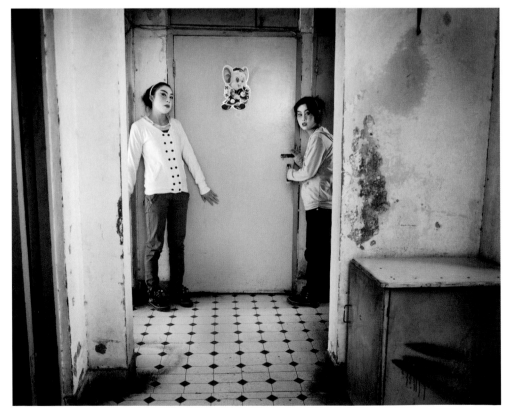

above right:
Hujialou #2. From the series *Forgotten Sceneries*,
2008

right:
Hujialou #50. From the series *Forgotten Sceneries*,
2009

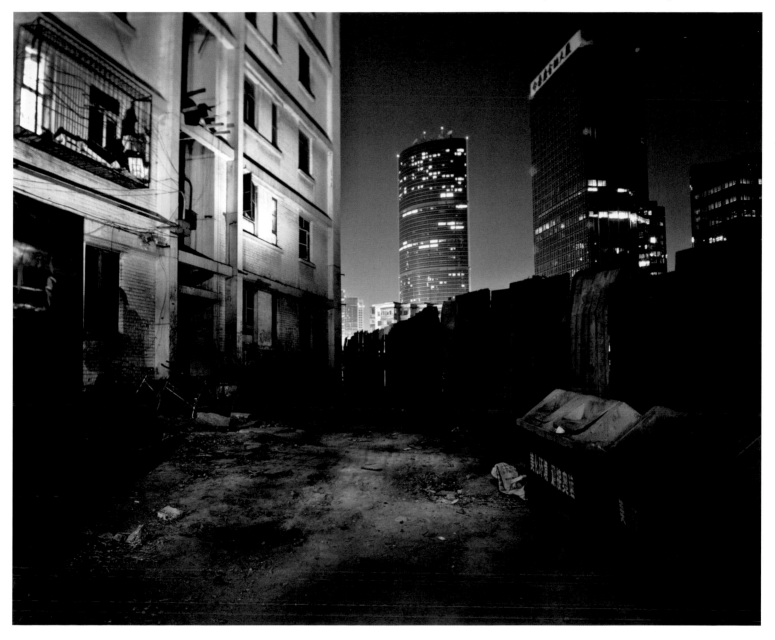

ROBERT WATERMEYER

South Africa, b. 1983
Michaelis School of Fine Art, University of
Cape Town, South Africa, 2005–2008
Massachusetts College of Art and Design,
Boston, MA, USA, since 2009

The theme of one project often gives rise to new
ideas. Photographers therefore engage in work
on subjects fed by previous projects. Robert
Watermeyer's *Ports of Entry* series illustrates this
approach. The photographer became interested in
border towns while working on a documentary on
the migrants who flock to his country, South Africa.
He decided to visit border posts in order to observe
their surroundings and buildings, and the way in
which they often become features in the wider
landscape. Beit Bridge is one of many border towns
that he visited. It is famous for its bridge, which
spans the Limpopo River connecting South Africa
and Zimbabwe. Over two million people pass through
this spot every year. The photograph opposite shows
that Watermeyer has managed to vary his approach.
He has switched from social documentary, which
focuses on people, to landscape, a genre with a
contemplative dimension.

Farm Entrance, Beit Bridge Port of Entry, Limpopo.
From the series *Ports of Entry*, 2008

ADRIAN WOOD

England, b. 1972
London College of Communication, London,
England, 2007–2008

Bob. From the series *Act II, Scene VII*, 2008

Photographers like to add some uncertainty to their work. This is doubtless the case with Adrian Wood, whose portraits could be the result of staging or of documentary shooting. Reality and fiction mix. The use of dramatic lighting, such as one might find on a film set, encourages the viewer to imagine the narrative of these scenes of domestic life. The high-angle viewpoint gives us the impression of emerging, like someone invisible, into a world that at first seems calm and reassuring. However, it soon becomes apparent that something is about to happen. The photographer gives us a visual experience, wherein time appears to be suspended, and he invites viewers to create their own story. The stage is set; the characters have begun to play.

Elijah. From the series *Transitions*, 2007

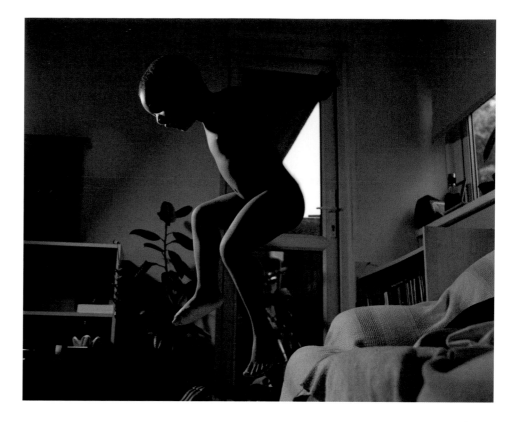

Ben. From the series *Act II, Scene VII*, 2008

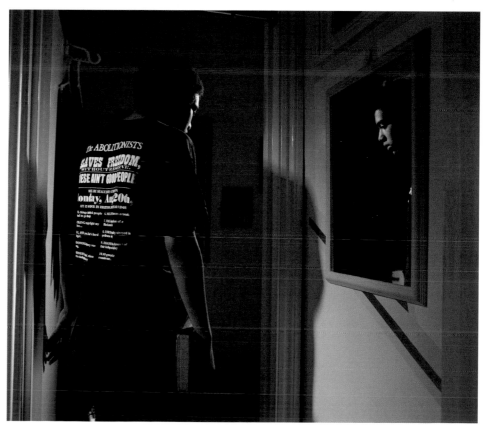

LIU XIAOFANG

China, b. 1980
CAFA – China Central Academy of Fine Arts,
Beijing, China, since 2009
Shanxi University, Taiyuan, China, 2000–2003

The lyrically staged photographs of Liu Xiaofang show
contemporary China and its explosive dynamism from
an unusual perspective: a little girl in a white dress
and red scarf is experiencing extraordinary events.
Urban China is absent; the scenes take place in a
landscape in which sea and sky merge in pure blue;
the miracles that occur are varied. Each image offers
us a new scene – apparitions in the sky, the launch
of a rocket, an act of levitation. The figure of the girl,
who seems contemplative and distant, observes the
interplay between earth and sky. Liu's photography,
with its precise format and colours, evokes traditional
Chinese painting, particularly renowned for its misty
landscapes. Somewhere between past and present
(the photographer has noted that she recognizes
many childhood memories in her work), somewhere
between painting and photography, this series evokes
a fairytale world in which illusion merges with reality.

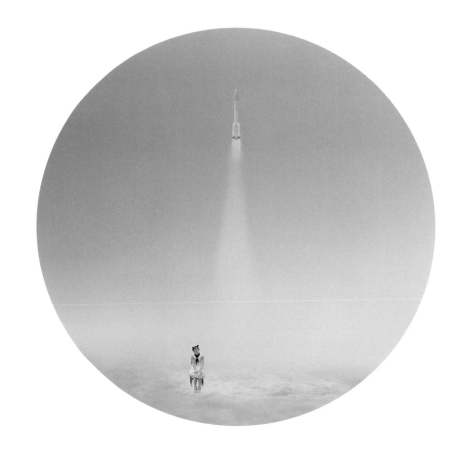

above right:

Set off a rocket. From the series *I remember*, 2008

opposite:

An atomic bomb. From the series *I remember*, 2008

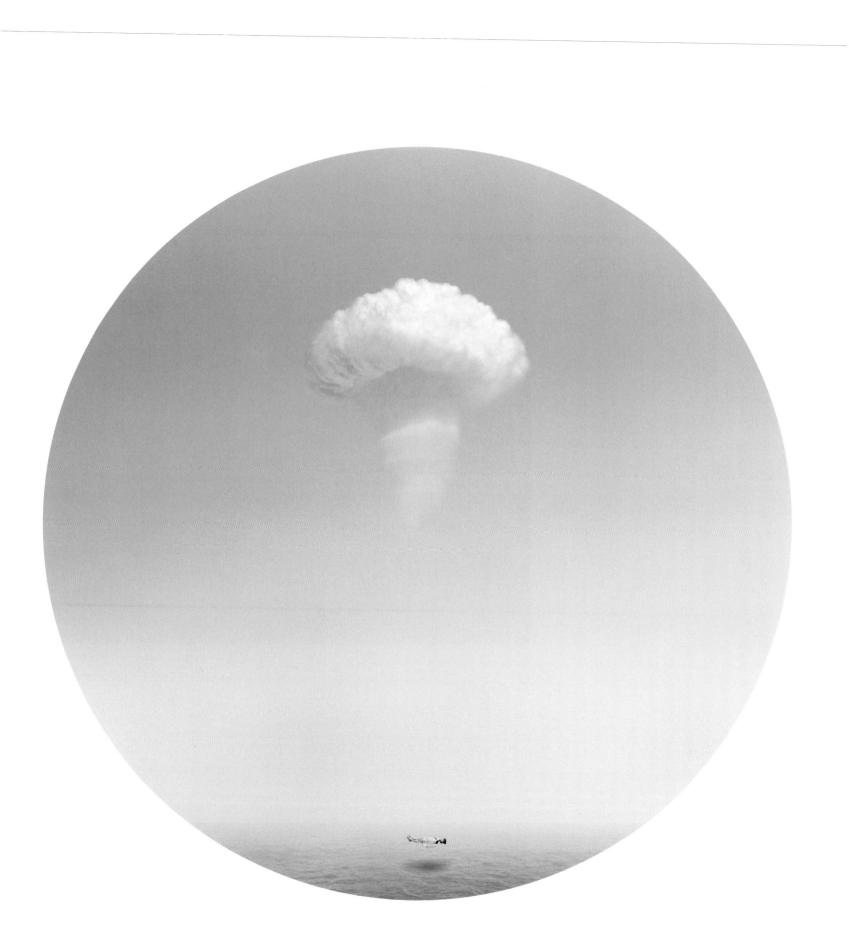

TAMARA ZIBNERS

USA, b. 1982
University of New Mexico, Albuquerque, NM,
USA, since 2008
University of California, Santa Cruz, CA, USA,
2000–2004

The collage works of Tamara Zibners recall the story of her grandparents, who fled Latvia in 1944 to take refuge in Germany before heading to the United States. Basing her work on an historical novel and diaries written by her grandparents, describing their exile, Zibners investigates her family history. A trip to Latvia notably allowed her to build the narrative of this quest for identity. *Mimi's Diary* presents a complex photographic device based on various sources of imagery and text. Past and present are united by the juxtaposition of archival documents found on site and images taken in Latvia by the artist. Where Marjane Satrapi and Art Spiegelman have chosen drawing to share their family histories, Zibners has managed to merge history and fiction through photography.

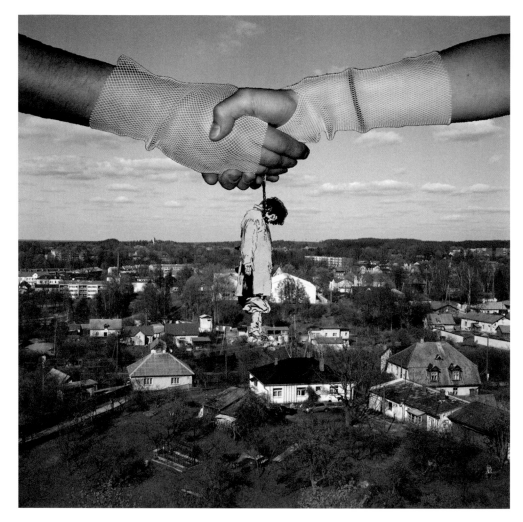

The Molotov, Ribbentrop Pact. From the series *Mimi's Diary*, 2008

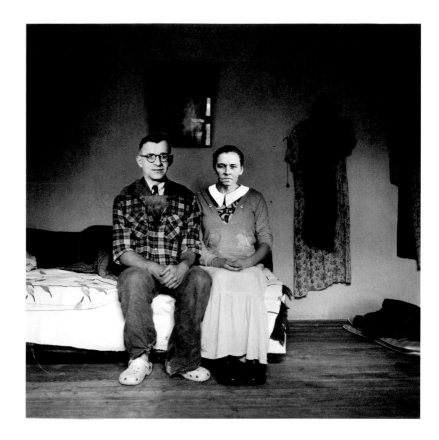

The Couple. From the series *Mimi's Diary*, 2008

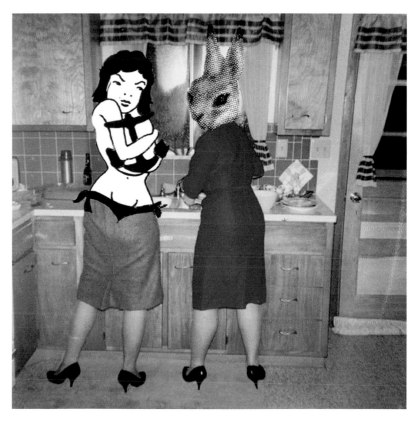

The Grabbing and Gorging Continues.
From the series *Mimi's Diary*, 2008

BARBORA AND RADIM ŽŮREK

Czech Republic, b. 1987 and 1971
Institute of Creative Photography, Silesian University
in Opava, Czech Republic, since 2006
Prague School of Photography, Prague, Czech
Republic, 2004–2006/2003–2005

The personal portrait – a major genre in photography
and in painting since the Renaissance – is based on
the concept of resemblance. Subjects expect a
realistic portrayal of their features, though some also
secretly hope to look like their idols. Barbora and
Radim Žůrek play with the idea of likeness and the
interchangeability of features. Their portraits of
children, amid landscapes that blend with the colour
of their clothing, bring to the surface other faces,
those of celebrities. Without giving us all the answers,
the artists seek out our visual memory. On reading
the captions, there is confusion and questions arise.
Can one live with the face of another? Does everyone
have a double? Are our faces really unique? Is it only
our imagination that reveals disturbing resemblances?

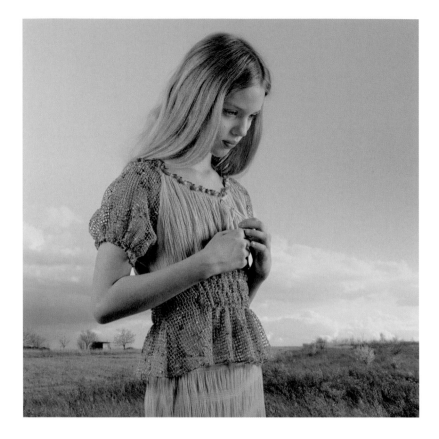

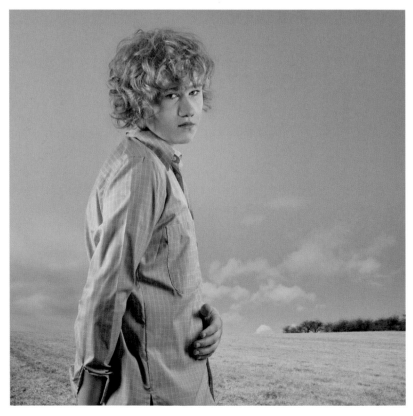

above right:
Scarlett Johansson. From the series *The Replacement*,
2009

right:
W. A. Mozart. From the series *The Replacement*, 2009

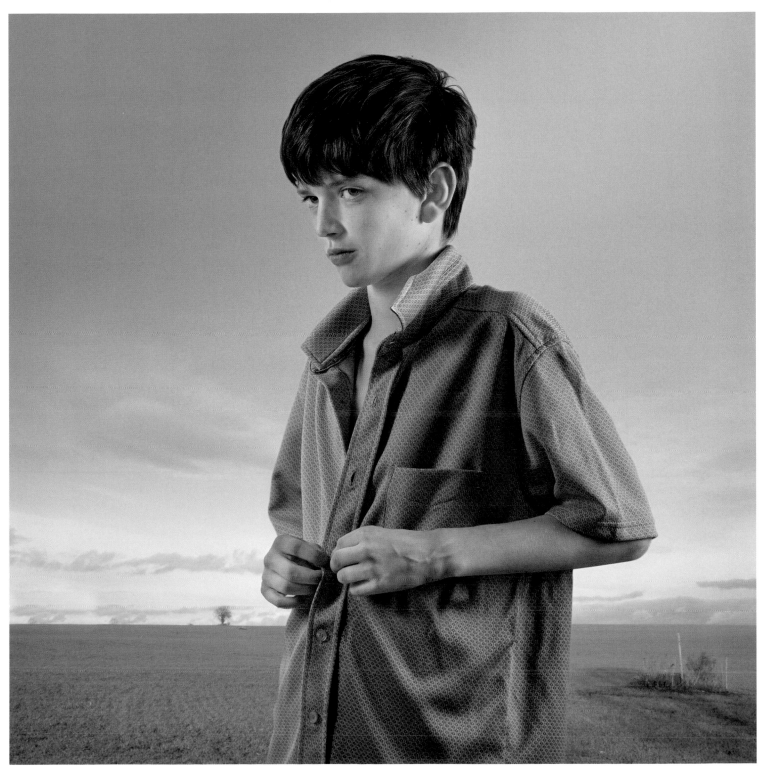

The following candidates – listed here with location of school – were invited to participate in *reGeneration*[2]:

Giacomo Abbruzzese, France
Ismaël Abdallah, Switzerland
M. Gabriela Abdo D., Ecuador
Serena W. Abi Chebel, Lebanon
Ben Absalom, UK
Alegria Acosta Varea, Ecuador
Amanda Acuri, Canada
Hélène Agniel, France
Anton Akimov, Russia
Jorge Ernesto Alcazar Gallardo, Chile
Ueli Alder, Switzerland
Jesse Alexander, UK
Ben Alper, USA
Andreia Alves de Oliveira, UK
Tonatiuh Ambrosetti, Switzerland
Zhenja Amdrushenko, Russia
Edith Amituanai, New Zealand
Mary Amor, USA
Chris Amos, USA
Yann Amstutz, Switzerland
Peter Ančic, Slovakia
Michael Anhalt, Netherlands
Dana Ariel, Israel
Tigran Asatrjan, UK
Ani Asvazadurian, Austria
Fleur Aude, Australia
Sasha Auerbakh, Russia
Martina Avilès Endara, Ecuador
Ohana Avshalom, Israel
George Awde, USA
Kristoffer Axén, USA
Anatoliy Babiychuk, Austria
Ladislav Babuščák, Czech Republic
Ori Bahat, Israel
Tania Baker, Australia
Julie Balagué, France
Seza Bali, USA
Vivien Balla, Hungary
Zsuszanna Barabas, Romania
Aajwanthi Baradwaj, India
Julieta Barone, Argentina
Tascha Barrie, Canada
Catalina Bartolome, Argentina
Berit Basten, Denmark
Ward Bastian, Canada
Mridul Batra, India

Lilo Bauer, Germany
Dorothée Baumann, Switzerland
Nico Baumgarten, Spain
Anna Beeke, USA
He Bei, China
Benjamin Beker, UK
Pamela Belknap, USA
Fabrizo Bellomo, Italy
Marta Belmonte Castellanos, Spain
Craig Bender, Australia
Erik Benjamins, USA
Federico Berardi, Switzerland
Peter Berko, Slovakia
Ranil Beyer, Germany
Rebecca Beynon, UK
Shine Bhola, India
Joshua Bilton, UK
Bin Zheng, China
Dafydd Bland, UK
Lorne Shawn Blythe, USA
Robert Bodnar, Austria
Rachel Boillot, USA
Bogdan Andrei Bordeianu, Romania
Jeffery Bordenkecher, USA
Caryline Boreham, New Zealand
Elin Borisdottir, Iceland
Kat Borishkewich, Australia
Petra Bošanská, Slovakia
Simon Bosch, Netherlands
Roger Boulay, USA
Salomé Bouloudnine, France
Ondrej Bouška, Czech Republic
Jacqueline Bovaird, USA
Arantxa Boyero, Spain
Savaş Boyraz, Turkey
Francesca Bozzo, Switzerland
Hadar Bracha, Israel
Yael Brandt, Israel
Daniel Bray, Canada
Karolina Bregula, Poland
Michele Bressan, Romania
Tom Bridge, UK
Gemma Bringloe, UK
Stephanie Broad, USA
Anne-Claire Broc'h, France
Gina Brocker, UK
Michiel Brouwer, Netherlands
Thibault Brunet, France
Maxime Brygo, Belgium
Lukasz Brzeskiewicz, Poland

Ola Buczkowska, Poland
Marion Burnier, Switzerland
Quentin Caffier, France
Kitra Cahana, Italy
Gerardo Calia, UK
Christine Callahan, USA
Emily D. Cameron, USA
Dan Campean, Romania
Charlotte Canner, USA
Luciana Caputo, Netherlands
Santi Caralt, Spain
Lourdes Carcedo de Sebastian, Spain
Kristy Lynn Carpenter, USA
Antonia Carrara, France
Mary Ann Caspillo, Canada
Steven Cavanagh, Australia
Anastasia Cazabon, USA
Petra Cepková, Slovakia
Maria Chamié, Lebanon
Pierre Chancel, France
Scott Chandler, Canada
Aida Chehrehgosha, Sweden
Chekuai, China
Yan ChenZhao, China
B. M. Chetana, India
Ben Chetta, USA
Zarina Chiforec, Romania
Christine Chin, USA
Yiannis Chiotopoylos, Greece
Line Chollet, Switzerland
Peter Cibák, Slovakia
Ewa Ciechanowska, Poland
Thomas Clarke, UK
Oliver Clément, France
Serena Clessi, Italy
Tehila Cohen, Israel
Michael Collins, USA
Danilo Correale, Italy
Bruno Costantini, France
Manuel Costantini, Italy
Sylvain Couzinet-Jacques, France
Roxana Cozaru, Romania
David Crespo Varela, Spain
Karen Crisp, New Zealand
Julia Curtin, UK
Kassim Dabaji, Lebanon
Steve Daly, USA
Ana Catalina Darder Piza, Spain
Sayantani Dasgupta, India
Bobby Davidson, USA

Philip Grant Davidson, USA
Dylan Davies, Canada
Jen Davis, USA
Rupert de Beer, South Africa
David De Beyter, France
Victor de Castro, Switzerland
Carlos A. de Castro Hernández, Spain
Pietro de Tilla, Italy
Theo de Waal, Netherlands
Magdalena Deffner, Israel
Nicolo Degiorgis, Italy
Alessio Del Lama, Italy
Léo Delafontaine, France
Nicolas Delaroche, Switzerland
Marion Denis, Germany
Sally Dennison, USA
Carolina Alejandra Denzer Zuazagoitia, Chile
Nastya Dergachyova, Russia
Diddharth Stephen Dharamjit, India
Lara Dhondt, Belgium
Federica Di Giovanni, Italy
Trakossas Dimitrios, Greece
Seyrane Diplomat, France
Victoria Ines Dobano, Argentina
Carmen Dobre, Romania
Sylvia Doebelt, Germany
Megan Dolan, USA
Jun Dong, China
Li Donghan, China
Dru Donovan, USA
Bryan Dooley, UK
Mercedes Dorame, USA
Yvette Marie Dostatni, USA
Edward D. Doty, USA
Daniela Droz, Switzerland
Caitlin Duennebier, USA
Suruchi Dumpawar, India
Lucile Dupraz, UK
Pascale Duval, UK
Eliza Jane Dyball, Australia
Tanya Dyhin, Australia
Masaru Eguchi, Japan
Benjamin Eichhorn, Austria
Gabriel Eisenmeier, Netherlands
Lina el Yafi, Sweden
Heidy Elainne, Spain
Salvatore Michele Elefante, Spain
Aliza Sarah Eliazarov, USA
Katarina Elven, Canada

Talia Elyon, Canada
Sári Ember, Hungary
Kate Emerson, USA
Teresa Eng, UK
Lina Esko, Finland
Rita Lino Eusebio Feliciano, Spain
James Evans, Australia
Peter Evans, New Zealand
Anna Fabríciusz, Hungary
Daniel Faibisoff, USA
Ge Fang, China
Giuseppe Fanizza, Italy
Niccòlo Fano, UK
Cathleen Faubert, USA
Camille Favaloro, Australia
David Favrod, Switzerland
Sandra Fayad, Lebanon
Noa Fellous, Israel
Alexander Ferrando, Austria
Antoine Feuer, France
Juraj Fifik, Slovakia
Camilla Figenschou, Sweden
Irene Finkelde, Australia
Stefanie Fiore, Canada
Mhairi-Clare Fitzpatrick, New Zealand
Erin Fitzsimmons, Canada
Martha Fleming-Ives, USA
Libor Fojtik, Czech Republic
Star Rae Foreman, USA
Ana Frechilla, Spain
Daniela Friebel, Germany
Robin Friend, UK
Sabrina Friio, Switzerland
Emilie Fux, Switzerland
Matthieu Gafsou, Switzerland
Liu Gang, China
Elon Ganor, Israel
Petter Garaas, UK
Viky Garcia Muela, Spain
Nuria Gas Ruiz, Spain
Tal Gertin, Israel
Sarah Getto, USA
Lawrence Getubig, USA
Chafa Ghaddar, Lebanon
Irina Gheorghe, Romania
Katherine Gibbons, USA
Marius Bogdan Girbovan, Romania
Melanie Glass, USA
Katja Gläss, Germany
Anne Golaz, Switzerland

Florian Goldman, Greece
Hannah Goldstein, Sweden
Eugene Gologursky, USA
Lena Gomon, Israel
Paul Gorra, Lebanon
Kristy Gosling, UK
Virginie Gouband, Belgium
Nick Graham, UK
Núria Gras, Spain
Samuel Gratacap, France
Rachel Graves, UK
Joanna Francesca Greco, UK
Bess Greenberg, USA
Nadya Grishina, Russia
Justyna Gryglewicz, Poland
Aneta Grzeszykowska, Canada
Audrey Guiraud, France
Dóra Gunics, Hungary
Rikki Gunton, USA
Devshish Guruji, India
Anna Gutova, Czech Republic
Nina Haab, Switzerland
Géraldine Haas, Switzerland
Nicolas Haeni, Switzerland
Aude Haenni, Switzerland
Nicole Hametner, Switzerland
Claudia Hanimann, Switzerland
Ulrike Hannemann, Germany
Eeva Hänninen, Finland
Tam Hare, UK
Bharath Haridas, India
Emily Harris, UK
Brendon Hartley, Canada
Itzik Haruhs, Israel
Thomas Hauser, France
Thomas Haywood, UK
Johanna Heldebro, USA
Simon Hempel, Netherlands
Tom Hemsley, UK
Ryan Hendon, USA
Laura Hennsser, UK
Pao Houa Her, USA
Megan Matt Liebel Hershman, USA
Judit Hettema, Belgium
Elizabeth Hingley, Italy
Thuy-An Hoang, Switzerland
Stefan Hobmaier, Spain
David Holden Smith, USA
Wouter Ivo Hooghiemstra, Netherlands
Robyn Hoonhout, New Zealand

Monica Hopland Mathal, Netherlands
Anna Horcinova, Slovakia
Árpád Horváth, Hungary
Deniz Hotamisligil, USA
Nadine Hottenrott, Netherlands
Christopher Houltberg, USA
Bente Elise How Lode, Norway
Marisa Howenstine, USA
Sophie Huguenot, Switzerland
Peter Hunner, USA
Michael J. Hunter, UK
Veronica Ibanez, USA
Yuko Ichikawa, Austria
Dorthe Ingvardsen, Netherlands
Kerry Ironside, UK
Emily Isles, Italy
Johanne Issa, Lebanon
Marie-Therese Jaboubek, Austria
Jenn Jackson, Canada
Krista Jahnke, Canada
Maria Oostra Janna Gepke, Netherlands
Wypke Jannette Walon, Netherlands
Olivia Franziska Jaques, Austria
Sofia Jaramillo Carrasco, Argentina
Lina Jaros, Sweden
Benjamin Jarosch, USA
Asa Johannesson, UK
Anders K. Johansson, Sweden
Sarah Anne Johnson, Canada
Sean M. Johnson, USA
Victoria Johnson, UK
Florian Joye, Switzerland
Katja Jug, Switzerland
Andrea Junekova, Slovakia
Carole Jung, USA
Tanja Jürgensen, Germany
Dragana Jurisic, UK
Adamantios Kafetzis, Greece
Karoliina Kagovere, Greece
Sonja Kälberer, Germany
Yoshi Kametani, UK
Misa Kanagawa, Japan
Maria Kapajeva, UK
Mark Kasumovic, Canada
Kalle Kataila, Finland
Daniel Kaufmann, USA
Michal Kawecki, Poland
Ján Kekeli, Slovakia
Courtney Kelsey, Canada
Jessica Keogh, Australia

Nour Bou Khalil, Lebanon
Nazish Khan, UK
Chang Kyun Kim, USA
Miikka Kiminki, Finland
Ani Kington, USA
Shiho Kito, UK
Symon Kliman, Czech Republic
Jáchym Kliment, Czech Republic
Markus Klingenhäger, Germany
Franziska Klose, Germany
William Knipscher, USA
Regina Kokoszka, USA
Richard Kolker, UK
Ville Koski, Finland
Ernst Koslitsch, Austria
Georgina Koureas, Australia
Catharina Kousbroek, Netherlands
Katalin Kovács, Hungary
Sylwia Kowalczyk, UK
Nina Kreuzinger, Austria
Mara Kristula-Green, USA
Karsten Kronas, Germany
Ania Krupiakov, Israel
Viktoria Kühn, Austria
Thomas Kuijpers, Netherlands
K. Pradeep Kumar, India
Andrea Kunkl, Italy
Ivar Kvaal, UK
Christos Kyvernites, Greece
Collin LaFleche, USA
Marikel Lahana, France
Virág Lajti, Hungary
Alexa Lambrose, USA
Elisa Larvego, Switzerland
Lise Latreille, Canada
Maija Laurinen, Slovakia
Shane Lavalette, USA
Matthieu Lavanchy, Switzerland
Bryan Lear, USA
Marianne Lecareux, France
Florian Leduc, France
Minu Lee, Germany
SungHee Lee, France
Pim Leenen, Netherlands
Sol Legault, Canada
Whitney Legge, USA
Ulrike Lehnisch, Germany
Barbour Lemuel, USA
Caitlin Lennon, USA
Ana Leoca, Romania

Jacinthe Lessard-L., Canada
Bella Lett, New Zealand
Joseph Lewandowski, USA
Deirdre Lewis, UK
Jenny Lewis, UK
Li Aixia, China
Benjamin Lichtenstein, Australia
Claire Liengme, Switzerland
LiHao, China
Krystal Lin, USA
Gabrielle Linzer, USA
Anat Litan, Israel
Ella Littwitz, Israel
Di Liu, China
Lijie Liu, China
Jing LiYa, China
Lucia Loiso, USA
Lize Louw, South Africa
Michael Love, Canada
James Kevin Lowe, New Zealand
Jonas Lund, Netherlands
Gabriele Lungarella, Italy
Sam Luntley, UK
Gabrielle Lurie, USA
Chrissy Lush, USA
Sophie T. Lvoff, USA
Anaïck Lynch, France
Charli Machado, Chile
Jenna Mack, USA
Hugo Madeira, UK
Agata Madejska, UK
Martin Maeder, Switzerland
Jan Mahr, Czech Republic
Evariste Maïga, Switzerland
Liisa Mäkinen, Finland
Sabrina Maltese, Canada
Jan Mammey, Germany
Sarah Mangialardo, Canada
Yan Yan Mao, USA
Aron Itai Margula, Austria
Anastasia Markelova, Russia
Krystel Marois, Canada
Frank Marschall, South Africa
Bryan Alfred Martello, USA
Julia Martin, Canada
Mar Martin, Spain
Piero Martinello, Italy
Sam Mason, UK
Ryan Mathieson, Canada
Masha Matijevic, Netherlands

Per Mattisson, UK
Alexandre Maubert, France
Casey McGonagle, USA
Michael Meier, Switzerland
Aurélie Menaldo, France
America Mendez Bermudez-Canete,
 Germany
Lindsay Metivier, USA
Kimmo Metsäranta, Finland
Ashley Meyers, USA
Florent Michel, France
Olga Migliaressi-Phoca, USA
Krzysztof Mille, Poland
Géraldine Millo, France
Christin Paige Minnotte, USA
Sabine Mirlesse, USA
Freja Mitchell, USA
Lui Mokrzycki, Denmark
David Molander, Sweden
Ágnes Éva Molnár, Hungary
Adriano Monteiro Batista, Spain
Carlos Alvarez Montero, USA
Paolo Monti, Italy
Molly Moreau, Canada
Yedda Morrison, Canada
Richard Mosse, USA
Joseph Mougel, USA
Tarek Moukaddem, Lebanon
Paula Muhr, Germany
Julian Mullan, Austria
Terence Munday, Australia
Marcus Munnelly, UK
Jackie Munro, USA
Eric Mutuel, France
Alice Myers, UK
Dominic Nahr, Canada
Yusuke Nakayama, Japan
Tryntsje Nauta, Netherlands
Jessica Ashley Nelson, USA
Rachael Nelson, USA
Boris Németh, Slovakia
Milo Newman, UK
Yusuke Nishimura, USA
NN, Austria
Maya Nohra, Lebanon
Mads Norgaard, South Africa
Luke Norton, UK
Vassilis Noulas, Greece
Felix Victor Nybergh, Spain
Zaida Oenema, Netherlands

Mayuko Ogawa, Japan
Jhinryung Oh, USA
Candice Okada, Canada
Zoé Olsommer, Switzerland
Midori Omachi, Japan
Mai Omer, Israel
Arif Emrah Orak, Turkey
Ya'ara Oren, Israel
Anna Orlowska, Poland
Anna Patrycja Orlowska, Poland
Pavla Ortová, Czech Republic
Jennifer Osborne, Italy
Margo Ovcharenko, Russia
Baran Ozdemir, Turkey
Daan Paans, Netherlands
Nelli Palomäki, Finland
Michala Paludan, Denmark
Georgeana Parsons, UK
Erin Leigh Pasternak, Canada
Vishnu Pasupathy, India
Jackson Patterson, USA
Rosa Paul, Austria
Meghan Paxton Sellars, USA
Rony Pearl, Israel
Bianca Pedrina, Switzerland
Solène Person, France
Bradley Peters, USA
Regine Petersen, UK
Anna Phillips, France
Keelin Pincus, South Africa
Jonathan Pinkhard, South Africa
Viola Pinzi, Italy
Joanna Piotrowska, Poland
Maria Platero, Spain
Izabela Pluta, Australia
Maria Pop, Romania
Alina Popa, Romania
Amelia Popovic, USA
Lea Porsager, Denmark
Elena Potter, Canada
Justin Poulsen, Canada
Martin Scott Powell, UK
Tim Power, Canada
Agnes Prammer, Austria
Marta Primavera, Italy
Simon Pruciak, UK
Pokrycki Przemyslaw, Poland
Edmund Pula, USA
Mahima Pushkarna, India
Enrica Quaranta, Italy

Ariane Questiaux, South Africa
Macarena Quezada, Chile
Amanda Quintenz, USA
Laura Raduta, Romania
S. R. Rahul, India
Aashim Raj, India
Maniyarasan Rajendran, India
Nachiappan Ramanathan, India
Tamara Rametsteiner, Austria
Augustin Rebetez, Switzerland
Andrea Star Reese, USA
Mada Refujio, USA
Francisco Reina, Spain
Elena Rendina, Switzerland
Adriana Rimpel, USA
Sarah Ritter, France
Alex Robaina Gil, Argentina
Nicole Robson, Australia
Maya Rochat, Switzerland
Camila Rodrigo Graña, Italy
Yago Rodriguez van der Wel, Spain
Catherine Roe, UK
Alvaro Rojas Sastre, Spain
David Johnathan Romero, Canada
Simone Rosenbauer, Australia
Jen Rosenstein, USA
Allyson Ross, USA
Maria Elena Ross Cadena, Ecuador
Bastien Roustan, France
Paul Rousteau, Switzerland
Marie Roux, UK
Sasha Rudensky, USA
Romy Rüegger, Switzerland
Dolores Ruiz Diaz, Spain
Catherine Rüttimann, Switzerland
Aidas Rygelis, Canada
Clare Samuel, Canada
Melinda Sanders, USA
Helma Sawatzky, Canada
Rico Scagliola, Switzerland
Céline Scaringi, France
Sophie Scher, France
Christophe Schiele, Austria
Robert Schlotter, Germany
Luuk Schöder, Netherlands
Anine Scholtz, South Africa
Vera Schöpe, France
Anja Schori, Switzerland
Michal Florence Schorro, Switzerland
Anne Kathrin Schuhmann, Germany

Karyna Schultz, Canada
Daniel Schumann, Germany
Phyllis Schwartz, Canada
Anika Schwarzlose, Netherlands
Sylvia Schwenk, Australia
Eduardo Seerafim, Switzerland
Alberto Segramora, Italy
Silvia Senčeková, Czech Republic
Simon Senn, Switzerland
Indre Serpytyte, UK
Helen Shabalina, Russia
Alfiah Shaul, Israel
Su Sheng, China
Maki Shibata, Japan
Ady Shimony, Israel
Yobe Shonga, South Africa
Geoffrey H. Short, New Zealand
Arumina Singh, India
Meera Margaret Singh, Canada
Jan Sipocz, Slovakia
Jan Smaga, Canada
Lenard Smith, USA
Reeves Smith, USA
Marie Snauwaert, Belgium
Kazu Soejima, Japan
Shimin Song, China
Floriane Spinetta, France
Monika Stacho, Slovakia
Alexander Kasimir Stanzel, Austria
Marcel Stecker, Czech Republic
Andrzej Steinbach, Germany
Carly Steinbrunn, France
Neal Stennet, USA
Emily Stepien, UK
Krista Belle Stewart, Canada
Elaine Stocki, USA
Sarah Stolfa, USA
Craig Stolke, USA
Lucia Stranaiova, Slovakia
Sarah Strassmann, Germany
Laura Stroie, Romania
Samantha Stroman, Canada
Julie Stybnarova, Czech Republic
Tamara Sudimac, Austria
Jinjin Sun, France
Collin Sundt, USA
Milena Surducan, Romania
Gergely Szatmári, Hungary
Monika Sziladi, USA
Éva Szombat, Hungary

Jonathan Taggart, Canada
Megumu Takasaki, Japan
Shuhei Takeshita, Japan
Isabel Tallos, Spain
Eyal Tamir, Israel
Miek Claudia Anne Marie Teelen,
 Netherlands
Ramaya Tegegne, Switzerland
Esther Teichmann, UK
Chiara Terraneo, Italy
Rodrigo Terren Toro, Argentina
Vicki Thai, USA
Amy Theiss Giese, USA
Despina Theocharakis, Greece
Michaela C. Theurl, Austria
Bjarki Þór Sólmundsson, Iceland
Kolbrún Þóra Löve, Iceland
Polly Rose Thorton, Australia
Jamie Tiller, UK
Sophie Tiller, Austria
Megumi Tomomitsu, USA
Mirjam Tonnaer, Netherlands
Sandra Torralba, Spain
Carlos Torres, Ecuador
Krissie Tosi, USA
Melanie Tralongo, Italy
Carla Tramullas, Spain
Katrin Trautner, Germany
Maria Trofimova, Switzerland
Liza Trottet, Switzerland
Dimitrios Tsalkanis, Greece
Antoine Turillon, Austria
Mert Cagil Türkay, Turkey
Yakup Turkoglu, Turkey
Zoë Twomey-Birks, Australia
Hildrun Urban, Austria
Mahipalsinh Vala, India
Janneke van Leeuwen, Netherlands
Teresa Van Twuijver, Netherlands
Stephanie Vance, USA
Ann-Marie VanTassell, USA
Maria Cristina Vega Videla, Chile
Marie Vic, USA
Frederick Vidal, Germany
Xenia Vinas Casadermunt, Spain
Tereza Vlčková, Czech Republic
Remi Voche, France
Benoît Vollmer, Switzerland
Lauren von Gogh, Belgium
Petros Vrellis, Greece

Anais Wade, USA
Saana Wang, Finland
Wei WangYi, China
Sophie Waridel, Switzerland
Dale Washkansky, South Africa
Robert Watermeyer, South Africa
Dan Watkins, USA
Sue Wendell-Smith, Australia
Sarah Westphal, Belgium
Janet Westwood, UK
Patrizia Isabella Wiesner, Austria
Jeff S. Willis, USA
Adrian Wood, UK
Yu Xiao, China
Liu XiaoFang, China
XinPeng, China
Qing XueBing, China
Jessica Yatrofsky, USA
Ilan Yona, Israel
Dong Yoon Kim, UK
Ozzy Yorulmaz, UK
Haim Yosef, Israel
Asuka Yoshino, Japan
Graeme Yule, UK
Suyeon Yun, USA
Oleg Yushko, Belgium
Elina Zabirova, Russia
Keren Zalt, Israel
Danilo Zappulla, Italy
Piotre Zbierski, Poland
Gang Zhai, China
ZhangHua, China
Qui Zhen, China
Ekaterina Zhuravleva, Russia
Tamara Zibners, USA
ZongNing, China
Barbora and Radim Žůrek,
 Czech Republic

LIST OF SCHOOLS

The following schools were invited to participate in *reGeneration²*:

AFAD – Academy of Fine Arts and Design, Bratislava, Slovakia
Akademie der bildenden Künste Wien, Vienna, Austria
AKV | St Joost Photography, Breda, Netherlands
ALBA – Académie libanaise des beaux-arts, Beirut, Lebanon
Alberta College of Art and Design, Calgary, Canada
Albion College, Albion, Michigan, USA
Art Center College of Design, Pasadena, California, USA
Athens School of Fine Arts, Athens, Greece
Banff Centre, Banff, Alberta, Canada
Beijing Film Academy, Beijing, China
Bezalel Academy of Art and Design, Jerusalem, Israel
Brooks Institute of Photography, Santa Barbara, California, USA
CAFA – China Central Academy of Fine Arts, Beijing, China
CalArts – California Institute of the Arts, Valencia, California, USA
CEPV – Ecole de photographie de Vevey, Switzerland
C.F.P. Centro Riccardo Bauer, Milan, Italy
COFA – College of Fine Arts, University of New South Wales, Paddington, Australia
Concordia University, Montreal, Canada
Corcoran College of Art and Design, Washington, DC, USA
ECAL – Ecole cantonale d'art de Lausanne, Switzerland
ECAV – Ecole cantonale d'art du Valais, Sierre, Switzerland
Ecole Nationale Supérieure de la Photographie, Arles, France
Ecole nationale supérieure Louis-Lumière, Noisy-le-Grand, France
Ecole supérieure des beaux-arts de Nîmes, France
Edinburgh College of Art, Edinburgh, Scotland
Edinburgh Napier University, Edinburgh, Scotland
Efti, Escuela de Fotografía, Centro de Imagen, Madrid, Spain
Elam School of Fine Arts, University of Auckland, New Zealand
ELISAVA – Escola Superior de Disseny, Barcelona, Spain
Emily Carr University of Art and Design, Vancouver, Canada
ENSA – Ecole nationale supérieure d'art Bourges, France
ESBAM – Ecole des beaux-arts de Marseille, France
Escuela Argentina de Fotografia, Buenos Aires, Argentina
Escuela de Foto Arte, Providencia, Chile
Fabrica, Catena di Villorba, Italy
Fachhochschule Bielefeld, Germany
FAMU – Film and TV School of Academy of Performing Arts, Prague, Czech Republic
Fondazione Studio Marangoni, Florence, Italy
Fordham College Lincoln Center, New York, NY, USA
Forma, Centro Internazionale di Fotografia, Milan, Italy
Gerrit Rietveld Academie, Amsterdam, Netherlands
GrisArt, Escola Superior de Fotografía, Barcelona, Spain
Harvard University, Cambridge, Massachusetts, USA
HEAD – Haute école d'art et de design Genève, Geneva, Switzerland
HGB – Hochschule für Grafik und Buchkunst Leipzig, Germany
HISK – Hoger Instituut voor Schone Kunsten, Ghent, Belgium
Hochschule der Künste Bern, Switzerland
Hochschule für bildende Künste Hamburg, Germany

Hogeschool voor de Kunsten Utrecht, Netherlands
ICP – International Center of Photography, New York, NY, USA
IDEP – Institut Superior de Disseny i Escola de la Imatge, Barcelona, Spain
Institute of Creative Photography, Silesian University in Opava, Czech Republic
Jan Matejko Academy of Fine Arts, Krakow, Poland
Jan van Eyck Academie, Maastricht, Netherlands
Konstfack, Stockholm, Sweden
Kunsthochschule Kassel, Germany
La Cambre, Brussels, Belgium
Le Fresnoy, Tourcoing, France
London College of Communication, London, England
Massachusetts College of Art and Design, Boston, Massachusetts, USA
Michaelis School of Fine Art, University of Cape Town, South Africa
Mimar Sinan Fine Arts University, Findikli/Istanbul, Turkey
Minneapolis College of Art and Design, Minneapolis, Minnesota, USA
MOME – Moholy-Nagy University of Art and Design Budapest, Hungary
Musrara – The Naggar School of Photography, Media and New Music, Jerusalem, Israel
Nanjing Arts Institute, Nanjing, China
National Academy of Fine Arts, Oslo, Norway
National Institute of Design Paldi, Ahmedabad, India
National University of Arts Bucharest, Romania
Nottingham Trent University, Nottingham, England
Nova Scotia College of Art and Design, Halifax, Canada
Nuova Accademia di Belle Arti Milano, Milan, Italy
Parsons The New School for Design, New York, NY, USA
Pontificia Universidad Católica de Chile, Santiago, Chile
Rhode Island School of Design, Providence, Rhode Island, USA
Rijksakademie van beeldende kunsten, Amsterdam, Netherlands
Rodchenko Moscow School of Photography and Multimedia, Moscow, Russia
Royal College of Art, London, England
Royal University College of Fine Arts, Stockholm, Sweden
Ryerson University, Toronto, Canada
San Francisco Art Institute, San Francisco, California, USA
Sandberg Instituut, Amsterdam, Netherlands
School of Photography, University of Gothenburg, Sweden
School of Visual Arts, New York, NY, USA
Schule für künstlerische Photographie, Vienna, Austria
SMFA – School of the Museum of Fine Arts, Boston, Massachusetts, USA
South African Centre for Photography, Cape Town, South Africa
Srishti School of Art, Design and Technology, Bangalore, India
State University of St Petersburg, Russia
TaiK – University of Art and Design Helsinki, Finland
Tasmanian School of Art – University of Tasmania, Hobart, Australia
The Art Institute of Boston, Massachusetts, USA
The Midrasha School of Art, Beit Berl, Israel
The National Art School, Darlinghurst, Australia
The Polish National Film, Television and Theater School, Łódź, Poland
The Reykjavík School of Visual Art, Reykjavík, Iceland
The Royal Danish Academy of Fine Arts, Copenhagen, Denmark

The School of the Art Institute of Chicago, Illinois, USA
The University of British Columbia, Vancouver, Canada
The University of Sydney, Australia
Tisch School of the Arts, New York, NY, USA
Tokyo College of Photography, Yokohama, Japan
Tshwane University of Technology, Pretoria, South Africa
Turku Art Academy, Turku, Finland
Universidad San Francisco de Quito, Ecuador
Universität für angewandte Kunst, Vienna, Austria
Universitatea de Arta si Design Cluj, Cluj-Napoca, Romania
University for the Creative Arts, Farnham, England
University for the Creative Arts, Rochester, England
University of Ioannina, Greece
University of New Mexico, Albuquerque, New Mexico, USA
University of Wales, Newport, Wales
University of Westminster, London, England
USM – University Sains Malaysia, Penang, Malaysia
Victorian College of the Arts, Melbourne, Australia
Villa Arson, Nice, France
Xi'an Institute of Fine Arts, Xi'an, China
Yale University School of Art, New Haven, Connecticut, USA
ZHdK – Zürcher Hochschule der Künste, Zurich, Switzerland

overleaf:
Florian Joye Bawadi. From the series *Desert Gate*, 2006

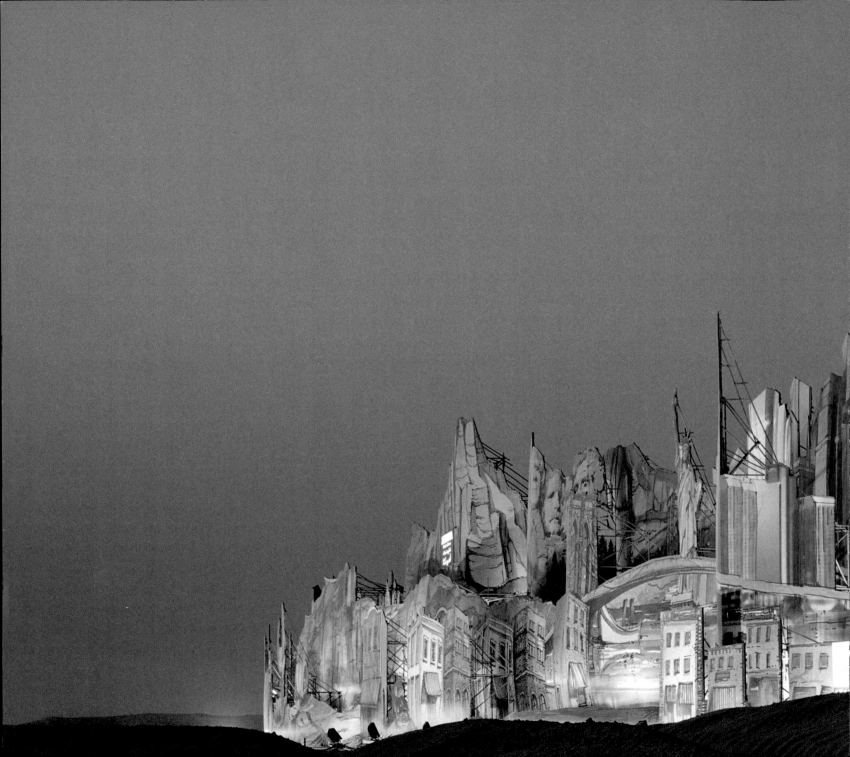

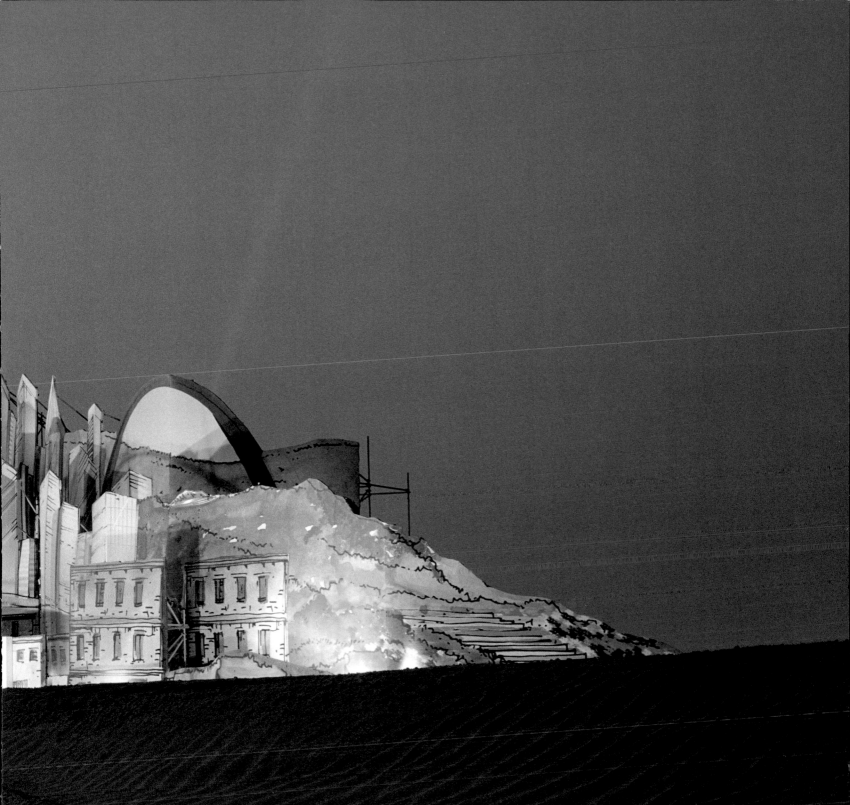

ACKNOWLEDGMENTS

First and foremost, the authors wish to thank the eighty photographers for their willingness to participate in this second edition of *reGeneration*. We also express our gratitude to the directors of the schools, along with their teachers, who responded enthusiastically to our invitation to submit their most promising candidates: Méhdi Aït-Kacimi, Ecole nationale supérieure Louis-Lumière, Noisy-le-Grand; Jenny Altschuler, South African Centre for Photography, Cape Town; Galia Arotchas, Bezalel Academy of Art and Design, Jerusalem; Athens School of Fine Arts; Anthony Aziz, Parsons The New School for Design, New York; Jaroslav Barta, FAMU – Film and TV School of Academy of Performing Arts, Prague; Brigitte Bauer, Ecole supérieure des beaux-arts de Nîmes; Roman Bezjak, Fachhochschule Bielefeld; Vladimír Birgus, Institute of Creative Photography, Silesian University in Opava; Enrico Bossan and Elisabetta Prando, Fabrica, Catena di Villorba; Ram Bracha, The Midrasha School of Art, Beit Berl; Koen Brams, Jan van Eyck Academie, Maastricht; Jean Bryant, University for the Creative Arts, Rochester; Robert Burley, Ryerson University, Toronto; Colin Cavers, Edinburgh Napier University and Edinburgh College of Art; C.F.P. Centro Riccardo Bauer, Milan; Hervé Charles, La Cambre, Brussels; Irene Cho, Tisch School of the Arts, New York; Alvin Comiter, Nova Scotia College of Art and Design, Halifax; María Lorena Daza Cortés, Pontificia Universidad Católica de Chile, Santiago; Geraint Cunnick, University of Wales, Newport; Barbara DeGenevieve, The School of the Art Institute of Chicago, Illinois; Bonnie Donohue, SMFA – School of the Museum of Fine Arts, Boston; Flip Du Toit, Tshwane University of Technology, Pretoria; Emily Carr University of Art and Design, Vancouver; Taina Erävaara, Turku Art Academy; Andrew Freeman, CalArts – California Institute of the Arts, Valencia; Sarah Fuller, Banff Centre, Alberta; Jack Fulton, San Francisco Art Institute, California; Elisabetta Galasso, Nuova Accademia di Belle Arti Milano, Milan; Andy Golding, University of Westminster, London; Jean-Pierre Greff and Virginie Otth, HEAD – Haute école d'art et de design Genève, Geneva; Robert R. Grimes, Fordham College Lincoln Center, New York; Andy Grundberg, Corcoran College of Art and Design, Washington, DC; Albert Gusi, GrisArt, Escola Superior de Fotografía, Barcelona; Willis E. Hartshorn and Coco Lee Thuman, ICP – International Center of Photography, New York; Jacqueline Hassink, The Art Institute of Boston, Massachusetts, and School of Photography, University of Gothenburg; Abdullah Hekimhan, Mimar Sinan Fine Arts University, Findikli/Istanbul; Hochschule für bildende Künste Hamburg; Jos Houweling, Sandberg Instituut, Amsterdam; Stephen Inggs, Michaelis School of Fine Art, University of Cape Town; Jan Matejko Academy of Fine Arts, Krakow; Megan Jenkinson, Elam School of Fine Arts, University of Auckland; Max Kandhola, Nottingham Trent University; Anna Kazimierczak and Lech Lechowicz, The Polish National Film, Television and Theater School, Łódź; Dennis Keeley, Art Center College of Design, Pasadena; Pierre Keller and Pierre Fantys, ECAL – Ecole cantonale d'art de Lausanne; Mitch Kern, Alberta College of Art and Design, Calgary; Chris Killip, Harvard University, Cambridge, Massachusetts; Iosif Kiraly, National University of Arts Bucharest; Christopher Koller, Victorian College of the Arts, Melbourne; Karin Krijgsman, AKV | St Joost Photography, Breda; Doris Krüger, Akademie der bildenden Künste Wien, Vienna; Friedl Kubelka, Schule für künstlerische Photographie, Vienna; Bernhard Prinz, Kunsthochschule Kassel; Björn Larsson, Royal University College of Fine Arts, Stockholm; Steven Lojewski, The University of Sydney; Anne MacDonald, Tasmanian School of Art – University of Tasmania, Hobart; Neyla Majdalani, ALBA – Académie libanaise des beaux-arts, Beirut; Martino Marangoni and Margherita Verdi, Fondazione Studio Marangoni, Florence; Hans Martens, HISK – Hoger Instituut voor Schone Kunsten, Ghent; Beatriz Martínez Barrio, Efti, Escuela de Fotografía, Centro de Imagen, Madrid;

Gábor Máté, MOME – Moholy-Nagy University of Art and Design Budapest; Deepak John Mathew, National Institute of Design Paldi, Ahmedabad; Brice Matthieussent, ESBAM – Ecole des beaux-arts de Marseille; Christine Messerli, Hochschule der Künste Bern; Scott Miles, Brooks Institute of Photography, Santa Barbara, California; A. Rahman Mohamed, USM – University Sains Malaysia, Penang; Marianne Mueller, ZHdK – Zürcher Hochschule der Künste, Zurich; Eline Mugaas, National Academy of Fine Arts, Oslo; Wieneke Mulder, Gerrit Rietveld Academie, Amsterdam; Pedro Vicente Mullor, ELISAVA – Escola Superior de Disseny, Barcelona; Nanjing Arts Institute; Paul Nelson, University for the Creative Arts, Farnham; John O'Brian, The University of British Columbia, Vancouver; Sybille Omlin, ECAV – Ecole cantonale d'art du Valais, Sierre; Galen Palmer, Massachusetts College of Art and Design, Boston; Tod Papageorge, Yale University School of Art, New Haven, Connecticut; Rob Philip, Hogeschool voor de Kunsten Utrecht; Peter Piller, HGB – Hochschule für Grafik und Buchkunst Leipzig; Maria Teresa Ponce, Universidad San Francisco de Quito; Marisa Portolese, Concordia University, Montreal; Stevie Rexroth, Minneapolis College of Art and Design, Minnesota; The Reykjavík School of Visual Art; Olivier Richon, Royal College of Art, London; Lynne Roberts-Goodwin, COFA – College of Fine Arts, University of New South Wales, Paddington; Gabriele Rothemann, Universität für angewandte Kunst, Vienna; Avi Sabag, Musrara – The Naggar School of Photography, Media and New Music, Jerusalem; Merja Salo, TaiK – University of Art and Design Helsinki; Camilla Sarantaris, The Royal Danish Academy of Fine Arts, Copenhagen; Pierre Savatier, ENSA – Ecole nationale supérieure d'art Bourges; Johannes Schwartz, Rijksakademie van beeldende kunsten, Amsterdam; Laurent Septier, Villa Arson, Nice; Rebecca Shanahan, The National Art School, Darlinghurst; Hernan Soza, Escuela de Foto Arte, Providencia; State University of St Petersburg; Olga Stefanovic, AFAD – Academy of Fine Arts and Design, Bratislava; Jim Stone, University of New Mexico, Albuquerque; Su ZhiGang, Beijing Film Academy; Eva Sutton, Rhode Island School of Design, Providence; Patrick Talbot, Ecole Nationale Supérieure de la Photographie, Arles; Miyabi Taniguchi, Tokyo College of Photography, Yokohama; Gunilla Thorgren, Konstfack, Stockholm; Anamaria Tomiuc, Universitatea de Arta si Design Cluj, Cluj-Napoca; Charles H. Traub, School of Visual Arts, New York; Natalia Trebik and Emilie Wartel, Le Fresnoy, Tourcoing; Manuel Ubeda, IDEP – Institut Superior de Disseny i Escola de la Imatge, Barcelona; University of Ioannina; Irina Uspenskaya, Rodchenko Moscow School of Photography and Multimedia; Ampat V. Varghese, Srishti School of Art, Design and Technology, Bangalore; Michel Berney, Léonore Veya and Nicolas Savary, CEPV – Ecole de photographie de Vevey; Gary Wahl, Albion College, Michigan; Anne Williams, London College of Communication; Xie Aijun, Xi'an Institute of Fine Arts; Yao Lu, CAFA – China Central Academy of Fine Arts, Beijing; Ines Yujnovsky, Escuela Argentina de Fotografia, Buenos Aires; and Francesco Zanot, Forma, Centro Internazionale di Fotografia, Milan.

We also offer our thanks to the numerous individuals and institutions who have contributed to this vast project: Ole John Aandal; Federica Angelucci, Michael Stevenson Gallery, Cape Town; Heliana Angotti Salgueiro; Judy Annear, Art Gallery of New South Wales, Sydney; Alexandra Athanasiadou and Vangelis Ioakimidis, Thessaloniki Museum of Photography; Quentin Bajac, Centre Pompidou – Musée national d'art moderne, Paris; Gabriel Bauret; Anda Boluza, Latvian Museum of Photography, Riga; Christian Caujolle, VU'; David Chandler, Photoworks, Brighton; Devika Daulet-Singh; Régis Durand; Ute Eskildsen, Museum Folkwang Essen; Monica Faber, Albertina, Vienna; Helen and Marc Feustel, Studio Equis, Paris; Pepe Font de

Mora, Fundació Foto Colectania, Barcelona; Elena Ochoa Foster; Frits Gierstberg, Nederlands Fotomuseum, Rotterdam; Gauri Gill; Sunil Gupta; Hanne Holm-Johnsen, Preus Museum, Horten; Julie M. Gallery, Tel Aviv; Gunilla Knape, Hasselblad Foundation, Gothenburg; Marloes Krijnen, Foam_Fotografiemuseum Amsterdam; Celina Lunsford, Fotografie Forum International Frankfurt; Alessandra Mauro, Contrasto, Rome; Pedro Meyer and Nadia Baram; Arno Rafael Minkkinen; Engin Ozendes, Istanbul Modern; Marta Ponsa, Jeu de Paume, Paris; Simone Eissrich, Inger-Lise McMillan, Faye Robson, Annette Rosenblatt and Denise Wolff, Aperture Foundation, New York; Rishi Singhal; Agnès Sire, Fondation Henri Cartier-Bresson, Paris; Urs Stahel, Fotomuseum Winterthur; Wim van Sinderen, Fotomuseum Den Haag, The Hague; and Alain Willaume.

We also wish to express our gratitude to our partners in Switzerland, without whom a project of this scope would never have been possible. In particular, we thank Manufacture Jaeger-LeCoultre director-general Jérôme Lambert and Jaeger-LeCoultre France director Yves Meylan. We also wish to thank the Boner Stiftung für Kunst und Kultur, Ernst Göhner Stiftung, the Fondation Leenaards, the Loterie Romande, the Office fédéral de la culture OFC and Pro Helvetia, as well as the Ecole hôtelière de Lausanne, which graciously provided lodging to the visiting photographers.

This publication has been made possible by a donation from the Cercle des Amis of the Musée de l'Elysée, and we thank the Cercle for its generosity: President Camilla Rochat and members Leslie Amoyal; Véronique and Marc Angebault; Hélène Béguin; Lorraine de Loriol; Danièle and Gian De Planta; Magali and Richard De Tscharner; Alexandre Devis; Jean-Claude Falciola; Nicole and Etienne Gaulis; Maud Carrard Gay and Philippe Gay; Vanessa and Fabrizio Giacometti; Caroline and Patrice Girardet; Soun and Pierre-Marie Glauser; Anne and Patrick Headon; Béatrice Helg; Yves and Tatiana Hervieu-Causse; Rosalie and Yves Hoffmann; Mary and François Kaiser; Camille Narbel; Isabelle and Alain Nicod; Mercedes Novier; Edgard Philippin; Marie-Pierre and Christian Pirker; Ruth and Jacky Rezzonico; Camilla and Jean-Philippe Rochat; Marie-Laure Rondeau; Anouk and Alexandre Scurlock; Marina and Armin Siegwart; Marie-Louise Stoffel; Aude Pugin Toker and Erol Toker; Muriel Waldvogel Huang; as well as Link Institut; Lombard Odier Darier Hentsch & Cie Lausanne and Patrimgest SA.

The authors also thank the Fondation de l'Elysée for its encouragement, in particular president Jean-Claude Falciola and members Daniel Girardin, Jacques Pilet, Camilla Rochat, Marco Solari and Brigitte Waridel.

We wish to thank the staff and interns of the Musée de l'Elysée for their commitment to this ambitious project: Lucas Bettex, Nathalie Choquard, Jean-Jean Clivaz, Corinne Coendoz, Nadia Daouas, Achour Djekhiane, Sami El Kasm, Claude Michel Etegny, Adèle Etter, Pascal Fritz, Pierre Furrer, Daniel Girardin, Christine Giraud, Michèle Guibert, Laurence Hanna-Daher, Kassara Hirt, Stefan Hulenstein, Pascal Hutschmid, Emilie Jendly, Sinje Kappes, Julie Liardet, Marie-Claire Mermoud, Pascale Pahud, Géraldine Piguet-Reisser, Patrice Riva, André Rouvinez, Elisa Rusca, Manuel Sigrist, Ludovic Stefanicki, Radu Stern, Michèle Vallotton, Rachel Verbin and Laurence Wagner. Special thanks are due to Jean-Christophe Blaser for his valuable editorial input, and to intern Corinne Currat who has been wholeheartedly committed to the project from the beginning.

As regards this publication, we wish to thank our publisher, Thames & Hudson, for its ongoing support of reGeneration: Thomas Neurath, Constance Kaine, Jamie Camplin, Johanna Neurath, Neil Palfreyman, Ginny Liggitt and Jenny Wilson at the London office, and Hélène Borraz in Paris. Profound thanks, too, to Maggi Smith for a most elegant design, with technical assistance from Elisa Merino. We also appreciate the support of Aperture, in particular Lesley Martin, for publishing the American edition and participating in the American tour of the exhibition.

The authors also thank Radu Stern, Corinne Currat, Sami El Kasm and Adèle Etter for assisting during the selection process. For photographic printing, thanks are due to Laurent Cochet, who produced superb prints for the exhibition.

Finally, we owe a word of thanks to François Hébel, director of the Rencontres d'Arles; Carla Sozzani, director of the Galleria Carla Sozzani, Milan; Juan García de Oteyza, director of Aperture Foundation, New York; and Sam Stourdzé, the new director of the Musée de l'Elysée, for all their support and encouragement.